Incidental Architect

Perspectives on the Art and
Architectural History of the
United States Capitol

Donald R. Kennon, Series Editor

Incidental Architect

William Thornton and the Cultural Life
of Early Washington, D.C., 1794–1828

Gordon S. Brown

published for the U.S. Capitol Historical Society by
Ohio University Press ATHENS

Ohio University Press, Athens, Ohio 45701
www.ohioswallow.com
© 2009 by Ohio University Press
All rights reserved

To obtain permission to quote, reprint, or otherwise reproduce or distribute material
from Ohio University Press publications, please contact our rights and
permissions department at (740) 593-1154 or (740) 593-4536 (fax).

Printed in the United States of America
Ohio University Press books are printed on acid-free paper ⊗ ™

16 15 14 13 12 11 10 09 5 4 3 2 1

Library of Congress Cataloging-in-Publication Data

Brown, Gordon S., 1936–
 Incidental architect : William Thornton and the cultural life of early Washington, D.C.,
1794–1828 / Gordon S. Brown. — 1st ed.
 p. cm. — (Perspectives on the art and architectural history of the United States Capitol)
 Includes bibliographical references and index.
 ISBN 978-0-8214-1862-8 (cloth : alk. paper) — ISBN 978-0-8214-1863-5 (pbk. : alk. paper)
 1. Thornton, William, 1759–1828. 2. Washington (D.C.)—Intellectual life—18th century.
3. Washington (D.C.)—Intellectual life—19th century. 4. Architects—United States—
Biography. I. Thornton, William, 1759–1828. II. Title. III. Title: William Thornton and
the cultural life of early Washington, D.C., 1794–1828.
 NA737.T47B76 2009
 720.92—dc22
 2008047574

Contents

Illustrations

Foreword

The U.S. Capitol Historical Society is pleased to continue its series of publications on the history of the U.S. Capitol with Gordon Brown's intriguing, revealing, and even tragic account of the role of the Capitol's original architect, William Thornton, in the social, cultural, and yes—political—development of the infant seat of the federal government. The reader should not expect to find here a detailed account of Thornton the architect and designer, for that, as the author states at the outset, is not his purpose. For Thornton's architecture one can turn to William C. Allen's *History of the United States Capitol* and the ongoing work of C. M. Harris. Rather, here, the reader will see Thornton as he possibly would have wanted to be seen—as a learned gentleman actively involved in all those cultural and economic pursuits that defined the landed gentry of the late eighteenth century, from horse racing to experimentation with steam powered navigation. His involvement in architecture was but one facet of his self-definition, not the principal profession it was for his nemesis, B. Henry Latrobe.

The reader will note a curious phenomenon as the author unwinds the intertwined stories of the man and the Federal City's cultural development: Thornton recedes from foreground to background as the city's cultural institutions grow and take life. In the process, Gordon Brown adds to the insights of Kenneth R. Bowling, Bob Arnebeck, Fergus Bordewich, and others whose writings have all made clear to us that the nation's capital did not spring Minerva-like fully grown from the Constitution. Washington, D.C.'s, success as the nation's capital was not foreordained by the principles of its inception but rather was the result of a slow, lengthy, and painful development in which men like Thornton contended with one another and with the intractable realities of the region's climate, geography, economy, and local and national politics. It was the latter that most marginalized William Thornton. In a story to be repeated many times in the city's history, a seismic shift in party fortunes pushed aside a whole set of elites. Thornton would remain a participant but not a force in the capital's cultural leadership, his decline made all the more poignant in that like the protagonist in a Greek tragedy, the qualities of his personality that brought success also bore the seeds of, if

not his destruction, at least his fading away. What emerges and what endures is the cultural and social vitality of the young city—not the thriving metropolis hoped for by its boosters but certainly far from the backward wilderness of its detractors. In Gordon Brown's dual accounts of an individual and his cultural setting, there is much to learn and much to ponder in the pages that follow.

Donald R. Kennon

Preface

In the many fine books and articles that have been written on the history of early Washington, D.C., most of the attention has been focused on two key aspects: the physical development of the new city and the growth of its political and social institutions. This is of course entirely fitting, as are not politics and real estate still prime topics of conversation in the modern city?

And yet, that record is somehow incomplete, lacking a sense of life as it really was. Construction of the Federal City, the debates in Congress, the prices of building lots, gossip from the latest official reception or diplomatic rumor—those were surely important. But residents of the new capital had more mundane concerns as well. Decent living quarters and food, of course, but beyond those needs lay the desire for a decent quality of life, including possibilities for cultural, educational, and spiritual enrichment. In the raw new town, what indeed was the everyday cultural environment of an average Washington resident family? What did they do with their leisure time? What were their cultural outlets? How did they reach for knowledge or inform themselves about the outside world? Even more specifically, how did the cultural institutions evolve that would serve the town's growing population?

This work aims to answer at least some of those questions, but it will inevitably leave as many unanswered. The written records on which it is based, for example, say virtually nothing about the cultural life of those residents who were outside the privileged class. The laborers, craftsmen, mechanics, slaves, and others who lived in the city surely had their pastimes, their music, weddings, dances, street theater, and amusements about which we have virtually no specific information, yet which were a vital part of the broader culture of the city's residents. Nor does the written record give us much detail about the primary vehicle for cultural education and even enjoyment of the time: the family circle. We have a good deal of anecdotal information in which we can see Washington families and their friends discussing books, learning foreign languages, painting, playing music, and singing together around the family hearth, and we realize how important a cultural vehicle the home could be and undoubtedly was. As part of

the cultural life of the period, the family was undoubtedly central, but our focus will be on the growth and evolution of the cultural facilities of the new community.

Early Washingtonians obviously lacked cultural institutions and opportunities like those of the established European capitals, or even those of the older, larger cities of the new republic. With no royal court or rich aristocracy to subsidize the fine arts, no American city could have hoped to mimic high European culture in any event. And Washington was a raw new settlement, with a cultural life which was of necessity that of a small town—albeit one with aspirations. What gave it particular reason for those aspirations were the facts that it was the seat of government, and that a sizable proportion of its new residents were individuals and families of talent and education. They had come to the capital to take part in the republican experiment and would enrich it culturally by their presence.

Dr. William Thornton was among the most urbane and brilliant of the early residents. A restless intellect, a prize-winning scholar and architect, a liberal enthusiast and an aesthete, he was also blessed with a talented and artistic wife and an important position in his adopted town. The couple would have made a mark in any American city, but in the new city of Washington, Thornton and his wife rapidly became prominent in the best social and intellectual circles. Since his arrival in 1795, Thornton's life effectively paralleled that of the new capital, and he was both an observer of, and an important actor in, the social and cultural development of the new city.

Through the prism of William and Anna Maria Thornton's lives, then, this work will explore the role and contributions of the new city's leading citizens to the local cultural and intellectual climate, and how they assisted in the gradual formation of new institutions. The focus will be on the new city of Washington, including to a large degree Georgetown, which was and still is a pole of the federal capital. Alexandria, which never integrated into the Federal City easily and eventually withdrew entirely, will mostly be ignored, as will the areas of the federal district that were outside the city limits—what was then known as Washington County.

The Thorntons undoubtedly would be amazed to see the cultural richness of today's city and its suburbs, with so many museums, theaters, concerts, nightclubs, intellectual institutions, and art galleries. And while they might well be shocked by some of today's offerings, they would certainly appreciate how much their little village and its cultural attractions have grown.

As someone who spent some years in childhood and many as an adult in Washington, I have reveled in the opportunity that this book has given me to travel in my mind back to the early village and then forward again to the city we know. I am grateful to the U.S. Capitol Historical Society for allowing me to embroider in this manner on the life of the Capitol's first architect, William Thornton, and am particularly thankful to Barbara Williamson for her invaluable help in researching the newspaper records.

Incidental Architect

1

An Incidental Architect

W ILLIAM THORNTON REALIZED THAT HIS FIRST ARCHITECTURAL DESIGN
for the proposed U.S. Capitol could not win the competition. It had been
drawn up before he left the West Indies and was, in the light of all the
new information he had gathered since his arrival in Philadelphia, unlikely to satisfy
the selection committee. That committee, which for all practical effect was President
George Washington himself, was said to be looking for something quite new and dif-
ferent. Aided by this new understanding of the criteria by which his submission would
be judged, Thornton saw that his first effort was trite; it was entirely too much in the
tradition of British colonial architecture.

An old friend, Judge George Turner, had confided that the president had set aside
all the plans thus far submitted for the proposed Capitol, in the apparent hope of see-
ing something more monumental. What was likely to catch the president's attention
favorably, Turner knew from his own experience as a disappointed applicant, would be
something grand, expressing the dignity and pride of the new nation. Moreover, both
Washington and Secretary of State Thomas Jefferson (who was advising the president
on this project) were leaning toward a building with a dome as a new and distin-
guishing element. And Jefferson had a known preference for classical architectural mo-
tifs: Rome, in his view, should be the model for the new republic's public buildings.

The advice had been very useful. And it would lead to an entirely new design.

It was the beginning of 1793, and Dr. William Thornton and his young wife had recently returned to Philadelphia from his plantation on Tortola, happy to leave the relative isolation of the West Indian island (and family problems there) for the stimulation and promise of the new American republic. But what had drawn him back to his adopted country at this particular time was an opportunity presented by the commissioners of the Federal District, who had decided to choose the design of the nation's new Capitol through an open competition. Dr. Thornton had, in fact, missed the original period for submissions, mailing his application from Tortola even as the July deadline was expiring. But the commissioners, faced as they were with a large number of designs of middling quality, none of which had struck the fancy of their revered president, had extended the deadline in order to allow Thornton to compete. The competition was still open.

Thornton was by no means a professional architect, having been trained in medicine. But the architectural profession was in its infancy, and only one of the competitors, Etienne (or Stephen) Hallet, had had any formal training in the discipline. Thornton was already well known in the right circles in Philadelphia from his earlier four-year sojourn there. He had established a reputation as a distinguished product of the Scottish Enlightenment, a polymath whose learning encompassed a liberal, republican outlook with practical skills in medicine, mechanics, the arts, botany, the natural sciences, and much more. Soon after his arrival in Philadelphia, he had been elected to membership in the respected American Philosophical Society. Moreover, had he not won the 1789 competition to design a new hall for the Library Company of Philadelphia, with his plan for an elegant, classical-style building? He had drawn up his winning plan on the basis of the architectural observations he had made during his travels on the Continent and in England, plus his extensive study of the architectural books of the period. That was architectural credential enough for the commissioners.

By the end of January, Thornton had submitted his new plan. A low central dome and grand columnar portico gave the building monumental scale, while two well-proportioned and embellished wings, one for each house of Congress, symbolized the building's function as the seat of the people's representatives. The design immediately captured the president's imagination. That was probably enough to assure a favorable decision, but Jefferson, too, was impressed. "Doctor Thornton's plan of a capitol has been produced," he wrote to the commissioners, "and has so captivated the eyes and judgment of all as to leave no doubt you will prefer it when it shall be exhibited to you; as no doubt exists here of its preference over all which have been produced, and among its admirers no one is more decided than him whose decision is most important. It is simple, noble, beautiful, excellently distributed, and moderate in size."[1]

[1]Jefferson to Commissioner Daniel Carroll (uncle to Daniel Carroll of Duddington), 1 Feb. 1793, Thomas Jefferson Papers, Library of Congress Manuscript Division, series 1, image 731. Accessed at Library of Congress, *American Memory,* http://memory.loc.gov/ammem/collections/jefferson_papers.

With the commissioners thus apprised that "[he] whose decision is most important," that is, General Washington, had already made up his mind, they declared the competition over and Thornton the winner. By the beginning of April, and following his tardy submission of the additional drawings required, Thornton's plan was formally approved. His design would guide construction of one of the first icons of the new republic: a grand capitol to be built in the new Federal City on the banks of the Potomac.

It was a singular moment for Thornton. A convinced republican, he had chosen to become a citizen of the new United States in early 1788, praising the American experiment and its potential to his British friends and colleagues. His enthusiasm over America's future extended even to the controversial plan to build a new capital city in the wilderness: years earlier he had told his skeptical Philadelphia mother-in-law that he was "informed that it would be the grandest city in the world."[2] Now he would play a part, a seminal part he hoped, in the development of that new capital.

His move to the United States indeed seemed to have been doubly justified, for at about the same time he was awarded still another American honor. His essay *Cadmus,* on what would now be considered applied linguistics—a treatise on phonetics and the teaching of languages—had been awarded the annual Magellanic Prize by the American Philosophical Society in Philadelphia. With that additional distinction, Thornton's new career in America indeed seemed very well launched. He had sought the opportunities that the new republic offered, and they had come within his grasp.

Thornton was technically already a second-generation American, his father William having left the ancestral home in England's Lancaster County in the 1750s to become a successful sugar grower on the British West Indies island of Tortola. The younger William was born on the island in 1759 but never truly knew his father, who died unexpectedly in 1760. As a result, and due to the lack of local schools, William and his younger brother were sent back to Lancaster when he was only five years old and entrusted to the care of relatives, particularly his Thornton aunts.

His experiences as a child as well as his education, as a result, were essentially English rather than American, but they were more specifically Quaker—that being the faith of both his Lancaster family and much of the Tortola colony. The Quaker education he received in Lancaster prepared him for a well-rounded life. His education had gone beyond training in the classics and sciences to practical matters such as business and accountancy, with a particular focus on the necessity of moral, civic, and humanitarian virtues. It was also, in keeping with Quaker custom, an extended period of both formal and informal schooling, lasting until he was eighteen, and was then capped by an additional four years as an apprentice to a local surgeon-apothecary. In the local market town of Ulverston, William learned the rudiments of small-town

[2]Thornton to Ann Brodeau, 3 Nov. 1791, in *The Papers of William Thornton,* ed. C. M. Harris (Charlottesville, Va., 1995), p. 167.

medical practice. But he also had time and inclination for rambles in the country, painting, and to exercise his budding interest in the natural sciences.

It was not until the relatively mature age of twenty-two, then, that Thornton went to university. In 1781, the University of Edinburgh was at the height of its success as one of Britain's leading centers of learning, and particularly as a vital contributor to the thought of the Enlightenment. Thornton, already shaped by the humanism of his Quaker schooling and his own scientific bent, took readily to the liberal, rational, and civic-minded atmosphere of the university. With a concentration in medicine, he soon was recognized as an accomplished scholar, elected as member to both the Antiquarian and Royal Medical societies, and an officer in the college's natural history society. Equally important, he developed a broad circle of influential and distinguished friends and sponsors. His evident intelligence and engaging personality, coupled with the entrée his wealth and family had provided, opened doors throughout northern England and Scotland. Broadening his contacts during the several natural history and artistic field trips he took along the Scottish coasts and into the Highlands, he had, by the time of his graduation, gained somewhat of a reputation as a distinguished young man on the rise.

Having completed his formal studies at Edinburgh, save a required course in botany, Thornton interrupted his university career in the fall of 1783 to attend the funeral of his great-uncle and sponsor in Lancaster, and from there to spend some time in London. In that city, he continued his medical studies at St. Bartholomew's Hospital while enjoying the company and stimulation of a circle of artistic friends. He also spent much time in the company of Dr. John Coakely Lettsom, a distinguished physician and philanthropist who, guided by his Quaker beliefs, had freed his slaves before leaving the West Indies. Lettsom became an important mentor and sponsor of his young compatriot, encouraging him, among other things, to travel to Paris, where he could deepen his acquaintance with Europe's medical and scientific communities.

Armed with suitable introductions, including one from Lettsom to Benjamin Franklin (then approaching the end of his triumphant mission as diplomatic representative from the successfully rebellious North American colonies), Thornton profitably spent a number of months in Paris. In addition to meeting many leading medical and scientific personalities, he absorbed the architectural and artistic climate of the city and was introduced into its vibrant social-intellectual life. He became, indeed, a regular at the salon of the author Countess Françoise de Beauharnais—to whom, in thanks, he presented a small portrait that he had painted.

Thornton left Paris that summer, having accepted an invitation from the French naturalist Faujas de St. Fond to accompany him on a geological field trip to the Scottish Highlands, a trip that, while not entirely successful, provided him with still more

opportunities for making acquaintances and friends in England's scientific community. Spending some months again in Lancaster, he never returned to Edinburgh to finish his course work, and as a result his medical degree was issued by the University of Aberdeen in late 1784. Early 1785 saw him once again in London, preparing to return —after an absence of more than twenty years—to his birthplace in Tortola.

His return was not a smooth one. This bright young man, who had been exposed to the best liberal ideas circulating in the capitals of Europe and was enthusiastic about the revolutionary republican experiment in North America, returned home with a worldly, reformist outlook that sat uncomfortably with the realities of the isolated, conservative, sugar- and slave-dependent West Indian colony. More than likely, he was more than a bit opinionated in expressing his views; even his mentor Lettsom had commented that the young man still had "too much sail" and not enough ballast.[3] And, coming as he did from a Quaker and antislavery atmosphere in England, his differences with the islanders on that issue were indeed significant. The Quaker Meeting on the island had been dissolved years earlier, with many of its members having left for North America, so that when Thornton began to voice his ideas about the injustices of slavery, he found few if any supporters on the island. Not even among his own family. His mother had remarried some years before, and both she and her husband, Thomas Thomason, opposed William's schemes to free some of his seventy or so slaves—unless they were to be transported to somewhere else, where they could not disturb the security of the local plantation system. Faced with this opposition, Thornton had to drop the scheme for the moment. But he had not dropped the idea of freeing the slaves; he had only added to it a further proposition—the idea of resettling those who would be freed.

Thornton practiced medicine only sporadically during his stay on the island, and it seems that he rarely collected fees for those services he did perform. Maybe this was because—as he confided to his English friends—he did not intend to stay there long. But the result was that he did not succeed in establishing a professional standing in Tortola. Nor was he able to obtain, as he wished, a satisfactory separation of his own share from the jointly held family plantation, Pleasant Valley. As a result, his income from that source would continue to be subject to his stepfather's management—not a problem as long as the plantation provided large returns such as those that had financed his education, but that was a situation that would not last.

For one reason or another, then—and one may have been an unsuccessful courtship of a local heiress—Thornton left Tortola after little more than a year. His destination, for a "visit" he said, was the new American republic, where he arrived in October

[3]John Lettsom to Benjamin Franklin, 28 Jan. 1784, ibid., p. xxxiv.

1786. He settled in Philadelphia, where his Quaker connections, wealth, contacts, and experiences once again opened doors for him. He was rapidly taken into the best circles in America's most important city and soon became a bright fixture of the city's intellectual life.

But his attention, for the moment, remained on the issue of slavery and how to resolve it by emancipation and resettlement. During his first winter and spring in the United States, he traveled to New York, Rhode Island, and Boston to promote his scheme of a colony of free blacks on the coast of Africa. Full of goodwill, enthusiasm, and piety, he even offered the audiences of free blacks with whom he met that he would lead such an expedition himself or join up with concurrent efforts in Britain to establish a colony in Sierra Leone. But he never succeeded in stirring his audiences into action, and—faced also with lukewarm support, at best, from Lettsom and other English mentors in this effort—he had to recognize that the time was not yet ripe.

When he returned to Philadelphia, Thornton found the town full of representatives from the various states, summoned there to a Constitutional Convention that was being held just a short distance away from his boardinghouse. The city brimmed with republican enthusiasm and exciting political ideas, and the atmosphere was so promising for a man of Thornton's liberal and reformist tendencies that before long he decided to become a citizen of the country whose ideals he had long admired. He swore fidelity to the state of Delaware—and thus the United States—in January 1788. Henceforward increasingly opposed to monarchy and an enthusiast for republicanism in the Americas, he would often, in his correspondence, lecture his English friends on the advantages of the American experiment.

Once again, however, Thornton did not practice medicine. He did take a few patients but made little effort to establish a clientele. Eventually he confided to friends that he found the American model of general practitioner—there were no specialists —both insufficiently rewarding and "not only laborious, but disgusting."[4] Instead, and still supported by an adequate even if decreasing income from Tortola, he turned to mechanical experimentation. He wrote a paper on distillation but never published it, and he claimed to have invented a steam-powered gun, though once again he neither patented it nor even wrote it up for the Philosophical Society, as he said he had been urged to do by Franklin. More important, however, he became heavily involved in the efforts of an unschooled Philadelphia inventor, John Fitch, to develop a practical steam-powered boat. Thornton was convinced that Fitch had not only the earliest but also the best idea for this rapidly evolving technology and soon became one of his main supporters in the effort. He took an important financial interest in Fitch's company and, as the member of the group who knew the most about steam engines, perfected a

[4]Thornton to Anthony Fothergill, 10 Oct. 1797, ibid., p. 425.

condenser design for one of the various prototype boats that were built and run in a briefly successful commercial service in 1788 and 1789.

Thornton's efforts during this period of innovation were not all mechanical. His letters are full of observations on the botany and natural features of his new country. Nor had he lost his interest in the fine arts. Having expressed to Lettsom that "the fine arts hardly exist here, and learning is little considered," he saw his lack of actual architectural experience as no barrier to joining the competition to design a new building for the Library Company.[5] His winning design was handsome, even if largely cribbed from architectural design books, and featured four white marble pilasters extending up the brick facade to the roof, a large central pediment, and an ornamental balustrade. In addition to the prestige attached to the award, he had the pleasure of seeing the building completed according to his design. A local builder completed the job in not much more than six months—an experience that was not to be repeated in the new national capital.

It was a productive and stimulating period for Thornton, who through his various enthusiasms and talents had established a place of respect for himself in Philadelphia. But perhaps his most lasting achievement during these years was his courtship and marriage to a local girl, Anna Maria Brodeau. He had met her when she was only fourteen years old, and no details of their courtship survive. Daughter of the proprietress of one of Philadelphia's best boarding schools for young ladies, Anna Maria had a range of talents that impressed even her polymath suitor. As he wrote to an English friend some months after his marriage, "She is just turned seventeen but speaks and writes French and Italian with ease and correctness. She has uncommon genius in all works of art and fancy—draws excellently; sings and plays on the piano forte and pedal harp with uncommon skill—is a capital accomptant, a critic in the English language, and possesses all the inferior accomplishments in an eminent degree; and besides a beauty which makes her much admired, has a heart suited only for benevolence and kindness."[6] The marriage had come, however, at one cost: because Miss Brodeau was not a Quaker, Thornton was disowned by the Philadelphia Meeting. But Thornton, whose deep Christian faith was tempered by a thoroughly nonsectarian approach, shrugged that off. He was about to leave Philadelphia, in any case.

The newlywed couple traveled to Tortola less than a week after their marriage. The trip apparently had a number of motivations: to introduce Anna Maria to her husband's family, to look into the growing problems of the plantation, and to reassess the possibilities of practicing medicine there. On the last point, Thornton was soon discouraged. He found that physicians' fees had dropped and that there was little chance

[5]Thornton to Lettsom, 15 Feb. 1787, ibid., p. 45.
[6]Thornton to Thomas Wilkinson, 28 July 1791, ibid., p. 152.

of his establishing a remunerative practice on the island. He did not help his chances, of course, by his continued vocal support of emancipation. Indeed, his enthusiasm for African resettlement projects soon made him rather suspect among his fellow plantation owners—"they hint me to be a dangerous member of society," he wrote.[7] Nonetheless, and in spite of the failure of the first British settlement in Sierra Leone, he continued to toy with the idea of leading an African settlement expedition himself, even to the point of cataloging useful plants to introduce there for cultivation and buying some cannon for defense of the colony. But more practical matters intervened and money became short. The family plantation suffered from bad crops and hurricanes, while letters from Philadelphia kept him informed of the slow death of the steamboat company. He thought of buying still more land on the island but could not raise the funds. In short, not much was going right.

Thornton filled his time during the three years he and his wife stayed on the island with studies and projects. He began an extensive collection of botanical drawings, with a view to publishing a book on tropical plants. Efforts to instruct his slaves led him toward the study of phonetic alphabets as a tool to teach the deaf, as well as to transliterate all languages, work which would eventually culminate in his prizewinning *Cadmus* essay. He even began to put together a dictionary, which did not, however, get very far. But life on the island apparently was not fulfilling, and by the end of his second year he was writing to friends that he hoped to return to America. Thus when his wife and mother-in-law informed him of the competition to design a trend-setting Capitol in the new Federal District, he jumped at the chance.

Thornton had won the competition to design the Capitol, but his troubles over it were just beginning. When his design was chosen, he had submitted a number of interior plans as well as exterior elevations. But the builder of such a major work, the commissioners felt, would need more detailed instructions, and since they had worked for some time with the losing competitor Stephen Hallet, and had respect for his talents as a trained architect, they asked him to comment on the Thornton design. Given this open opportunity to undercut his competitor, Hallet not unexpectedly replied in June 1793 with a stinging critique: Thornton's plan was impractical in places; the building too dark in others; it would be too expensive to build in the seven years before the government moved to Washington; and on and on. The criticism hurt. Thornton, the gentleman-scholar, did not appreciate his work being thus attacked, and by a man whom he considered as little more than tradesman builder, at that. His sharp reply to the commissioners attempted to dismiss Hallet's objections, even while recognizing in essence that some problems were correctable. Thornton, it seems, could not openly

[7]Thornton to Grenville Sharp, 5 May 1792, ibid., p. 184.

admit that his plan was indeed flawed. The elegance and the logic of his prize-winning exterior conflicted in a number of key respects with the actual necessities of construction, ventilation, lighting, and circulation.

Given this impasse, President Washington told Jefferson to get together the two adversaries plus qualified builders, and others, to work out an agreed plan. Meeting in Philadelphia, the group—the president himself attending for a while to indicate the importance he attached to a quick solution—came up with a compromise plan, which rearranged a good deal of the interiors of the two wings but retained Thornton's design for the exterior and the domed central portion. But the compromise, it would turn out, was also flawed: the interior and exterior spaces still did not mesh correctly. The dispute was by no means over, but work, at least, could start.

Thornton remained in Philadelphia, not directly involved in the construction of the new building. That had been entrusted to Stephen Hallet, under the supervision of James Hoban, the designer and builder of the President's House. Thornton did take several short trips to the new Federal City in 1793, but he was not part of the ceremony when, in September of the following year, President Washington, with considerable civic, military, and Masonic pomp, laid the cornerstone. Nor was he involved when the president and the commissioners began to realize that Hallet, in the process of laying the foundations, had deviated substantially from the agreed plan—and even claimed not to recognize Thornton's plan as valid. Hallet's insubordination in time reached a degree at which the commissioners found it necessary to fire him. But Thornton, while consulted on the conflicting design ideas, was able to remain largely aloof from the controversy that had already begun to surround the construction of this symbolically important building.

The Thorntons, on their return from Tortola, had moved into a Philadelphia house that had been engaged and furnished for them by Mrs. Brodeau. But city life, they found, was expensive. Remittances from Tortola were diminishing when available at all, while the difficulties of opening a medical practice had once again discouraged the doctor from that profession. Moreover, the steamboat enterprise had all but gone sour, at a not inconsiderable cost to both pocketbook and morale. Dr. Thornton, in fact, was once again restless and a bit perplexed as to how to advance himself in this new society in which he had chosen to live. Admitting that he "sighed after" the intellectual life of London, he complained, "I languish here among merchants, and talents here are in a measure useless. I must work in politics, and exert myself in a way suited, not to myself, but to those about me."[8] In reality, he badly needed a job—but would consider only those that he saw as befitting his status as a gentleman. He tried to land a position

[8]Thornton to Lettsom, 21 Feb. 1794, ibid., p. 276.

as President Washington's private secretary, and then as a teacher at the University of Pennsylvania. Unfortunately he failed; his distinctions did not assure him the necessary patronage. Finding it necessary to economize, the couple moved their principal residence some distance into the country, where indeed it would have been possible to cut costs—had not Thornton taken up the expensive avocation of raising blood horses.

Then, in the late summer of 1794, he received an unexpected invitation from Jefferson to become one of the commissioners of the Federal District. One of the conditions of the offer was that it would require moving to the new city of Washington in order to help supervise the public works under way there. But for someone who had consistently been an enthusiast for the concept of a new federal capital, it was an opportunity not to be passed over. While the job would not pay highly, he wrote Lettsom, he and his fellow commissioners would enjoy "very extensive" powers over the development of the town. His options in Philadelphia were not brilliant, his need for new distinction—and, of course, a salary—pressing. He accepted.

Thornton did not know, of course, that he was somewhat of a default candidate for the job. President Washington, annoyed at the slow pace of work of the first commissioners, had insisted that any new commissioners live in the District, where they would be in a position to oversee the work directly and meet regularly. That, for many potential candidates, was a fatal condition. At the same time, Washington was cautious about selecting one of the local landowners, fearing that "their local, or perhaps jarring, interests and views might render them unfit for the trust."[9] With few candidates thus available, Washington had asked his secretary, Tobias Lear (who had declined the job himself because he wanted to go into commerce), to look into Thornton's qualifications. "The Doctor is sensible, and indefatigable I am told, in the execution of whatever he engages; to which may be added his taste for architecture, but being little known doubts arise on that head," Washington cautioned.[10] After talking to the landed proprietors of the area—with whom the commissioners had to work closely—Lear reported back with a recommendation but also a warning. "I find that Dr. Thornton is much esteemed by those of the proprietors and others hereabouts of whom I have been in the way of drawing an opinion. They consider him a very sensible, genteel and well informed man, ardent in his pursuits, but liable to strong prejudices, and such I understand is his prejudice against Hoban that I conceive it would hardly be possible for them to agree on any point where each might consider himself a judge. Weight of character, from not being known, seems also to be wanting."[11] The president, however, had few options. He chose Thornton, it seems, largely because he expected that

[9]Washington to Commissioner David Stuart, 20 Jan. 1794, George Washington Papers, Library of Congress Manuscript Division, series 2, letter book 24, image 58. Accessed at Library of Congress, *American Memory,* http://memory/loc/gov/ammem/gwhtml/gwhome.html.

[10]Washington to Tobias Lear, 28 Aug. 1794, ibid., series 4, image 244.

[11]Lear to Washington, 5 Sept. 1794, ibid., series 4, image 304.

the clever amateur architect, who had no parochial ties and did have a record of sup-
porting the idea of a new, monumental, but republican capital, would be an effective
booster of the Potomac location the president had selected.

So the Thorntons and Mrs. Brodeau packed up their houses in Philadelphia
and moved to Washington—or more specifically, to Georgetown—in October 1794.
William was looking forward to the new challenge and the important work on which
he would be engaged. He was ambitious, even impatient, but all too easily distracted.
As he wrote to his mentor Lettsom a few months after his arrival, "I am sought for by
company; when I hear music, my ear is tickled; my eye delighted by painting; the
murmuring brook arrests my attention, and I forget that it represents time, which
glides away and returns not. Nature is always regenerating, but man is dying. I must
do more than I have ever done, or my name too will die."[12]

The somewhat bleak reality of the small settlement on the Potomac frontier must,
however, have left him and Anna Maria wondering. If he had sighed for the intellec-
tual and cultural excitement of Europe while in Philadelphia, what would be the pos-
sibilities in his new home?

[12]Thornton to Lettsom, 8 Jan. 1795, in Harris, *Thornton Papers,* p. 295.

2

"A Little Genius at Everything"

T HE FEDERAL CITY TO WHICH THE THORNTONS AND MRS. BRODEAU MOVED was still more concept than reality. Construction of the major public works was lagging; the Capitol itself only an incomplete set of trenches slowly filling with foundation stone—some of it so badly laid that it would have to be redone. While the President's House was further advanced, the would-be avenue connecting the two buildings was a muddy track through the woods, fields, and the creek at the bottom of Capitol Hill. The local landowners, whose farm houses were among the few permanent structures around, continued to operate their farms in spite of the hypothetical streets and avenues being traced across their fields. One of the more important proprietors, Daniel Carroll, had indeed just finished a large new home, Duddington, at the edge of Capitol Hill, hopeful that the city would soon build up on his neighboring property. At the same time, however, he continued to clear land and grow crops for current income. A bit further up the Potomac, Notley Young's large plantation house and its dependencies was yet another notable landmark of the still-present past.

The urban future was represented, tentatively at best, by a number of scattered brick houses in clusters along the river and around the construction sites of the Capitol and the President's House. A first set of row houses had just been built, just down the river from Young's farm in an area that became known as Greenleaf's Point. All in all, however, work on the nation's future capital had so far spawned more workmen's barracks

and shanties, clay pits, brick kilns, saw pits, semi-cleared roads, and fallen timber than urban construction.

Georgetown, where the Thorntons rented a house on Falls Street, was a welcome contrast. Although technically part of the Federal District, it had not yet been incorporated into the future capital and had its own town government under Maryland law. As a well-established port, it had a grid of streets, some fine townhouses, an adequate variety of shops, and some basic social and cultural amenities. Thus, while his ladies began to explore the possibilities of their new home, Dr. Thornton was able to plunge directly into his new job as commissioner.

It was no easy job. The three commissioners had a difficult and thankless task, and the previous members were retiring, exhausted, after some four years of contention and only limited progress. It had become obvious that the scheme that Congress had set in motion by the 1790 Residence Act was seriously flawed. The expectation had been that the expense of laying out the city and its public buildings was to be financed through the sale of building lots, of which the government owned half. Unfortunately, land values had not met expectations; the lots had been selling slowly. Money was scarce, and serious investors timid—the Federal City project still had powerful enemies in Congress and to the north. In such an uncertain climate speculators were active, but actual building was painfully slow.

As a result of poor sales, the commissioners never had enough money to spend on the public works and had become dangerously dependent on small advance payments from speculators and entrepreneurs whose development projects were as ambitious as their pockets were empty. Negotiations with the original proprietors (who disposed of half of the building lots in return for having signed their lands over to the commission) were also difficult and tiring. The proprietors wanted faster progress laying out and grading the streets and prompt payment for land taken as government reserves, but they also harassed the commission regularly through their own bitter competition over which end of the district would be developed first—the Georgetown end or the Capitol Hill–Anacostia River end. Finally, the commissioners were responsible for overseeing the myriad annoyances of the actual projects, obtaining materials and labor, and managing a quarrelsome set of architects, surveyors, construction supervisors, and contractors.

President Washington's intense interest in the project was, for the commissioners, both a blessing—he could provide needed political leverage—and a problem—progress could never live up to his expectations. Owning some sixty thousand acres of land in the Potomac and Ohio River watershed areas and determined to make the new capital a key gateway to the western lands, the president expected each of the commissioners to

share his enthusiasms and promote the city actively. Anxious to prove to a skeptical Congress in Philadelphia that the project was progressing, the president kept closely in touch with the commissioners' work, pushing them to meet the 1800 deadline for receiving the government. He also visited the site periodically on his trips between Philadelphia and Mount Vernon, giving Thornton a chance to escort him and even to begin a friendship that was, to the younger and newer American, one of the most important of his life.

As commissioner, Thornton had become one of those responsible for carrying out his own plan for the Capitol. Unlike the Philadelphia library project, this was not a simple matter of turning things over to a builder. Too much politics and too many egos were involved, not the least of which was his own. He was immediately involved in a controversy as to whether the foundation level of the building should be raised to better accommodate the site. Since the dismissal of Stephen Hallet, work on the building had been proceeding indifferently under the supervision of James Hoban, the builder of the President's House. The previous commissioners had also appointed Samuel Blodgett, an enthusiastic promoter of the Federal City, to oversee the works, but he was proving to be a disappointment—too heavily involved as he was in his Philadelphia business, as well as in a plan to build a huge hotel in Washington through the proceeds of a lottery. Thornton and Blodgett became close friends, even though Thornton remained wary of Blodgett's somewhat dodgy lottery scheme. The lottery idea however was just another symptom of the overriding problem—the lack of investment in the new city. In March of 1795, Thornton was sent to Philadelphia to try to raise a loan to finance the commission's work, but the bankers found the proposed surety—the city lots—unconvincing, and Thornton returned from his mission unsuccessful.

Thornton and his fellow commissioners were automatically key figures in the new city, as success depended so largely on the commission's success or lack of it. But Thornton brought entirely different qualities to the job from those of his financially and politically more astute colleagues, Gustavus Scott of Maryland and (by 1795) Alexander White of Virginia. The polymath who was an aesthete, an idealist, and a visionary was not entirely appreciated by the hardheaded proprietors and speculators whose fortunes he could affect. One of them, indeed, wrote snidely to the president that Thornton, while "a little genius at everything," was not well respected as a manager.[1]

What the Thorntons—the doctor, his talented wife, and his mother-in-law—did bring to the shores of the Potomac was a strong whiff of urban sophistication. Their

[1]William Cranch to John Adams, March 1797, quoted in Bob Arnebeck, *Through a Fiery Trial: Building Washington, 1790–1800* (Lanham, Md., 1991), p. 428. Cranch, a nephew of Adams, was in Washington as local agent for the biggest syndicate of investors, that of John Nicholson, Robert Morris, and James Greenleaf, the eventual collapse of which was fatal to Washington real estate values. Ironically, Cranch would for a short time himself become a commissioner but quickly accepted an appointment as Washington circuit court judge. In that position, he became a highly respected member of the local community and a regular collaborator of Dr. Thornton.

arrival constituted a welcome addition to the social and cultural life of the town of Georgetown—and obviously even more so to the frontier settlement of Washington City. The man who had earned acclaim in Edinburgh, Paris, and Philadelphia, who combined a "great thirst for knowledge" with "noble and enlarged views" and a "buoyant and cheerful disposition" rapidly became a leading citizen of the new Federal City.[2]

The Thorntons had, of course, come into a small society, one that was as much in gestation as was the city around it. Its nucleus in 1795 was still the small group of proprietors who had settled the land a century or so earlier, many of them Catholic, such as Notley Young and members of other branches of the Carroll family. As the tobacco and grain trade grew, those stable and respected proprietor families were joined by merchants, tradesmen, and others who settled in the ports of Georgetown, Alexandria, and Bladensburg. Once the "ten mile square" that bordered on those towns had been selected as the site of a national capital, however, drastic changes in the composition of the local population began. No sooner had the existing proprietors and local businessmen begun to position themselves for the expected land boom than they were joined by outside investors and speculators, some of whom came to settle permanently. The community grew and diversified still further once the public works projects—surveying, clearing land, grading roads, and finally construction of the Capitol and the President's House—began. With the influx of builders, craftsmen, and trade and service providers came a flood of poorer laborers, attracted by the prospects (if not always the reality) of work. The slow pace of plantation life was giving way to a frenzy of speculation, building, and politics. But the setting was by no means an urban one, and the local society was still inchoate.

Of the many frontier towns of America, however, Washington was unique. Its very existence was the result of political considerations rather than some real comparative advantage; its growth was dependent on the decisions of others, and its pretensions as the future capital were of necessity exceptional. President Washington and others, Thornton among them, envisaged it as a monumental city that would also become the cultural capital of the country—a place of learning, science, and the arts. By early 1795, Thornton was enthusing to his old mentor Dr. Lettsom that he hoped to establish agricultural and scientific (or "philosophical") societies in the new city, and that he was in contact with the president about establishing a university, "which has long lived in my mind."[3]

The social and cultural reality of Washington was, of course, far from able to support such a lofty ideal. The number of individuals and families of serious education

[2]Anna Maria Thornton, "The Life of Dr. William Thornton," Anna Maria Thornton Papers, Library of Congress Manuscript Division, reel 7, container 18, n.p.

[3]Thornton to Lettsom, 8 Jan. 1795, in *The Papers of William Thornton,* ed. C. M. Harris (Charlottesville, Va., 1995), p. 295.

and culture was quite small; few even of the landed gentry qualified. And while the number of respectable and even educated tradesmen and merchants was much larger, few of them fell into the category of worldly and cultured gentlemen with whom the rather choosy Thornton felt wholly comfortable. And yet this was, at least until the government could arrive, the best society that Washington could offer, and it welcomed the Thorntons with open arms.

The cultural life of the new city was still governed by the customs of the rural South. Washington City, of course, hardly existed as yet, while Georgetown and Alexandria were just reaching the stage of urbanism at which they could support permanent cultural institutions or resident artisans—not yet artists. Cultural life for most residents was something that happened largely inside the family circle. As it was for the plantation families, the comfortable town families entertained each other at their homes with conversation (learned or, more often, not), reading, music, card games, or the occasional dance—with most of the performers being members of the family rather than professionals. Usually, indeed, musical entertainment was furnished by the women, whose education included much more emphasis on the arts than that of the menfolk. A steady round of visiting, moreover, not only enlivened social networks but also served as a transmission belt for the latest in fashion or culture: new books, music, and information came in the door with each new visitor. These families, then, were potential customers for more urban cultural institutions, but they as yet were too few to support such growth.

A far larger number of the new city's residents, it is true, were to play only supporting roles—or none at all—in its finer cultural development, or for that matter in Thornton's professional and social life. Working men of all trades—ax and shovel men, masons, brick makers, carpenters, carters and stable hands, mechanics, cobblers, cooks, tavern-keepers, and others—they had come to the city in search of work. Their jerry-built boardinghouses and shanties filled the worksites and the woods beyond, and some of these workers and their families would, in time, settle down in the city. But for the time being, they were preoccupied with making a living in hard times. Such, too, was the case for the few free blacks who were trying to make a home in the city, as it was for the large number of local slaves—many of whom were hired out by their owners to work on the projects. Black or white, slave or free, these were the residents whose labor would build the new city, but whose life was one of subsistence and hardship and whose cultural opportunities were limited largely to the tavern, the song at night, the fiddler at a wedding, or the church on a Sunday.

The churches, indeed, were the first permanent cultural institutions to take root in the area. This was only natural. For many, going to church was a major event of the week, and in an epoch in which listening to oratory was as much an intellectual as a

religious experience, sermons were carefully followed and good preachers were leading figures in any community. The times moreover were especially religious ones; a new phase of the Great Awakening was creating a cultural current that would crest in a great new wave of evangelism, particularly in the West and the South. And though it was a period of religious enthusiasms, it was also a period of relative ecumenicalism; the Catholics had finally earned parity of status through the recent revolutionary struggle, while the Protestant denominations had not yet begun to compete strenuously against each other. With its growing and increasingly heterogeneous population, Washington was destined to become a ground for friendly rivalry between America's various denominations.

The original Catholic proprietors, with their families and slaves, had traditionally worshiped on their plantations and farms. But the growth of ports such as Georgetown had brought about changes in both the religious complexion of the community and in the need for public houses of worship. Georgetown had seen the springing up of Protestant churches since 1772, when the Methodists founded what would later become the Dumbarton Street church. The Presbyterians were not far behind, establishing their first congregation in 1780 in a schoolhouse; it had as its pastor the seminal figure Stephen Bloomer Balch, who would become one of the leading figures of the new city. The Catholics in their turn established Holy Trinity parish in 1792, and four years later the Episcopalians founded St. John's, still in Georgetown.

But the beginning of work on the new Federal City would mean the growth of new congregations; Georgetown was simply too far away in those days of rudimentary roads and transport. The first church established within Washington City was Christ Church Episcopal, which opened in 1794 in a converted tobacco barn at the edge of Capitol Hill, bought from the Catholic landowner Daniel Carroll of Duddington. The next year, Presbyterians too opened a parish, St. Andrew's, in the new city, but the poor health of its pastor and other factors led to its decline and eventual abandonment. The Catholics, who felt the obligation to serve the many Irish newcomers who had come to the new city to labor on the public works, bought a plot of land between the Capitol and the President's House. With active backing from the Irish-born builder James Hoban, they succeeded by 1798 in raising the first, tiny St. Patrick's Church for their poor but active congregation.

The most significant Catholic contribution to the cultural life of the city was not, however, a church but a school. This modest school, which would eventually become Georgetown University, was the creation of Father John Carroll of the ubiquitous local family, who had been promoting his vision of a national denominational school for more than a decade. In 1786, he had gained the approval of his superiors to build in Georgetown, which at the time was already a town of more than two hundred houses

with a near-majority of Catholic residents. Several years later, the school was officially launched, even though Georgetown's demographics had changed in favor of Protestants in the meantime. Carroll's status had changed as well—he had achieved the dignity, and authority, of appointment as America's first Catholic bishop. Carroll pursued his dream and succeeded in attracting both money and pupils from other states and even the West Indies. The result was that Georgetown College was, when the first students occupied its still unfinished buildings in 1791, the first institution with national aspirations to spring up within the boundaries of the prospective national capital. By 1797, under its active and worldly president William DuBourg, the college had also begun to make connections to the city springing up just down the river and promised to become a significant presence in the new capital. Unfortunately, DuBourg, a French refugee from rebellion-wracked Haiti, came under suspicion in the following year during the undeclared war with France and had to resign—a setback to the college's growth as a regional and even national institution.

Georgetown College was not the only school to open in the Washington City limits, but it was the main one to survive and prosper. The region's plantation owners had long hired home tutors for their children's education, but more formal schools had also sprung up in the towns, where the propertied inhabitants demanded at least a rudimentary education for their children. Many of the resulting schools were ephemeral; teachers came and went, working in rented space and moving on to where prospects may have seemed better. Some schools lasted longer. One was founded in the early 1780s by the Presbyterian Stephen Bloomer Balch, a popular preacher of the hell-and-damnation type who had married into a Georgetown family, was active in local society and got along comfortably with his Catholic colleagues. Like other local clergymen, Balch found that he could not earn a comfortable living from his small parish alone. He took in private pupils to make ends meet, and before long he set up a boarding school called the Columbian Academy. The school attracted a number of young men from prominent local families—including, for a year or so, two of George Washington's nephews. (He had them withdrawn, however, when it turned out that they had been running up large bills at his expense.)

President Washington had still greater ambitions for education in the Federal City. He wanted the new capital to be a center for learning in America, and specifically he wanted a national university at the seat of government. Knowledge was essential to public happiness and to informed government, he had argued when he first raised the subject in his 1790 address to Congress. Since that time, he had actively promoted the idea of placing the university in the capital and promised to turn over some of his private assets to supplement the necessary congressional funding. By 1795, he had the

enthusiastic support of men such as Samuel Blodgett and the Federal District commissioners, foremost of whom was Dr. Thornton. Thornton, by his own account, had several discussions with the president on the subject and was encouraged to submit his ideas, which are included in a long paper he wrote in 1796 on a system of national education. The commissioners even set aside a site for the university, on the 23rd Street hill overlooking the Potomac, and sent a strongly supportive memorial to Congress (largely drafted by Thornton). Their optimism, unfortunately, was premature. The president, in spite of his great respect and stature, and a strong recommendation in his last address to Congress, could not get that body—suspicious as it was of federal institutions, Potomac boosterism, or both—to charter or fund such an institution.

The lack of a national university in the federal district was, for the time being, only a minor loss. The "ten mile square" was slowly accreting other cultural amenities, even though most of them at the beginning were not in Washington but rather in Georgetown or in even more remote Alexandria. Georgetown by the end of the century had already seen the opening and then the closing of a number of small newspapers: the *Columbian Chronicle,* the *Centinel and Georgetown Advertiser,* and the first incarnation of the *Washington Gazette.* Washington did not get its first paper, the *Impartial Observer and Washington Advertiser,* until 1796. Unfortunately, Thomas Wilson, the publisher, died some six months later and the paper folded. As a result, Washington City did not get a permanent journal until 1800. Nor did it have a real bookstore or a lending library. Nicholas King, the commissioners' surveyor, did try to open a subscription library in the city in 1795, but the number of his intended customers apparently did not match his love of books, and the effort failed within two years. In Georgetown, on the other hand, another of Reverend Balch's initiatives, the Columbian subscription library, was doing reasonably well. It served its members for more than fifteen years after its opening in 1795.

In the arts as in literature, most of the action was in Georgetown. Among the expenses that had driven Washington to pull his nephews out of Reverend Balch's school had been that of sending them to Mr. Tarterson's dancing school—an indication that, as early as 1785, there were at least some semiprofessional musicians resident in town. The holding of regular subscription dancing assemblies, first in Georgetown and later in the capital, also shows that musicians, able at least to play piano or a fiddle at a dance, were available. Concerts, dramatic performances, and other entertainments began to be held in Georgetown and Alexandria by the 1790s. These were almost invariably by itinerant performers who generally rented a room at one of the local taverns for their shows, which included the rare serious play, "olios" (variety shows), and "learned dog" and other curiosities or acts. For a short time, Georgetown even boasted a "theater"—

actually just a room in a tavern. Presumably, this was the location in which the play "The Revenge: or Spanish Insults Repaid," was performed on July 21 of 1795.[4] Alexandria did have a proper theater, to which the Philadelphia company Weingert and Reinagle took summer road shows. The Thorntons, who were theater buffs, took in a play there in 1799, even though the long trip meant spending the night away from home. But by the turn of the decade, construction of the first substantial buildings in the new city (such as the Six Buildings on upper Pennsylvania Avenue) finally made it possible for Washington to attract an occasional performance.

Washington did have at least one resident artist. Perhaps artisan would be a better term, as Lewis Clephane was, above all, an illustrator and decorative painter who had come to the city to work on embellishing the interior of the Capitol. He settled in the city, sold art supplies, raised a family—one son became a painter—and completed a few primitivist portraits. Other than Clephane, the only artists to work in Washington in this early period were temporary visitors: the English painter Parkyns, who did some landscapes, mainly around Georgetown; the miniaturist Robert Field, who stayed in the city several times after 1795; and John Vermonnet, a miniaturist who in early 1797 set up a studio near Conningham's brewery at the foot of Camp Hill.

Such small additions to the cultural capital of the new city might seem insignificant, but given the small size of the population each new newspaper, artist, civic-minded clergyman, dramatic or musical performance, or school could make a meaningful contribution. Gradually but surely, Washington was becoming a more acceptable place to live, and as the roads improved between the city and Georgetown, it became possible to look upon some cultural amenities as shared ones. Toward the end of the century, the white population of Washington reached parity with that of Georgetown, and even though the older town still had the majority of the good houses, shops, and other facilities, there was a decided bustle of activity in the new town. Its inhabitants were building their own social and cultural institutions, partly in competition with Georgetown and partly out of convenience. That tireless organizer James Hoban, for example, had petitioned successfully as early as 1793 for a Masonic lodge in the city, separate from the four-year-old Georgetown lodge; he had also established the city's first benevolent society, the Sons of Erin. Other residents had set up not one, but two, dancing assemblies by 1797, reflecting competition between the two ends of the city: the proprietors on Capitol Hill and the Georgetown interests who wanted the city to develop to the west of the President's House.

That competition was, however, a source of worry for President Washington and the commissioners. The president was insistent that the major public buildings be completed in time for the government's move in 1800 and saw the competition between the two groups of proprietors as posing a risk to that timetable. By 1796, he was insisting

[4]*Columbia Chronicle*, 21 July 1795.

that the commissioners move to the city itself: "The residence in George Town, of those who are entrusted with the management of matters in the City, is a drawback and a serious evil," he wrote, and until the commissioners relocate, "the Jealousies between the upper and lower ends of the city will not subside."[5]

Thornton, who by this time had gotten to know the president reasonably well, admired him greatly and shared his dream for the Federal City. Bowing to the president's wishes, in summer 1797 he and his wife and mother-in-law moved into Washington proper. They rented a house owned by their friend Samuel Blodgett on F Street, near 13th Street. It was a convenient location in many ways, although Mrs. Thornton would continue to do much of her shopping in Georgetown. Situated as it was on high ground above the marshes and blackberry thickets bordering Pennsylvania Avenue and Tiber Creek, F Street had become a key part of the post road linking Georgetown, the President's House, and Capitol Hill, and then Bladensburg and the world beyond. The Thornton house as a result became a convenient stopping place for the city's elite going to or from one of those locations, a welcoming place for an exchange of news and opinions. The comings and goings would be continuous. The Thorntons' role in the new city's elite was thus cemented: William had power as a commissioner, respect as an intellectual and artist, and friends from his engaging if somewhat quirky personality, while Anna Marie's skills as an artist, musician, and linguist opened all doors. Together, they had earned a central position in the community's rudimentary but developing social and cultural network.

What the Thorntons did not have, unfortunately, was enough money. While the job of commissioner paid reasonably well, the salary was not adequate to support the gentleman's standard of living—including the expense of keeping horse and carriage —that Thornton expected for himself and his family. Shortly after arriving in the area, he and Anna Maria had bought a large farm called Grove Park in nearby Maryland, which would serve as both a welcome summer refuge from the city heat and as an important source of food and fodder.[6] Owning the farm also meant, less positively, that Thornton once again had the ability to pursue his expensive passion for raising blood horses. It also faced the would-be emancipationist with the reality of slaveholding. Mrs. Thornton's diary and the household accounts indicate that the country place came with at least several families of slaves.[7] And though the Thorntons appear to have been

[5]Washington to Commissioner Gustavus Scott, 25 May 1796, and Washington to Thornton, 26 Dec. 1796, George Washington Papers, series 2, letter book 24, image 203, and series 2, letter book 24, item 271.

[6]The farm was in Bethesda. Bought in 1795, it cost Thornton six thousand dollars for 572 acres. The farm produced fruits, vegetables, and fresh meat for the table, firewood in the winter, and grain, hay, and pasturage for the working horses as well as the thoroughbreds.

[7]When Anna Maria sold the farm after Dr. Thornton's death, she also sold eleven slaves who were living there. Earlier, when obliged to sell a difficult domestic slave whom she had tried unsuccessfully to hire out, Anna Maria confided to her diary: "It is very contrary to my wishes and feelings to sell any of them, but if they will not behave what can I do? I cannot afford to give them free." Anna Maria Thornton Diary, 3 Nov. 1828, Anna Maria Thornton Papers, reel 1, no. 705.

considerate and humane masters, they nonetheless accepted slavery as a normal—even if morally repugnant—part of their life.

At first, income from Tortola filled the financial gap and enabled Thornton to make investments in Washington real estate. But a few years later, his income from Tortola had become increasingly uncertain and indeed precarious, and by late 1800 it would almost dry up as a result of low sugar prices and the bankruptcy of the plantation's agent in England. Money problems would bedevil Thornton for the rest of his career, exacerbated by his sad judgment in matters of investments and business partners.

So the Thorntons kept house in an elegant if not grand style on F Street. But then, the social requirements of the community at the time—before the arrival of the federal government and the diplomatic community—were as yet very modest. Just the same, the city was beginning to attract newcomers of fame and fortune. The first of these was the investor Thomas Law, son of the Bishop of Carlisle in Great Britain, who had made a fortune in India before deciding to settle in the United States. Drawn like Thornton to the adventure a new capital, he would invest—and over time lose—much of his fortune in Capitol Hill real estate. By 1795, he was courting Eliza Parke Custis, Martha Washington's granddaughter. Although he was a widower with two half-Indian sons and was most decidedly eccentric, Law's talents, his contacts, energy, and of course his money made him a desirable match. He and Eliza were married the following year and began what would be a short if tempestuous marriage in a large new house along the river near the Young plantation. There, they began entertaining on a scale not previously seen in the new town and immediately became key members of its permanent elite. One of their first house guests of distinction was Charles Talleyrand de Perigord, later to be Napoleon's foreign minister but at the time in flight from the French revolution; he and Thornton had an opportunity during his visit to exchange ideas on national education schemes.

The Thorntons themselves, at first while still living in Georgetown, were hosts to another distinguished French visitor. Constantin Volney, an ardent republican whose celebrated travels in and writings on the Middle East were the model for his current 1795–98 trip to the United States, stayed with the Thorntons on several extended occasions at the doctor's invitation. Those visits were undoubtedly an intellectual feast for Thornton, who had a rare chance to test his views on politics, education, language, phonetics, slavery, architecture, town planning, and other subjects with a colleague of equally broad learning and liberal interests.

Another important newcomer to town was a couple who would play a lasting role in the Thorntons' private and professional lives. John Tayloe, a wealthy—extremely wealthy—planter from Mount Airy in Virginia, had married Anne, daughter of the prominent Ogle family of Maryland. With some prodding it is said from the presi-

dent, who felt that the new capital would benefit from new residents of such standing, they decided to build an important townhouse in Washington that would be a platform for Tayloe's political and business ambitions. Tayloe asked Thornton to design a suitable house, and after a number of exchanges between the two, work began in the summer of 1799. The well-considered builder, William Lovering, had an important share in the eventual result, while Lewis Clephane did the paintwork, but the basic plan that distinguishes the spacious and elegant building—now known as Octagon House—was Thornton's. During the construction, he and the English-educated Tayloe became close, sharing among other things a love of fine horses. Thornton looked upon his work as architect as a favor to a fellow gentleman, something to be repaid in kind if at all, and certainly not something for which he would have asked a fee. (Exactly what Anna Maria's feelings on this were, given her responsibilities for the household's daily expenses, was not, unfortunately, recorded.) In any event, the house was a success for both men: the Tayloes had a grand residence at which they would pass winters in the city, and Thornton had another feather in his artistic cap, as well as an influential new friend.

The Tayloe house was not the only private architectural project that Thornton took on. Indeed, his advice was often sought, and he was usually ready to oblige even though many of the projects did not come to fruition. He provided plans for the building of St. John's church in Georgetown, though they were apparently not used. The same fate would await plans he made for Daniel Carroll of Duddington for a set of houses to be built on Capitol Hill, as well as plans for a Catholic cathedral to be built in Baltimore by Bishop Carroll. He would also help Thomas Law design a practical and attractive solution to a hillside site when that gentleman decided to build his own substantial house on the crown of Capitol Hill. But the most satisfying work of this nature that Thornton engaged in, even though it took a good deal of time and trouble, was the assistance he gave to George Washington.

The recently retired president, convinced by Thomas Law and other local landholders that his sponsorship of construction on Capitol Hill would help fill the need for congressional lodging quarters there as well as be a good investment, had decided to build. He turned to Thornton to help him in overseeing the construction, if not the design, of a double building not far north of the nearly completed north wing of the Capitol. For much of 1798 and 1799, then, Thornton supervised the work of builder George Blagden, making suggestions and changes as necessary, keeping the ex-president closely informed by regular correspondence (which covered news and political subjects as well as the progress of the building project), and drawing on a substantial bank account over which Washington had given him full authority. The building project seemed to solidify the relationship between the two men and was reinforced by

the fact that the Thorntons had become friendly with yet another of Martha Washington's granddaughters, Martha Parke Custis, who had married Thomas Peter, the son of a leading Georgetown proprietor and developer. Whether the famously reserved president even faintly reciprocated Thornton's warmth of feeling toward him or not, there was, at this time, a good deal of visiting back and forth to Mount Vernon and exchanges of gifts (including some special rum from Tortola), and the Washingtons and Thorntons dined frequently in each others' company. It was a relationship that Thornton and his ladies cherished and which allowed him to write, much later, that "when he [Washington] died he was the best friend I ever had."[8]

Thornton, the commissioner, and Washington, the prime mover of the Federal City project, became still more closely allied as they tried to prepare the city for the scheduled arrival of Congress and the administration. The commissioners were harassed and overworked from all angles. The proprietors fought with each other, and with the commission, over work on the ground. Labor, supply, survey, and public hygiene problems threatened progress on the public works. Most significantly, money remained extremely short. Property values had fallen further, and titles were left in great legal confusion, as a result of a gradual collapse, starting in 1795, of the biggest property speculation scheme. Congress had reluctantly appropriated money in 1796 and again in 1798 to keep the public buildings under construction, but its debates had led to much open criticism over the commissioners' work and alleged waste, the grand "unrepublican" scale of the public buildings, and indeed the whole concept. With President Adams only a lukewarm supporter at best, the work inched forward under a cloud of doubt and controversy.

Construction of the Capitol in particular continued to be fraught with difficulties. The commissioners' 1795 choice of the English architect George Hadfield to supervise the work had proven to be a mistake, as Hadfield was almost as difficult as Hallet before him. He revised the approved designs without authorization, fought with Thornton over the plans, designed a roof and floors that had to be torn up and restarted, got in a row with his foreman, resigned in a fit of pique but was reinstated, and resigned again in 1798. Hoban, who had been involved all along, replaced Hadfield, only to fall himself into fights with Thornton, who had proved over time to be highly sensitive to any criticism of his original design and not fully cooperative in resolving the various problems that arose. In spite of all the fights and necessary revisions, however, the first phase of the project was nearing completion, and a rush of building on Capitol Hill (including Washington's houses) assured that there would at least be enough housing for the members of Congress.

[8]William Thornton manuscript, dated 13 Aug. 1823, to an unidentified newspaper, responding to reportage about President Washington. It is not clear if this letter was published at the time. William Thornton Papers, Library of Congress Manuscript Division, reel 3, no. 995.

Thornton's working relations with the other commissioners, in the midst of all the tension and frustration of the project, remained good. They disagreed on more than one occasion, as would only be normal in a project of this scope and novelty, and Thornton on occasion put his dissent in writing when he was outvoted. Where he differed, to his credit, his objections were usually consistent with his ideal view of the capital as a grand and monumental city. He resisted attempted encroachments by the proprietors into areas that had been set aside for public reserves, or even into the odd-shaped blocks formed by intersection of the diagonal avenues and the grid of streets; he thought those areas should be preserved for churches, monuments, and parks rather than go on sale. He fought for broad and clear streets along the water, rather than allowing them to become obstructed by warehouses and other commercial buildings. He argued for a spacious, riverside naval hospital and a large botanical garden. He even found fault with L'Enfant's plan for the city, as it had not set aside a major plot for the national university that Thornton saw as centerpiece of the city.

And then, before the new capital could be officially inaugurated and its founder properly honored in the site he had chosen, George Washington died. Thornton arrived at Mount Vernon shortly after the death on 14 December 1799, in the company of Thomas and Eliza Law, who had invited him to accompany them in the quality of friend and physician. Martha Washington and the Peters were the other family members present, the president's body already in storage, frozen. The doctor, in his own account, then made an entirely bizarre proposal to attempt resuscitation by means of thawing the body and transfusing lamb's blood. But this was turned down, and he instead had the body sealed in a lead coffin.[9]

Thornton's grief over the loss of his idol, friend, and sponsor led him to become a champion of moves to erect a suitable monument to the great man's memory. As his concept of the Capitol's central rotunda had always included its possible use as a monumental space, he was quick to urge that idea to a grieving government. Scarcely two weeks after the president's death, Thornton wrote to Secretary of State John Marshall, urging his support for a monumental tomb in the rotunda. With Mrs. Washington's concurrence, a bill to that effect was submitted to Congress—where it was smothered to death in a jumble of competing projects, both for the monument and the Capitol.

Plans for a monument, and for the Capitol, would indeed be debated for years. At the beginning of 1800, partisan politics were white-hot; the maneuvering for the next presidential election was already under way, and the move of the government still being resisted. All these rivalries however were dropped temporarily, in the Federal City as elsewhere, to mark the first posthumous Washington's Birthday celebration. Thornton and Hoban were, of course, on the committee to make arrangements, but their task

[9]From an undated draft account. Harris, *Papers of William Thornton*, p. 528.

—and the day—were inevitably somber. Almost a thousand people crowded into Reverend Balch's Georgetown church to hear the service where, according to Anna Maria, "the society is too small for them to equal other cities in pomp, but they did their best."[10]

The rush to get things ready for the government preoccupied everyone in Washington. Boardinghouses, including Washington's, were being rushed to completion on Capitol Hill in time for the December congressional session. Plaster, paint, and other last-minute work was being done on the Capitol, the President's House, and the two executive office buildings flanking it. Benjamin Stoddert, the secretary of the navy and a Georgetown landowner, noted that the grounds around the President's House were still a mess—full of brick kilns and construction debris and totally unsuitable—and asked Thornton to lend not only landscaping advice but also assets from the commission's scarce workforce. Thornton drew up some plans, the other commissioners grudgingly agreed to lend a few men, but little of real substance was achieved. There was neither money nor, at this point, time to do a decent job, and there were too many other unfinished items of business. The government was coming in summer, whether the Federal City was fully ready or not.

[10]Anna Maria Thornton, "Diary of Mrs. William Thornton, 1800," *Records of the Columbia Historical Society* 10 (1927):110.

3

The Government Comes to Town

B Y MID-JUNE OF 1800, THE NEWCOMERS HAD BEGUN TO ARRIVE. THEY WERE not that numerous, as the government at the time was extremely small by today's standards, and many of its employees were stationed in various ports, military establishments, or other scattered localities. Nor was all of the central government being moved to Washington. Less than a dozen senior officials and a hundred clerks from the executive departments were being uprooted from the urbane pleasures of Philadelphia to the struggling development on the Potomac—which one visitor described as "the scattered buildings of the desert."[1] But even if few, these new permanent residents were for the most part learned, accomplished, and worldly men, many of them with families, and their arrival would greatly expand the local demand for cultural as well as physical amenities. With their arrival also came several hundred minor officials and their families, a few military units, and a gaggle of entrepreneurs providing support services, all of whom would add something to the town's potential. And of course the government payroll and government-financed public works brought a steadier stream of income to the city, one that was likely to encourage the springing up of new public facilities.

With the move, Washington changed. No longer just a building site, it had become the experimental seat of a still experimental government, a place of international political interest, and a magnet for the curious. Once Congress came to town for its first

[1] John Davis, *Travels of Four Years and a Half in the United States of America* (London, 1803), p. 185.

session in November, still more visitors were sure to come, on both business and plea-
sure. But the raw and scattered settlement was still not a real town. Outside of George-
town and Alexandria, parts of the Federal District if not the Federal City, there was a
serious lack of public institutions, forums, or sense of community.

President Adams marked the official transfer of the capital to the Potomac in June,
making a symbolic but short visit. His carriage stopped by Dr. Thornton's house to in-
clude him in the official party, which then went on to inspect the still unfinished gov-
ernment buildings and eat its way through a flurry of official banquets. Adams's visit
was not, however, a rousing success. It was a tense time; the upcoming presidential elec-
tion was still hotly contested, and the government's move to Washington continued
to have its enemies. Thornton and his fellow commissioners were under considerable
pressure. Even while scrambling to finish the President's House, the north wing of the
Capitol, and other improvements, they were beleaguered by endless disputes about
the design for the rest of the Capitol, the proposed monument to Washington, the lo-
cation of such improvements as they could afford, and the city's failing finances.

The commissioners did, at least, meet the deadline. By late autumn, with both the
executive and Congress more or less successfully lodged and in operation, they might
have felt some sense of satisfaction over what they had achieved, as well as for the
prospects for the city and their commission. President Adams had failed in his bid for
reelection, and Jefferson, the leading candidate to replace him, had been a proponent
of the Washington site from the beginning. So when Jefferson finally prevailed over
Aaron Burr in a prolonged series of congressional votes, it may have represented a
major political shift for the country, but it was not necessarily a challenge to the com-
missioners' role as developers of the capital city. They had already submitted a report
in which they tried to place the financial situation of the city in as favorable light as
possible, in spite of the uncomfortable facts that land values continued to be distress-
ingly low and that repayment of a large loan from Maryland was coming due with no
source of revenue adequate to pay it.

Jefferson, as it turned out, saw things somewhat differently from the commission-
ers. As a good Virginian, he had of course supported Washington's choice of location
for the new federal city, and he maintained an intense interest in the architecture of its
public and private buildings. But he had never been an enthusiast for a grand, monu-
mental city. In fact, his concept of limited central government had led him initially to
propose that the federal district be a modest town snuggled in between Tiber (or Goose)
Creek and Georgetown. This was obviously a far cry from the expansive, monument-
rich tableau that had been painted by Peter L'Enfant, approved by Washington, and
subsequently supported by Thornton and the other commissioners. Jefferson had lost
that fight over the city's design, but now he was president, and he was in a position to re-
sist any development that smacked of the royal capitals of Europe that he so distrusted.

Jeffersonian economy, as well, would mean that there would be precious little new money for the city. The only new public work would be to grade Pennsylvania Avenue and border it with pedestrian walkways and poplar trees. Thornton and Nicholas King devised plans for the project, but beautification rather than urbanization seemed to be the president's motive. Jefferson would also oppose, quietly but effectively, the various projects for a monument honoring Washington, particularly the idea favored by Thornton (entirely too monarchical!) of a grand tomb in the Capitol. The president did obtain congressional funding for the next stage of work on the ever-unfinished Capitol, and even to pay off the commission's debt to Maryland, but most other civic projects were left to the private sector.

Moreover, in 1802 Washington City was incorporated (Georgetown and Alexandria retaining their own governments), in accordance with the Organic Act that had been passed by Congress the previous year. While the city thus gained its own government, it lost in the end because it effectively became a ward of Congress, with no outside political constituency or support and consequently little influence over appropriations. The new city council, for example, was initially authorized to tap sources of income that would allow it to pay for only a few basic services.

Finally, a committee of the new Congress, dominated as it was by Jefferson's small-government-oriented Democratic-Republicans, found that the commission for the federal district itself was an expensive and no longer necessary instrument—and recommended that it be abolished. Thornton's job was at risk, as well as the grand, monumental city he had envisaged. Although he could breathe a sigh of relief when no action was taken on the committee recommendation at the time, the writing nonetheless was on the wall.

The dynamic indeed had changed drastically. Previously, Thornton and the other commissioners had been able to use President Washington's immense prestige to win benefits for the city, but now their champion was gone, and a skeptical, penny-pinching administration and Congress were to dominate the scene. Moreover, those who had been friendly to the previous administration or who had Federalist ties (as did Thornton) were somewhat suspect in the politically polarized capital. As he had foreseen in Philadelphia, Thornton would need to "work in politics" to maintain a position of leadership in the expanding community. But unfortunately for him, this was one of the few skills he had not mastered. Aristocratic, visionary, and somewhat impractical, he was all too often outspoken and quick to take offense; he made friends through his engaging personality and his brilliance, but he also made enemies and did not seek compromise.

When the commission was finally abolished by Congress in June of 1802, Thornton, as senior commissioner, hoped briefly to be appointed to the position of superintendent of public works, a job that would keep him involved in the city's planning as well as

construction of his beloved Capitol. That job, however, went to the commission's ex-secretary Thomas Munroe, Thornton's disappointment only partly assuaged by the fact that Munroe at first received no salary for his work. Thornton, who would prove time and again that he had minimal business skills, by now desperately needed a government salary. Remittances from Tortola had virtually dried up and the bankruptcy of his Liverpool agent had multiplied his debts; he already was borrowing from friends such as Thomas Law to make ends meet. He applied, through his old friend James Madison, who would be secretary of state in the new administration, for a job at the Treasury Department, but did not win it. Jefferson, appreciating his qualities, at first appointed him as commissioner of bankruptcies, but that position was temporary, and it brought in virtually no income. Later in the year, Thornton was offered the job of commissioner of patents. The position suited him: it was respectable, it would exercise his scientific and mechanical talents, and it was central to the technological advances that were being made in the country. The salary, at least initially, was adequate. Thornton was pleased to accept the president's offer of a position that, in spite of many frustrations, he would hold for the rest of his life.

In the small society of the new federal town, the Thorntons soon were on easy social terms with the new president. They dined frequently at the president's, where as mutual friends of the Madisons they were often part of a circle of intimates. In the comfortable setting of those elegant and expansive dinners, Jefferson and Thornton—quite possibly the two most wide-ranging minds in town at the time—began an exchange on scientific, artistic, and intellectual matters that persisted over the years.[2] Thornton and Madison had been friends since the heady days of the Constitutional Convention in Philadelphia, when they boarded together in the same house. Thornton, this time, offered to share his own house with the Madisons when the latter first came to Washington. They declined but entrusted him to obtain, repair, and fit out a house for them on F Street—right next door, in fact. Now neighbors, the two couples rapidly became intimates, with regular visits between the two houses. Anna Maria and Dolley shared many enthusiasms in fashion and the arts, while William and James combined their business and intellectual exchanges with love of good horses; they even were partners in a racer called "Medley Man."

[2] The letters almost never touch on political issues. Typically, the exchanges are about farming or household manufactures. Thus, in 1809, Thornton offered Jefferson a merino ram to replace one that died; Jefferson returned the favor with a Marseilles fig tree and shepherd dog. In 1812, Jefferson asked for information about new spinning machines and Thornton tried to obtain one for him; this led to a number of letters over the next several years concerning weaving machines, patent rights, etc. By 1814, Thornton was borrowing paintings and other artworks from Monticello in order to study and/or copy them. In 1817, they began a correspondence on plans for the University of Virginia, which enabled Thornton to dust off his paper on a system of general education and send it to Jefferson. The letters are courteous and businesslike, but it appears that what real ease there had once been in the relationship had long since dissipated.

Dining at the President's House was indeed an important element of the expanding life of Washington. Jefferson, for personal as well as republican reasons, disliked crowded events and formal receptions. He opened the doors of the President's House, reluctantly, only twice a year to the general public. "We have an agreeable society here, and not too much of it," he had written to Madison.[3] His late afternoon dinners, by preference, were never large. Lubricated as they were by excellent food, wine, and the host's genial personality, they were often "an elegant mental treat," as one participant described an evening of conversation about "literature, wit, and a little business, with a great deal of miscellaneous remarks on agriculture and building."[4] But the president entertained essentially for political purposes—it kept him at the center of things—and he tailored his guest lists to meet his political needs. So his dinners, although frequent, could never develop into the kind of forum at which the disparate groups that now inhabited the capital city—politicians, government officials, and members of the local establishment—could mix, get to know each other better, and begin to form a new community.

That community was growing rapidly, and a number of the new arrivals would be influential in expanding the intellectual horizons and the cultural possibilities of their new town. Members of Congress and the Supreme Court brought often exceptional talents to the new city, but unfortunately most of them were residents for only a number of months and usually, in these early days, without their wives. As a result, they had little commitment to or interest in promoting the new capital city's growth. A fine example was Samuel Mitchill, a college professor who had degrees in both medicine and law, and who was known as Congress's leading savant. Over the ten years he served as congressman and senator, he (and his wife, on the rare occasions she joined him) graced Congress and many a Washington dinner table with wit and learning. But Mitchill's heart remained firmly in New York, and when he eventually opened a museum with his life's collections, it was in his home state and not in the city that had housed his political career.

Among the more interesting of the new permanent residents were Samuel Harrison Smith and his wife, Margaret Bayard. Smith had been enticed to Washington by Jefferson, with the objective of providing the new administration with an unofficial voice through the daily *National Intelligencer,* which Smith founded on Capitol Hill in 1800. While her husband threw himself into the political arena, the bright and observant Margaret Smith (who already had published, under pseudonyms, a number of magazine articles) rapidly became part of the circle of leading wives, which included

[3]Jefferson to James Madison, 12 Mar. 1801, in *The Papers of James Madison,* ed. Robert J. Brugger et. al., Secretary of State Series (Charlottesville, Va., 1986), 1:12.

[4]B. Henry Latrobe on a dinner in November 1802, in *The Papers of Benjamin Henry Latrobe,* ed. Edward C. Carter (New Haven, Conn., 1984), 1:232.

Dolley Madison, Anna Maria Thornton, and others such as Martha Gallatin, wife of the Treasury secretary.

Another newcomer who would play a lasting role in Washington was New York congressman John Peter Van Ness, who not long after his arrival married a local woman, Marcia Burnes. The new Mrs. Van Ness was indeed a catch. Daughter of David Burnes, one of the more successful Federal District proprietors—that is, one who had actually increased and not lost his money in real estate ventures—she had been carefully educated at Baltimore and elsewhere. Her position and wealth, added to Van Ness's already sizable fortune, assured them an important role in the city once Van Ness decided, in 1803, to settle in Washington and help promote the city's growth.

Other newcomers came who would add their own particular enthusiasms and talents to the new community. Thomas Tingey, for example, commander of the newly created Navy Yard on the Anacostia River and a hero of the recent naval war with France, brought a love of music and dance which rapidly provided him and his wife a prominent position in community social activities. At another remove was the pious Joseph Nourse, a senior official at the Treasury Department who became a pillar of the governmental and Presbyterian communities. Or William Cranch, who was already resident in Washington as local representative of the major real estate speculators, but who had become a permanent resident when he was appointed judge of the Washington County circuit court at the tail end of President Adams's term of office.

Each new government official brought his own after-work interests and needs, and each family that settled in the city expanded the market for such items of culture, luxury, or refinement that would help satisfy their aspirations to gentility.

To this expanding community, new churchmen contributed intellectual firepower as well as dedication to service, and men like James Laurie, William Matthews, Obadiah Brown, and Andrew McCormick would soon play a notable role in the growth and cultural development of the city.

A newcomer who would prove a great addition to the community's artistic and intellectual life (but, alas, a thorn in the side of Dr. Thornton) was Benjamin Henry Latrobe. Hired as superintendent of public works by Jefferson early in 1803, the brilliant, multitalented, but arrogant young architect would, over the next fifteen years, provide much talent, color, and controversy to life in Washington—even though he never settled in as a resident.

Another notable addition to the city's intellectual capital was the renowned essayist, businessman, diplomat, and poet Joel Barlow. Jefferson himself had encouraged Barlow to settle in the city, in part so that the staunchly Republican writer would pen a friendly history of the late Washington presidency. The gregarious Barlow never managed to perform that service for the president during his 1804–11 stay in Wash-

ington, but he did succeed in performing a still greater service for his fellow residents. His home and extensive library at Kalorama, in effect, provided the young town with its closest approximation to a literary salon.

While the various American newcomers contributed, each in his or her own way, to the emergence of a more well-rounded and cultured community, it was the growth of the diplomatic corps that provided it with a sense of worldly sophistication. Headed at first by less than a handful of lesser-ranking chargés d'affaires, the foreign missions increased in number, level of representation, and in size over the next few years. By 1805 the major establishments were headed by ministers, whose larger budgets enabled them to make a show, and to entertain on a scale that not only bedazzled the "first circle" of local society but also greatly increased the local demand for artisans, decorators, musicians, caterers, and purveyors of quality goods.

In short, the foundations of a community that might support a lively cultural life were emerging. A thin but well-connected group of landholding families, with their southern plantation manners, served as the social and moral backdrop. Prominent among them were the Carroll family, with branches both in Georgetown and on Capitol Hill; George Washington's relatives, the Custises, from just across the river in Arlington, Virginia; the Forrests, of Georgetown; the Tayloes; and the Brents, whose quarries in Virginia were furnishing the stone for the Capitol, and one of whom became the first mayor of the city. But it was the large and growing group of senior government officials who would furnish the urban foreground; they and their families provided both a potential audience and participants for events in their new community. Equally important, their growing number had begun to provide the kind of a market that would attract those providers of services—including booksellers, clergymen, or dancing masters—that could enrich life on the Potomac frontier. And, finally, the overarching presence of the president, his senior colleagues, and the diplomats, to which was added the drama of Congress in its periodic sojourns, gave the community both focus and national importance.

But it was still just a small town. "This may be considered as a pleasant country-residence," said its first citizen, President Jefferson, in 1802, "with a number of neat little villages scattered around within the distance of a mile and a half, and furnishing a plain and substantially good society."[5] That was as he wanted to see the new capital, a setting that corresponded to Virginia traditions—in short, a federal town in a rural setting, where the tone (and the politics) would be set in the manor house. No entrenched urban families, no pushy merchants or bankers, no troublesome divines, no

[5]Jefferson to Joel Barlow, 3 May 1802, Thomas Jefferson Papers, Library of Congress Manuscript Division, series 1, no. 268. Accessed at Library of Congress, *American Memory,* http://memory.loc.gov/ammem/collections/jefferson_papers.

local political cliques. Indeed, for a number of years, that was how it was. But it would not, and could not, last. A national capital would inevitably bring activity, governmental and private, that was on a national scale. In the next year Jefferson's Louisiana Purchase would make the United States a continental empire. The diplomatic community would grow and inspire a taste for luxury. Congress would expand and bring the West to Washington; office-seekers and other petitioners would descend on the boardinghouses and inns to plead their cases. Such a growing and diversified population was going to demand services and amenities beyond those of a small town, and in fact the process had already begun. It would take the capital many years to become a real city, but it was already beginning to outgrow its village start.

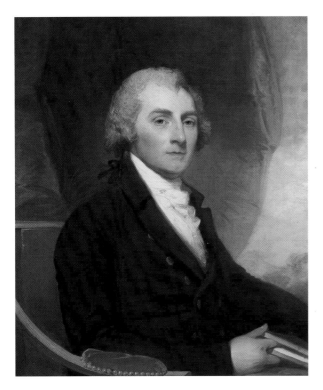

PLATE 1. William Thornton, oil portrait by Gilbert Stuart. Gilbert Stuart painted this portrait in 1803 as part of a pair with that of Mrs. Thornton. Stuart's portrayal appears rather hasty and impersonal, with Thornton looking almost as if he were annoyed that someone had interrupted his reading. Thornton seems to have liked the painting; he made at least one copy of it. *(Andrew W. Mellon Collection, image courtesy of the Board of Trustees, National Gallery of Art, Washington, D.C.)*

PLATE 2. Anna Maria Brodeau Thornton, oil portrait by Gilbert Stuart. Stuart acknowledged Anna Maria's musical talents by having her hold a score in her hand and by including a pipe organ (an instrument she did not play) in the background. Mrs. Thornton visited Stuart in his workshop several times during his 1803–4 stay in Washington. *(Andrew W. Mellon Collection, image courtesy of the Board of Trustees, National Gallery of Art, Washington, D.C.)*

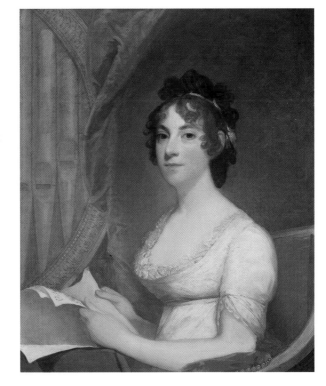

PLATE 3. Dolley Madison. The original watercolor of Dolley, from which this drawing was taken, appears to have been painted by Dr. Thornton while the Madisons were his neighbors on F Street and James was secretary of state. When the Madisons moved to the President's House in 1809 and took on the official and social responsibilities of that office, their close friendship with the Thorntons gradually became more distant and formal. *(Courtesy Library of Congress.)*

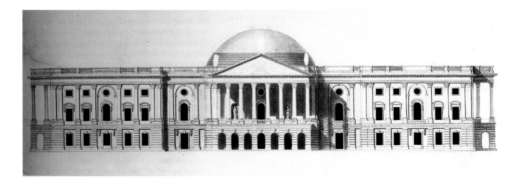

PLATE 4. Thornton's design for the Capitol. William Thornton won the competition to design the Capitol with this exterior plan, which combined classical Roman motifs with ornate Georgian stonework in a manner pleasing to both Jefferson and Washington. His design, however, proved to be inadequate as to interior spaces and engineering detail and led him into endless disputes with the architects who oversaw its construction, including Hallet, Hoban, Hadfield, Latrobe, and Bulfinch. His basic concept, however—two wings united by a central, domed ceremonial space—still gives the building its character. *(Courtesy of Office of Architect of the Capitol.)*

PLATE 5. James Hoban, wax bas-relief attributed to John Christian Rauschner, circa 1800. Hoban, the Irish-born designer and builder of the White House, was also involved in the Capitol project at various periods and designed Blogdett's Hotel. Hoban was a leading civic organizer, active in the Masons, St. Patrick's Church, the Sons of Erin, and the militia and was a founding member of the F Street Proprietors Association and what is now Congressional Cemetery, in addition to serving for twenty years as a city councilman. *(Courtesy White House Historical Association.)*

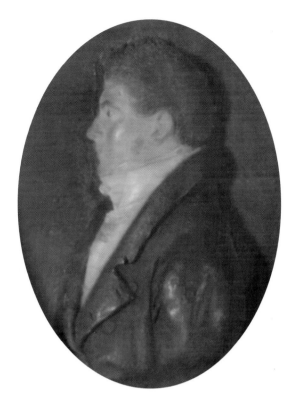

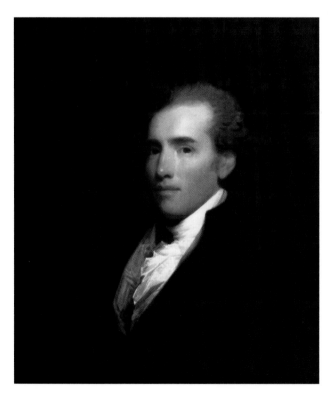

PLATE 6. Thomas Law, oil portrait by Gilbert Stuart. From a distinguished English family, Law had amassed a sizable fortune in India before coming to Washington in the 1790s. He married Eliza Parke Custis, Martha Washington's granddaughter, and began to invest heavily in Capitol Hill and other Washington properties. Personally quite eccentric, he became one of the new city's most influential promoters, an investor in civic improvements, and a leading citizen, but over the years he lost most of his fortune. *(Courtesy of the present owner, Grosvenor Merle-Smith.)*

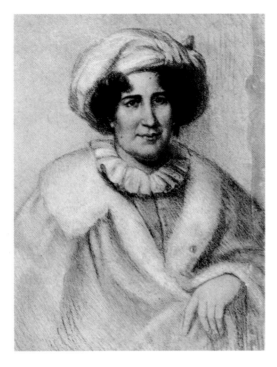

PLATE 7. Margaret Bayard Smith, engraving after portrait by Charles Bird King. Mrs. Smith and her husband, Stephen Harrison Smith, were among the leaders of Washington's social and cultural life. While he was editor of the influential daily newspaper the *National Intelligencer,* she was an active observer of the local scene, a feminist, and a writer of magazine articles and several novels. *(Courtesy Library of Congress.)*

PLATE 8. B. Henry Latrobe, oil portrait by George B. Matthews after C. W. Peale. Latrobe's talents as an architect are on display in many Washington area buildings other than the Capitol, including St. John's Church, the Decatur House, the gate at the Navy Yard, and the Baltimore Catholic cathedral. He and Thornton clashed often and publicly over his changes to Thornton's original Capitol plans and Robert Fulton's steamship project. Latrobe left his work on the Capitol in 1818 amid controversy. He died, bankrupt, of yellow fever in 1820. *(Courtesy Office of Architect of the Capitol.)*

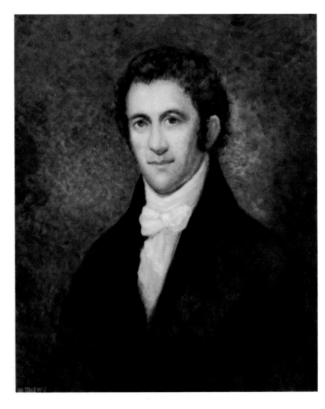

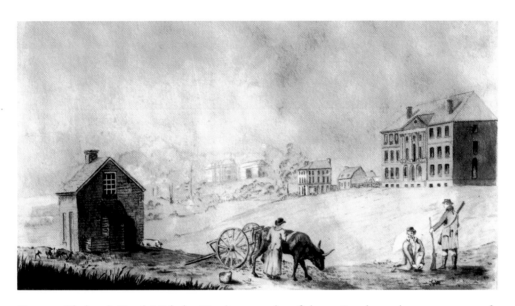

PLATE 9. Blodgett's Hotel. Nicholas King's watercolor of about 1803 shows the spotty nature of the town's growth. The President's House can be seen in the distance, beyond the trees, while brick and frame houses are scattered along the unfinished streets. Blodgett's large building, at 8th and E streets, was never used as a hotel and was eventually bought by the government after the lottery that was to have financed it failed. It housed, at various times, the town's first theater, Thornton's Patent Office, the Post Office, and, for a period following the 1814 fire, many other government offices. King contributed to the town as a surveyor, artist, mapmaker, and bibliophile. *(Courtesy Library of Congress.)*

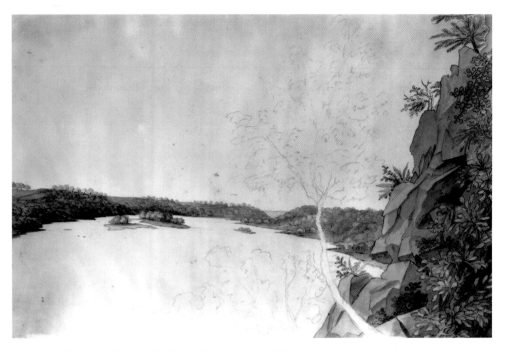

PLATE 10. Potomac River and Three Sisters Islands. Thornton's watercolor shows a scene just upriver from Georgetown. The Thorntons and other residents of early Washington were enthusiasts for the magnificent countryside surrounding the town, enjoying "botanising" excursions and expeditions to sites of interest such as the Great Falls of the Potomac. *(Courtesy Library of Congress.)*

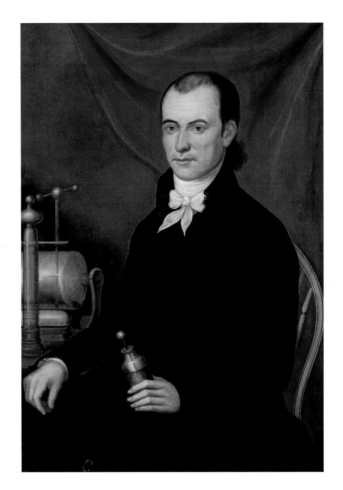

PLATE 11. Rev. David Wiley, oil portrait by Charles Peale Polk. At first a junior colleague of Georgetown's Presbyterian minister Stephen Bloomer Balch, Wiley was principal of the Columbian Academy and librarian of the subscription Columbian Library. His interests were scientific, as shown in this portrait, which depicts him with an electricity-generating machine. He also was an amateur astronomer, edited the city's first journal dedicated to agriculture, and was mayor of Georgetown for a term. *(Courtesy National Portrait Gallery, Smithsonian Institution.)*

PLATE 12. Octagon House. Thornton designed this elegant house for John Tayloe, a wealthy Virginia planter who married into the influential Maryland Ogle family. The Tayloes used the house as their winter residence, entertaining there in grand style, and loaned it to the Madisons as the presidential residence for a period after the nearby White House had been burned. The Tayloes and Thorntons were on close and friendly terms, cemented in part by the two gentlemen's love of thoroughbred horses. *(Courtesy Library of Congress.)*

PLATE 13. John P. Van Ness. New York Congressman Van Ness met and married Marcia Burnes in Washington in 1802, combining his fortune with her substantial real estate holdings in the city. Resigning from Congress, he became an influential member of the community, commander of the militia, and an investor in civic improvements such as the theater and the Library Company. Following the 1814 British raid, he and his wife demonstrated their confidence in the city's future by having Latrobe design and build a large, elegant home near the White House. This daguerreotype dates from the 1840s. *(Courtesy Library of Congress.)*

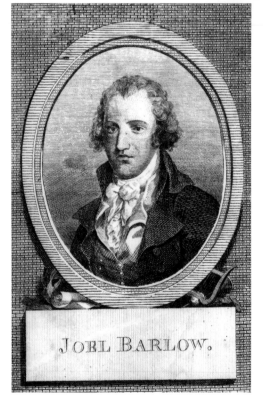

JOEL BARLOW.

PLATE 14. Joel Barlow. The essayist, poet, and diplomat Barlow came to Washington at Jefferson's suggestion but stayed only six years. His literary interests, extensive private library, and public oratory assured him a leading role in the town's intellectual and literary life. Entertaining at his secluded hilltop estate called Kalorama (a property that he had bought from the estate of commissioner Gustavus Scott), he also provided the town's political and literary figures the closest thing to a literary salon. *(Courtesy Library of Congress.)*

PLATE 15. Rev. James Laurie, oil portrait by John Neagle. Laurie came to Washington shortly after his graduation from Edinburgh University to head a new Presbyterian congregation near the President's House. Sociable and civic-minded, he made his F Street church a center of the town's life and was particularly active in sponsoring education during the forty-plus years he served the community. *(Courtesy New York Avenue Presbyterian Church, Washington, D.C.)*

PLATE 16. Rev. Obadiah Brown. Brown was invited to Washington in 1807 by the town's newly formed Baptist congregation and served it for over forty years. He also remained active in national Baptist affairs and tried to center the denomination's national activities in the capital city. His greatest achievement was as one of the founders of Columbian College, which he had planned as a Baptist seminary. The college, however, soon lost its denominational character and in time became George Washington University. *(Courtesy Middleton R. L. Train.)*

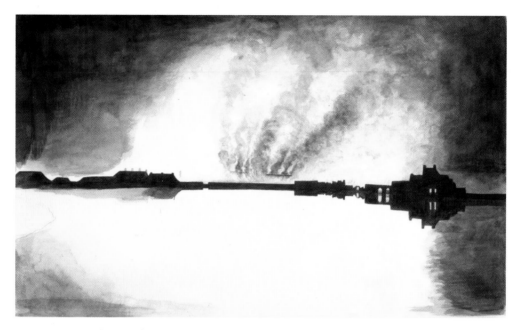

PLATE 17. Washington burning. Thornton's watercolor *Riverscape* is believed to depict the burning of the Navy Yard in 1814. He could not have painted the picture at the time, however, as he spent the days of the British raid in the country and later in the city, saving the Patent Office and dealing with wounded American and British soldiers. (*Courtesy Library of Congress.*)

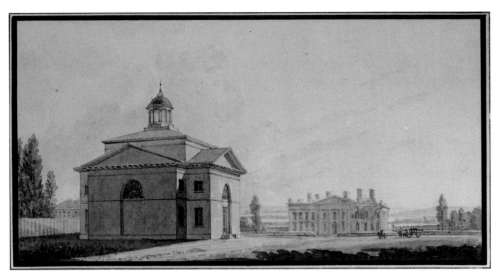

PLATE 18. St. John's and the White House. Benjamin Henry Latrobe, who designed the church and was its first organist, also made this drawing. He depicted the White House as a burned-out shell, whereas in fact its reconstruction was well under way by the time the church was dedicated in 1817. President's Square, between the two buildings, is shown as essentially an empty field; it was not landscaped until it was dedicated as a park in honor of Lafayette's visit in 1824. *(Courtesy St. John's Church.)*

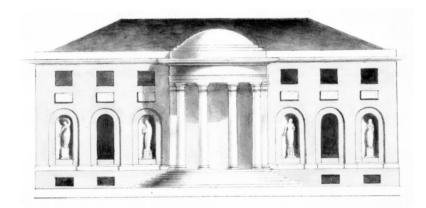

PLATE 19. Design for Tudor Place. Thornton's drawing is an early concept for the Georgetown hilltop residence he designed for his friend Thomas Peters. Peters, a merchant and landowner, married Martha Parke Custis, one of Martha Washington's granddaughters, and their friendship brought the Thorntons closely into the Washington family circle. The Peterses had decidedly Federalist political views, however, and Thornton's friendship with them and the Tayloes may have cost him somewhat in his relationships with Republican presidents Jefferson, Madison, and Monroe. *(Courtesy Library of Congress.)*

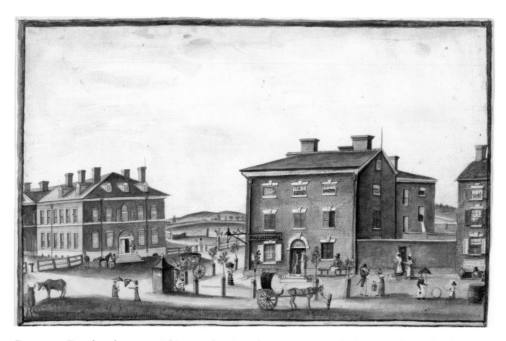

PLATE 20. F and 15th streets. This was the view the Baroness Hyde de Neuville, wife of the French minister, saw and painted circa 1817 from the French Legation, a double brick house on the south side of F Street. The building to the left housed the State Department, while the one on the right was at various times a bank, a tavern (Rhodes), and a boardinghouse. The Thorntons lived two blocks away, in a brick house near 13th Street, but there were also a number of frame houses on the street. Note the open countryside immediately to the north. *(Courtesy I. N. Phelps Stokes Collection, Miriam and Ira D. Wallach Division of Art, Prints and Photographs, New York Public Library, Astor, Lenox, and Tilden Foundations.)*

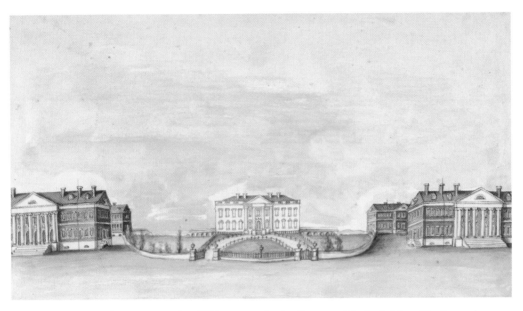

PLATE 21. The White House, 1820. This watercolor by Baroness Hyde de Neuville shows the President's Park and the two government office buildings flanking the White House in 1820. The State Department building, on the left, appears again from another angle in her painting of F and 15th streets. Lafayette Park would not be laid out until the general's visit in 1824.

(Courtesy I. N. Phelps Stokes Collection, Miriam and Ira D. Wallach Division of Art, Prints and Photographs, New York Public Library, Astor, Lenox, and Tilden Foundations.)

PLATE 22. George Watterson. A lawyer by training, Watterson has the distinction of being the first Washington resident to publish novels about life in the city, in which he took a satirical and cynical view of the local society. He also wrote a number of plays, was active politically, and served as Librarian of Congress from 1815 to 1829. *(Courtesy Library of Congress.)*

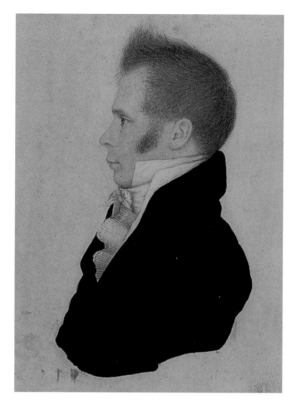

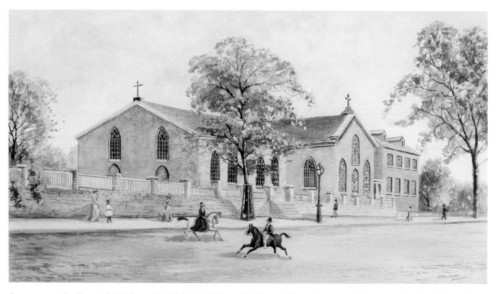

PLATE 23. St. Patrick's Church. This building, dedicated in 1810, was the second church on the site, replacing the wooden chapel originally raised for the city's Catholics who did not worship in family chapels. Father William Matthews, the priest for many years, was also active in city affairs. *(Courtesy Saint Patrick's Church Collection, Washington, D.C.)*

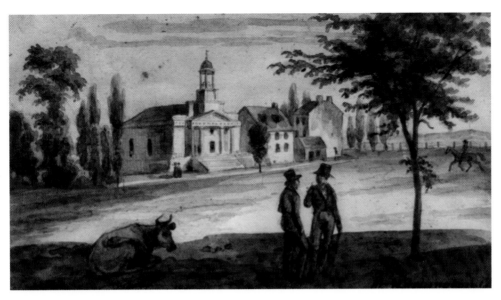

PLATE 24. Pennsylvania Avenue and 7th Street. Even in 1839, when August Kollner made this brown ink and graphite drawing, cows wandered along the main avenue of the town. In the background is the Unitarian church, designed by Capitol architect Charles Bulfinch, who was a member of the congregation. *(Courtesy Library of Congress.)*

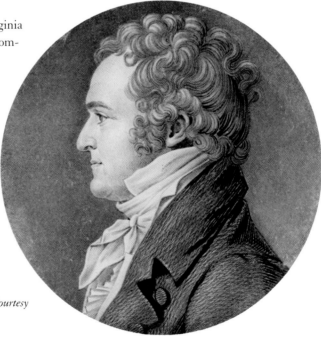

PLATE 25. William Wirt. A Virginia lawyer and author of political commentaries and a biography of Patrick Henry, Wirt and his family came to Washington in the Monroe administration. He held the job of attorney general for a record twelve years and represented the government in a number of important cases before the Supreme Court. A commanding figure, he was renowned both as an orator and as an author. The portrait, done in Richmond in 1808, is a typical Saint-Mémin profile. *(Courtesy Library of Congress.)*

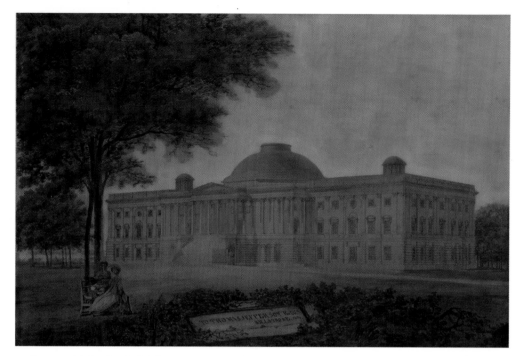

PLATE 26. The Capitol. This presentation drawing was prepared by Latrobe in 1806 to show the Capitol as he expected it to appear when finished. Thornton's basic 1794 design for the exterior still remains very evident, although with lanterns added to the domed roof of each wing, the elimination of Thornton's end colonnades, and the addition of a grand east stairway with its flanking colonnades. The first dome, when it was finally built under Bulfinch, kept Thornton's proportions on the inside but was higher on the outside. *(Courtesy Library of Congress.)*

A Community Germinates

ASHINGTON WAS A CITY THAT HAD BEEN DESIGNED AROUND ITS MAJOR public buildings, even if they—and the urban pattern designed by Peter L'Enfant—had just begun to emerge from the woods and fields. The public buildings, moreover, were special. Built on an exceptional scale for the time, they were symbols of the philosophy and the pride of the new republic. The Capitol in particular was an object of such curiosity, admiration (or dislike), and discussion that all serious visitors to the city toured the building site and wanted to see and comment on the plans for its completion. The north wing, the only part finished, gave a hint of the grand building to come. But it was already cramped and needed repairs as a result of shoddy construction and design flaws. Construction of the central rotunda and dome, vital parts of Thornton's plan, had been put off indefinitely for lack of funds. The new priority was to build a south wing, so that the rapidly expanding House of Representatives could have a larger and more suitable space. A new design for the House chamber—one that would entail major changes to Thornton's original plan—was being drafted by the newly arrived architect and surveyor of public buildings, B. Henry Latrobe.

Latrobe had been hired by Jefferson on the basis of his architectural achievements in Virginia and Philadelphia, where he had made his permanent home. Trained as an engineer and architect in England, Latrobe had completed a number of successful public and private projects there but emigrated to the United States in 1795 after the death

of his first wife and a subsequent bankruptcy (like Thornton, he was never good with money). In Philadelphia, he introduced the Greek Revival style to America through his design for the Bank of Pennsylvania building, and he also designed the city water-works and a number of private houses. Like Thornton before him, Latrobe became prominent in Philadelphia society, in part due to his marriage with Mary Elizabeth Hazelhurst of that town, but also because of his additional talents as a linguist, artist, and humanist.

Latrobe's work in Washington rapidly impinged on Thornton's self-defined role as guardian of the original, George Washington–approved plan for the Capitol. Thorn-ton was a proud and stubborn man, and, as his fights with Stephen Hallett and George Hadfield had shown, he was deeply invested on a personal level in "his" plan for the building. It was virtually inevitable that he would have problems with almost any new architect. But Latrobe's confidence in his own talent and professionalism, his closeness to Jefferson, and his advocacy of a new neoclassical style must all have been irritants to Thornton, who, to cap it all, had coveted the job for himself. Nonetheless, the two men remained on polite terms at first, complimenting each other's work and dining together in apparent harmony at the president's as well as the Thorntons' own house. Latrobe however was a man who did not hide his opinions, among which was a fierce pride in his credentials as America's first trained architect, and a corresponding scorn for amateur "charlatans in architecture," by which he meant Thornton—as well as Peter L'Enfant, whose work he also attacked.[1]

This dry tinder needed only a spark. Latrobe supplied it when, in successive annual reports to Congress, he put his criticisms of Thornton's design into the public record. A feud was launched that would last for years. Latrobe's criticism of the work on the completed north wing blamed Thornton, by indirection, for all the faults of design and construction there. (Privately, he attributed the design flaws to the "stupid genius" of Thornton.)[2] Latrobe's criticism was not entirely fair; many hands had bungled the work on the north wing, while his critique of the design for the south wing ignored the various compromises and changes that had been made since Thornton's original submission. Thornton reacted personally to the criticism, curtly refusing to discuss their differences when Latrobe (on the suggestion of would-be peacemaker Jefferson) called on him in his office. Jefferson, while characteristically remaining out of the battle, con-sulted Thornton and at first held to the original plan but eventually agreed to imple-ment Latrobe's plans for the House chamber. The design of the new and elegant hall would thus be Latrobe's, and Thornton, as a result, held a lasting grudge. He published

[1]Edward C. Carter, ed., *The Journals of Benjamin Henry Latrobe* (New Haven, Conn., 1980), 3:72.
[2]Latrobe to John Lenthall, 5 May 1803, in *The Papers of Benjamin Henry Latrobe,* ed. Edward C. Carter (New Haven, Conn., 1984), 1:289.

an angry rebuttal to Latrobe's charges in his own public message to Congress and also began to attack his rival through innuendo and in the press. Thornton, it must be admitted, engaged in some fairly juvenile taunting of his opponent over the next years, as, for example, the following poem, which he circulated after a Latrobe-designed arch at the Treasury building collapsed during a winter freeze:

> This Dutchman in taste, this monument builder,
> This planner of grand steps and walls;
> This falling arch-maker, this blunder-proof gilder
> Himself an architect calls.[3]

An angry exchange of public statements and private letters in early 1804 made the debate sharp and personal. Latrobe told Thornton that he accepted his "declaration of war," adding maliciously that "the show of good understanding which has prevailed between us, and which was kept up last winter by the respect of my wife for the Ladies of your family" was now over.[4] He sued for libel. The resultant imbroglio—much of it played out in public but reinforced by mutual private slanders—sadly reflected little credit on either of the two brilliant but proud combatants. Years later, Anna Maria was still bitter about Latrobe's design victory (and presumably Jefferson's role in it), writing, "Even of this honor they wish to deprive him, by attributing the plan to Hadfield, Latrobe, Bulfinch, anybody but him!"[5]

The feud between the architects notwithstanding, work on the Capitol continued. Latrobe's genius was appreciated by Jefferson, and the two collaborated closely on a number of other projects, including the Washington Canal and work at the Navy Yard. But progress all the same was slow. Congress, ever stingy, was distrustful of Latrobe's arrogance and loose accounting, and appropriations became particularly tight after the depressive effects of the 1807 trade embargo began to be felt. But there was still another reason for the slow progress, and that was the lack, from the beginning, of trained artisans. The Capitol was seen by Jefferson, Thornton, and Latrobe—in this, at least, they were in agreement—as a national monument, indeed a temple, to democracy, and that it needed the best in painted and ornamental embellishments to achieve that goal. There were, however, few such artisans available in America. So Jefferson and Latrobe recruited them from overseas.

Thus it was that Washington's miniscule artistic community gained two Italian sculptors, Giuseppe Franzoni and Giovanni Andrei, who arrived in early 1806 along

[3]Quoted in Thomas Froncek, *An Illustrated History of the City of Washington* (New York, 1977), p. 111.
[4]Latrobe to Thornton, 28 Apr. 1804, in Carter, *Papers of Benjamin Henry Latrobe,* 1:481.
[5]Anna Maria Thornton, "The Life of Dr. William Thornton," Anna Maria Thornton Papers, Library of Congress Manuscript Division, reel 7, container 18, n.p.

with their families. Franzoni, who had been president of the Carrara Academy of Fine Arts, soon went to work on a huge eagle to be placed on the wall above the Speaker's desk in the new House of Representatives. But, with no American eagles in his classical training, he couldn't get it right until Latrobe arranged for Charles Willson Peale to lend him a stuffed bird from his art and natural history museum in Philadelphia. Andrei, on the other hand, went to work on the capitals of the large columns that adorned the House, as well as other chambers. In time, the two would be joined by siblings and other artisans from Italy. And a new Italian work of art.

In 1808, a sculpture arrived from Italy that caught the attention of the general public as well as the few artistically inclined residents. The first of the many monuments that would eventually grace the new capital, the work had in fact been commissioned privately by naval officers to commemorate their comrades who fell in the war against the Barbary pirates. Brought home in the USS *Constitution,* it had been put in a place of honor at the Navy Yard—then the prime facility of that service. Anna Maria Thornton was among those who came to see the classically inspired work, but unfortunately she did not record her impression of the heavily allegorical design.[6]

The proposal for a tomb and monument to President Washington, however, continued to be contentious. Thornton had originally envisaged that an equestrian statue of the first president would occupy the center of Capitol's future rotunda, with room for a tomb one story below it. After Washington's death, he proposed a huge allegorical monument for the same location, with a heroic figure of Washington on top of a granite crag and multiple figures from history and legend embellishing the work. Other proposals were more restrained. But they had all failed to gain congressional approval back in 1801, when the House had approved money only to have the Senate kill the idea. Thornton and other supporters of a monument did not give up, however, and for several more years came up with still other ideas, including those of a freestanding mausoleum or a smaller allegorical work at the western end of the building.

Latrobe described a dinner he attended during this period at which Thornton enthusiastically described his concept for a monument. But Latrobe, no fan of allegorical works at any time, could not resist responding to Thornton's flights of imagination. Offering an amusing alternative set of allegories that could be drawn from Thornton's proposed figures, he soon had the guests chuckling—and Thornton embarrassed. "I was going on," he wrote in his journal, "but the laughter of company and the impatience of the Doctor, stopped my mouth. I had said enough, and was not easily forgotten."[7] Latrobe's ridicule, of course, simply fed the rivalry between the two men; it did not

[6]Known as the Tripoli Monument, it was carved from white Carrara marble by Carlo Micali of Livorno. Damaged in the 1814 fire, it was repaired and moved to a location in front of the Capitol after the war, and then to the Naval Academy in Annapolis in 1860.
[7]Carter, *Journals of Benjamin Henry Latrobe*, 3:265.

doom the monument project. But the fact was that there was simply no meaningful support in Congress for the idea of a shrine-like monument to Washington. Jefferson and his Republican colleagues distrusted anything that was supported by Federalists, smelled of monarchy, or cost money. In the end, the various proposals simply remained in congressional limbo, where they expired for lack of support.

Years later, the project would be revived but privately financed and in a different form—the Washington family by then had turned against the idea of a monumental tomb. And the Capitol was no longer to be the site. William Thornton was spared any further frustration, however—he had been dead for twenty years when the cornerstone of today's huge memorial obelisk was laid.

Congressional indifference also complicated the prospects for another kind of monument to Washington—the national university he had wished to see as a central feature of the new capital city. President Jefferson, intent on balancing the budget, did nothing to advance the proposal during his first term of office. Fascinated by educational ideas, he and his friend Joel Barlow periodically exchanged ideas on university organization, academic disciplines, and whether or not Washington should also be the seat of a national philosophical society. The idea even had some support outside of Washington. Charles Willson Peale of Philadelphia had heard enough to think that a national university might provide an opportunity to sell his museum to the government. And that tireless promoter Samuel Blodgett, who continued to correspond with William Thornton concerning "our university on Peter's Hill" (the site above 23rd Street approved by the commissioners), had begun to do something practical. He was raising money and claimed to have signed up more than a thousand subscribers to a fund for a university in Washington, centered around a monument to the first president—trying, it seems, to get two birds with one stone.

But to succeed the university project needed congressional support. And Jefferson was faced with a dilemma: a national university might be a good idea, but he and many of his supporters were of the opinion that funding it from the federal budget was not acceptable without authorization by way of a Constitutional amendment. So when Peale inquired about selling his museum to a national center of learning in Washington, the president responded somewhat disingenuously that Congress was unlikely to oblige. The majority of congressmen, he wrote, were unlikely to approve money for "any program not specifically enumerated by the Constitution."[8] The majority of which he spoke were, of course, himself and the strong states' righters in his own party, who wanted no strong national institutions. An alternative course was also problematical. Congress had helped other state universities get established through land grants, but

[8]Jefferson to Charles Peale, 16 Jan. 1802, Thomas Jefferson Papers, Library of Congress Manuscript Division, series 1, image 696. Accessed at Library of Congress, *American Memory,* http://memory.loc.gov/ammem/collections/jefferson_papers.

virtually all the government-owned land in Washington was already pledged to finance the growth of the city. So the president, by and large, went through the motions of asking Congress to support a national university without striving to make it happen.

There was simply no significant coalition of support for the university. Working separately, Blodgett and Barlow had promoted the idea, with support from a few enthusiasts like Dr. Thornton. In early 1803, Blodgett had gotten John Van Ness to propose a congressional study on financing a university. But Van Ness, only two weeks later, had to resign his congressional seat when it was ruled that he could not have both a militia commission and remain a representative. Without its sponsor that proposal died in committee. Blodgett, persisting, petitioned Congress again two years later, but once again no action was taken. Joel Barlow, with Jefferson's approval, got Senator George Logan to propose a bill in 1806. Unfortunately, it too died in committee. The private supporters of a national university simply had too little political weight to give reality to their aspirations.

Jefferson had done little to help; it was never a real priority for him. He was for it in principle but could not overcome his reluctance to paying for it out of the federal budget. In 1807, he asked Congress to act on the plan but did not push for the constitutional amendment that he said was necessary for funding. So Congress, parsimonious at best when it came to the national capital, and protective as well of the various states' existing colleges, listened politely to the president's ideas but took no action. Jefferson made one last plea for a university in his final message to Congress, and Joel Barlow renewed his argument for a national education policy in that year's Fourth of July oration, but once again no specific legislative proposal emerged. Jefferson passed the issue on to his successor. Retiring to Monticello, he gave up on a fight he had never really joined and began to plan seriously for what was his real enthusiasm—he had as much as admitted it to Peale seven years earlier—a university in his home state of Virginia.

While the national university project languished, less ambitious educational steps went forward. The transfer of government to Washington had brought an influx of tutors and private school arrangements to serve the children of government officials, and even if few of these stand out in the records of the time, the new residents clearly had a variety of choices. In Georgetown, the two existing secondary schools continued to operate, without any particular distinction but nonetheless providing schooling and an occasional cultural attraction, such as drama or oratorical performances, for parents and residents. Georgetown College lost some ground, however, under the strong sectarian approach taken by its presidents Leonard and then Francis Neale. Although the Neales increased educational opportunities for girls by opening Visitation Academy, the enrollment at Georgetown itself withered. The student body had dropped to fifty by 1809, and few out-of-area or Protestant students remained due to the emphasis on

Catholic piety and discipline. Nearby, the even smaller Columbian Academy, under the leadership of the Presbyterian minister, scientist, and librarian David Wiley, taught a more liberal curriculum to local boys, including the future businessman and philanthropist Thomas Corcoran.

In Washington City, where a good number of private schools had set up, the first steps had also been taken toward a system of free general education. When the city was incorporated in 1802, it had been given only limited powers and taxing authority, and no responsibility for schools. By 1804, however, Mayor Robert Brent and the councilmen had come to the conclusion that they needed to take some responsibility for the education of local youth—particularly the children of the many poor families that had come to the city looking for work. The city charter was amended to authorize publicly run schools, to be financed—there being too many other demands on the property taxes— by a sort of "sin tax" on licenses for selling wines and spirits, operating billiard tables or hackney cabs, and owning dogs, slaves, or carriages. It was expected that the license fees would raise about $1,500 per year, enough to operate two schools, but that an additional $4,000 would be needed for start-up costs. A citizens' committee was set up and soon raised the money; among the many contributors were Samuel Smith, Thomas Tingey, Nicholas King, Thomas Munroe, and John Tayloe. (William Thornton's name, surprisingly—given his professed interest in education—does not appear on any of the lists published in the papers. He was, as usual, in financial trouble—an insurance company that he and Samuel Blodgett had tried to start had failed, and he was beginning to pour money into a putative gold mine in North Carolina—but the ten-dollar minimum contribution being asked for the schools should not have been beyond his means.)

Two schoolhouses were obtained, one on Capitol Hill and a second one off Pennsylvania Avenue near 17th Street. The schools, grandly called the Washington Academy, provided free education for the poor and also accepted paying students. At first, the schools were well viewed; the Latrobes even sent their sons for a short time. But their offerings were limited; no girls or blacks were accepted, and the curriculum was a two-year course designed simply to teach basic literacy and numerical skills. Gradually, they began to be considered as "paupers' schools," and the paying students went elsewhere. And then the municipality had to cut back its yearly support by almost half, to a mere eight hundred dollars. To save money, the schools were eventually converted to a "Lancastrian" system—in which the older students tutored the younger ones.[9] The step did not, however, improve the schools' reputation, and they would languish for years at the lower edge of financial solvency and educational respectability.

[9]John Lancaster, the English Quaker, who devised the monitorial system (as it was also called), had made a number of trips to Washington to promote his ideas. A Lancastrian school would also open in Georgetown in 1811.

Frozen out of the public schools, free blacks in the city also took the first steps toward organizing their own schools. In Washington, unlike many other southern jurisdictions, providing education for blacks (free or slave) was not a criminal offense, and so three freemen from Virginia—George Bell, Nicholas Franklin and Moses Liverpool—decided to take advantage of the small opening provided. Although the local community of free blacks was still fairly small—less than five hundred people in 1807, the year the school opened—it was concentrated to some degree in the area around the integrated Navy Yard (where two of the founders worked), and the salaried employees there could afford education for their children. The school opened and proved a modest success, the first of its kind. By 1810, a second school for black children had been opened, this time in Georgetown, and run by an English woman, Mrs. Billings.

The slow death of the project of a national university stifled the city's potential as a center of learning. Virtually without scientific institutions, the national government was able to play only a negligible role in the new technological advances that would soon propel the United States into the industrial revolution. It looked as if Washington would never be more than a scientific backwater. Indeed, opportunities were missed to give the new capital city any role at all in the nation's technical progress. The Lewis and Clark expedition, for example—a national enterprise if ever there had been one—was financed and planned in Washington, its principal map prepared by that Washington man of many skills, Nicholas King (then cartographer at the War Department), and yet, when it came time to safeguard the records and collections of the expedition, the national capital was ignored. Congressional and administration parsimony meant that no government funds would be spent to publish the results, or to study or even to display the collection, which was sent instead to Philadelphia—where it languished for years.

The main, indeed the only, scientific establishment in early Washington was Dr. Thornton's patent office. Authorized by the Constitution to promote invention, it handled a rapidly growing number of patent applications, reflecting the proliferation of American chemical, mechanical, and other innovations. It was a huge job, one he enjoyed because of the mental stimulation it offered, but it was also troublesome. Thornton had no professional staff; he had to research and evaluate every application himself as to its originality, practicality, or operability, as well as keep all the records. However rigorous he may have been in examining the technical merits of the applications, however, he was an unsystematic manager, careless in accounting for the fees collected and even, on occasion, waiving the fees for penniless inventors. The job was also full of potential controversy, which he tried to avoid as much as possible by granting patents fairly freely, leaving it to the courts to determine matters of precedence or originality where there were disputes. But he himself had been and was an inventor, and sometimes took a personal interest in the issues. He kept a sharp eye out for items that he

thought might prejudice his own numerous patents or those of his old steamboat part-
ner, John Fitch. On occasion, in that day before conflict of interest legislation, he even
persuaded inventors that they should co-patent, claiming that he had had prior knowl-
edge or use of their supposed innovation. Thornton was, in short, as idiosyncratic in
running the office as he was in much of the rest of his life, but he was dedicated to the
work and put in many hours beyond the rather relaxed work schedules of the day.

The Patent Office, with its intriguing collection of working models of the mechani-
cal inventions, became part of the sightseeing tour of Washington. While the attention
may have gratified Thornton with interesting visitors, it took up too much of his time
until 1810, when he was finally able to get funding for a clerk to help him. Virtually all
scientifically inclined visitors sought out Thornton, both for his learning and for his in-
sights into the local scene. Of particular interest to some of his visitors were the pictures
of West Indian tropical plants that he had made in Tortola, and which were "as neatly
done as anything of the kind I have ever seen," according to Charles Willson Peale.

Peale had called on Thornton in company with the renowned German naturalist and
geographer Alexander von Humboldt in early 1804. Humboldt, who had just spent
five years of scientifically important exploration in South America, was the toast of the
town, his conversation "an intellectual festival . . . I could have listened to him for
days," according to Margaret Bayard Smith. Jefferson however hoped for more than
just conversation from the visit and had Thornton accompany Humboldt on his offi-
cial calls as well as to dinner at the "mansion," as the President's House was beginning
to be called. Having just obtained Louisiana and commissioned the Lewis and Clark
expedition, Jefferson was hoping to persuade Humboldt to stay in the United States
and explore the new western territories as well. Humboldt was well fed and entertained
throughout his short stay—a dinner at the Thorntons included the Madisons and, ac-
cording to Peale, "was elegant, and the close harmonious, for Mrs. Thornton played
on her fortepiano and sang some very pleasing songs in English, French and Italian
and in a high style of execution." But Humboldt soon left America, not to return, and
the visit became one of those intriguing events that might have lead somewhere inter-
esting, but did not—beyond the scientific titillation of Washington society.[10]

Washington's only other establishment with any scientific purposes was the Navy
Yard. That establishment's main mission at the time was as a construction and fitting-
out yard for navy vessels, or a place to store them when not on campaign (at one time
almost all the major ships in the tiny navy were laid up there). But the mission re-
quired heavy mechanical tools, and the yard became a significant industrial site. If not
a place of scientific innovation, it at least was a place where interesting and state-of-

[10]Margaret Bayard Smith Papers, Library of Congress Manuscript Division, reel 1, no. 07; Extract from Peale
Diary, 7 June 1804, Charles Willson Peale Papers, Library of Congress Manuscript Division.

the-art machines were being used or tried out—Anna Maria's diary talks of going there to see a "telegraph" and a "Mr. Adam's perpetual motion machine."[11] But it was not yet a center for ordnance or weapons technology, even though Robert Fulton came to Washington in 1807 to try to sell the government on his idea for torpedoes. (Thornton went to the demonstration and undoubtedly kept an alert eye on Fulton, who he knew was trying to register steamboat patents that could conflict with Fitch's.)

Joel Barlow, an enthusiastic supporter of the sciences and Fulton's efforts, tried to convince the president that the government should actively promote research through establishing a national scientific institute, presumably in the capital city. "The cultivation of the sciences has become so essential to the useful arts, and these at this commercial period of the world are so interwoven with political economy and the preservation of liberty, that I think it should be ranked among the duties of the federal government to give a certain public importance to scientific research," he wrote.[12] And yet the president, constrained as usual by tight budgets and his own vision of a limited federal government, set the idea aside.

When Congress in 1807 set up the government's first true scientific branch, the Coastal Survey, it was not given a home in Washington. In fact, no serious thought seems to have been given as to where it was to be located. In any event, lack of appropriate instruments, the crippling effect of the embargo, and other impediments assured that the survey would not get truly under way for almost a decade, and for some time after that it was largely a field operation. Later, much later, the survey would bring its expertise and scientific skill to Washington. But at the time, the most scientific American president, Jefferson, had missed an opportunity to place the germ of a scientific community in the nation's capital.

Such interest as there was in science was largely directed to the natural sciences, especially agricultural ones. Thornton, along with many fellow residents (including the wife of the first British minister), was an avid student of botany. Trips to the countryside to collect plant samples were a popular pastime which, combined with a sort of romantic pastoralism (as well as economic advantage for the permanent residents), created a fashion for country living. Many residents had nearby summer or weekend homes—the Smiths' home, Sidney, was in the hills north of the Capitol; John Mason had his idyll on Analostan Island, opposite Georgetown; and the Thorntons had their place in Bethesda. These country places were, of course, retreats from summer mugginess and threat of fevers in the city, but they were also working farms that provided pasture and feed for the all-important horses, fruits and vegetables for the table, and

[11]Anna Maria Thornton Diary, 8 June 1808 and 13 Apr. 1814, Anna Maria Thornton Papers, reel 1, nos. 477 and 591.

[12]Joel Barlow to Jefferson, 4 Dec. 1808, Jefferson Papers, series 1, image 1178.

wood for the stoves and fireplaces. Some landowners—including Thornton, who used a plot of land he owned opposite the Tayloe house—even raised crops in the city.

It followed naturally that many of Washington's gentry, for all that they were "city" people, also had to concern themselves with agricultural technology, specifically the new ideas of scientific farming. They exchanged information, regularly and seriously, about crops, seeds, farming techniques, livestock, wool qualities, propagation of fruit and other trees, and so on. This was not only about running efficient or profitable farms; it was also an important element in the role of a landed gentleman. George Washington Parke Custis led by example. Since early in the century, he had sponsored an annual "sheepshearing" at his Arlington estate, where prizes were awarded to the best sheep, and where the landowners came to socialize with their peers and compare notes on scientific farming. When the embargo cut off trade with Europe, it also became patriotic for those same gentlemen to promote home manufactures—wool and linen fabrics and other substitutes for the missing imported goods.

Of course, one part of the landholding gentleman's image was to keep fine horses—and the ultimate status symbol was to run thoroughbred racers. There was not much science in this, other than a basic knowledge of genetics. Nor much economy. It was a diversion, affordable for an exceedingly rich man like Tayloe, but an unfortunate and expensive passion for a man with precarious finances, like Thornton. The two men were founders and pillars of the local Jockey Club, deeply involved in the annual fall race meets in town, and Thornton designed and built one of the several tracks in town. His expenditures in this area were of course a constant strain on the family finances, even though he insisted to his wife and others that he was actually making money from stud fees. He apparently wrote the following poem on the subject after a debate with Margaret Bayard Smith:

Bayard	Pray Doctor, why so fond of horses?
	I think them all so many curses
	As you have money, and are able
	Why don't you make your wealth more stable?
Thornton:	Stable? My friend, look at those bloods
	What can more stable be than studs?
	Or stallions, as the English call
	Those noble lions of the Stall
	They *cover* all expenses too
	And bring a *standing* revenue[13]

[13]The poem was apparently never sent—it may have been a bit too ribald. The words in italics are underlined in the original. William Thornton, undated, W. Thornton Papers, Library of Congress Manuscript Division, vol. 4, no. 2463.

In view of the great popularity of the races, however (they were attended by all classes, from the "first circle" to the slaves, and Congress was even known to adjourn on race days), Thornton's conspicuous participation at least helped to cement his position as one of the town's leading citizens.

While the annual race meets provided occasion for public displays of a good number of the deadly sins—including cupidity, drunkenness, pride, envy, and thievery—churches in the new city were expanding as well, and spiritual education and guidance was increasingly available to the city's growing population. The churches in Georgetown grew throughout the period, but it was in the federal district that the need for new congregations was most notable. The new capital was drawing in people from all areas of the country, and each of the nation's religious denominations naturally wanted a presence in the city once a few of its members took root there. Yet the population was not yet large enough, nor for that matter well-heeled enough, to support much building, and as a result the newly formed congregations generally took their initial form through services in members' homes. Some congregations took years to graduate. The Friends Meeting, which Thornton attended from time to time in spite of his having been dropped by the Society, did not, for example, have a permanent home until 1811.

The Baptists, on the other hand, were able to move slightly more rapidly. They began to meet in Washington homes in 1802 and started a church near 19th and I streets in the following year, but their congregation was not officially organized until 1807. In that year, they invited the young Rev. Obadiah Bruen Brown to become their minister. The church stipend, however, was minimal, and Brown—like many of the early ministers —worked as a government clerk to make ends meet. "Pastor Brown," as the stocky and jovial man came to be known, stayed for more than forty years and added very significantly to the cultural and educational scenery of his new home.

The Ebenezer United Methodist-Episcopal congregation, somewhat along the same line, was organized early in the century and met in homes along the river in the area known as Greenleaf's Point. It was not until 1807 that the congregation even met in a church, and that was the old tobacco shed on Capitol Hill that had just been abandoned by the Episcopalians. Like many of the early churches, it had both black and white members—but the blacks were expected to sit separately and were not included in management decisions.

Presbyterians in Washington also founded a new congregation. Dissatisfied with both the faltering St. Andrew's congregation as well as Reverend Balch's older congregation in Georgetown, a group of members of the Associated Reformed branch of the church began meeting privately in the city. Led by Joseph Nourse, a senior official at the Treasury Department and a leading citizen, the group soon formed itself into a

congregation. In 1803 they invited a young and recently married graduate of Edinburgh University, James Andrew Laurie, to lead the new congregation, providing him also with a job at the Treasury Department. Laurie, a sociable and warmhearted man, even though a dedicated Calvinist, immediately began to raise money to build a church. When it was finally inaugurated in 1807, the building at F and 14th streets soon became one of the centers of Washington life. Convenient, spacious, and boasting good acoustics, the church was regularly made available to civic organizations by its public-spirited pastor and became known as "Mr. Laurie's church." Laurie, like Obadiah Brown, provided the Washington community with committed leadership for more than forty years.

The other two existing Washington denominations, Episcopal and Catholic, also expanded. Christ Church Episcopal, which was also known as the Navy Yard church, finally moved to its own building at 6th and G streets S.E., on Capitol Hill, in 1806. Its minister, Andrew T. McCormick, was an active Mason and supplemented his income by running a school from his nearby home. James Barry, who owned the pier at the foot of New Jersey Avenue, built a small Catholic chapel near Greenleaf's Point in the east end of the city, to serve the growing population of that area. However, the church, known as St. Mary's, never became the home of an organized congregation. On the other side of Tiber Creek, St. Patrick's was gradually upgraded from a small wooden chapel to a brick church, which was completed in 1810. When the building was finally dedicated, the congregation had a special reward: the church had the first pipe organ in Washington. The priest, Father William Matthews, had a congregation divided between the wealthy English-origin landowner families, such as the Carrolls, Brents, and Youngs (who still held services in their domestic chapels), and a larger but poorer group of slaves and immigrant workers, many Irish. But Matthews was from the influential Maryland Neale family and a calm and sensible man; he succeeded in uniting his congregation and made his ministry and St. Patrick's an important voice in the community.

With so many of the congregations, new and old, in temporary quarters during these early years, the government's buildings were regularly made available for religious services. In the tolerant spirit of the time, the chaplains of the Senate and House (themselves elected for one-year terms) rotated with visiting divines to give regular Sunday morning services in the hall of the House of Representatives. In a period when "first events" were more or less routine in the new city, one of these services nonetheless draws attention: the sermon preached one Sunday in early 1806 by a woman evangelist, Dorothy Ripley. Afternoon services were held as well in the Treasury Department, where James Laurie among others was able to preach to an open congregation.

Indeed, churchgoing of a Sunday appears to have been, for many Washingtonians, as much a social and intellectual experience as it was devotional. Washington's resident preachers, unfortunately, did not shine as orators. Reverend Balch's sermons in Georgetown, full of fire and brimstone, attracted attention but were not universally admired: [he] "relies more on the strength of his voice than upon any other of the arts of persuasion or conviction," commented one resident.[14] The Thorntons and others seem to have attended church pretty much as their intellectual curiosity or the rotation of preachers appealed to them. Anna Maria's diary notes visits to almost all the churches and even becomes unusually judgmental about the performances. One preacher whom she went to hear, in the company of the ladies Madison and Forrest, she called a "madman." (They did not stay.) She also went to a camp meeting above the Great Falls in 1807 and found the crowd and animated preaching to be stimulating.

Washington's best preachers, it appears, were the rotating congressional chaplains or visiting clergy invited to speak at the Capitol Hill services. Those events, in a town where oratory was prized and there was little else to do, not surprisingly became popular. In fact, the services became rather worldly. The town's elite came to Congress of a Sunday to hear a sermon, true, but also to see each other. It was a place where bored congressmen could get out of their boardinghouses to mix with the citizens, pass time with the ladies, and perhaps enjoy a bit of good nonpolitical oratory. It was also, as Margaret Smith put it, "a favorable [occasion] for the youth, beauty and fashion of the city" to show themselves.[15]

It was as if the hall of Congress had become, in some respects, the city's assembly room. For a city so intimately connected, from the start, with politics, the symbolism was appropriate.

[14]William Cranch to his mother, quoted in Christopher Pearse Cranch, "The Life of William Cranch" (1882), Cranch Family Papers, Library of Congress Manuscript Division, 466.

[15]Gaillard Hunt, ed., *The First Forty Years of Washington Society* (1906; reprint ed., New York, 1965), p. 14.

5

Cultural Amenities Emerge

ONGRESS IN SESSION WAS, INDEED, THE BEST SHOW IN TOWN. WHILE THE administration and the Senate preferred to do their work behind closed doors, the House of Representatives had open debate, and admission to its galleries was free. The debates were a striking demonstration of the new republic in action, to which visitors from out of town were naturally drawn. Attendance there soon became a required stop for the curious. The debates also provided a sort of daily theater—and perhaps the main cultural attraction—for Washington residents, both men and women. They attended for a variety of reasons: to follow the key deliberations of their government, to bask in or critique the performance of the orators, or simply to pass some time out of the home with friends and in a stimulating environment. Catherine Mitchill, wife of the senator, reported back home during one of her stays in Washington that it was "fashionable" among Washington wives to go. Heavy attendance in the galleries, where much of the audience typically was female, sometimes even influenced the course of the debates themselves. With the exception of the misogynic John Randolph of Roanoke, most congressmen were only too happy to play to the females in the galleries when the occasion warranted: gallantries were expressed, speeches repeated, notes exchanged, and the oratory became more flowery. As Mrs. Mitchill summed up, "It was as good a thing as going to a play, but here all the characters are real instead of fictitious."[1]

[1]Catherine Mitchill to Mrs. Sylvanus Miller, 3 Apr. 1806 and 19 Dec. 1808, Catherine Ackley Mitchill Papers, Library of Congress Manuscript Division.

The sense that Congress was a political theater was highlighted in 1805, when the Senate sat for the impeachment trial of Associate Supreme Court Justice Samuel Chase. The drama of the event, which occupied most of the spring session, was emphasized by a rearrangement of the seats in the chamber, which were designed to transform it into a courtroom—but which also made it resemble a theater where an audience could watch the performance unfold.

The presence of government contributed to the cultural life of the new city in many other ways. The public banquet marking special occasions was already an American institution, but in Washington there were both a larger number of opportunities to commemorate and a richer cast of potential attendees. The standard celebrations—the Fourth of July, Washington's Birthday—were supplemented by the visits of foreign dignitaries, Indian tribal delegations, or victorious naval vessels. The events called for special ceremonies and often introduced new information and experiences to the local residents. The resident and visiting diplomatic corps, likewise, brought not only a bit of the taste, refinement, and luxury of Europe to Washington, but sometimes something entirely more exotic. Thus was the case during the prolonged 1806 visit of a Tunisian delegation under Sidi Suleiman Melmelli, and the effect made by his retinue, rich robes, and spectacular outfits, not to speak of his somewhat bizarre behavior, enlivened Washington conversation for months.

Government business and the heat of summer also set the calendar for the city. The "season" usually kicked off with the fall horse races in October and ran through two sessions of Congress, typically ending by May. The social life of the leading citizens, resident diplomats, and the visiting congressmen was concentrated in those months and, in spite of Jefferson's disapproval, gradually became more active and elegant. By the end of Jefferson's first term, his round of small private dinners had come to be supplemented by grander affairs. Residents of the "first circle" could enjoy diplomatic dinners and balls, periodic dancing assemblies, and dinners or even balls hosted by the Madisons, Tayloes, Laws, Van Nesses or, when their finances permitted, the Thorntons. "Luxury increases daily—in the cities one can now live as well as in Europe. We have some excellent restaurant-keepers, confectioners, pastry shops," wrote Bladensburg resident Rosalie Calvert at the time, although one suspects that as far as shops were concerned, she had Baltimore in mind more than Washington.[2] But Washington society had indeed already achieved a certain degree of elegance. One congressman, after seeing the finely dressed ladies at the autumn horse races, quipped that "if they were not all democrats, I should call them noblesse."[3]

[2]Rosalie Calvert to Henri Stier, 25 Jan. 1805, in *Mistress of Riversdale: The Plantation Letters of Rosalie Stier Calvert,* ed. Margaret Law Calcott (Baltimore, Md., 1991), p. 109.

[3]Manasseh Cutler, 8 Nov. 1803, in Julia P. Cutler and William P. Cutler, *The Life, Journals and Correspondence of the Reverend Manasseh Cutler* (Cincinnati, Ohio, 1888), 1:142.

It was as yet, however, a relatively restrained social scene. What opulence there was, was seen largely at the diplomatic missions, where the competitive European missions attempted to bedazzle their American guests with displays of wealth and power. American entertainments on the other hand were less lavish, and local taste and custom were by and large modest, indeed almost prudish. Even such a relative feminist and modern woman as Margaret Bayard Smith, for example, was shocked when Elizabeth Patterson Bonaparte, the beautiful Baltimorean who had just married Napoleon's brother Jerome, appeared—all but too much of her—in the diaphanous fabrics then fashionable in Europe. "Almost naked," huffed Mrs. Smith, who joined a small boycott of wives who said they would not attend evenings with Mrs. Bonaparte unless she dressed more modestly. The men, it seems, were not quite as offended by the display. Thomas Law reportedly penned a comic poem in which he called Mrs. Bonaparte "a little whore at heart"—a line he had to revise quickly (and more favorably to the lady in question) when Aaron Burr informed her that a poem had been written about her.[4]

These increasingly urbane social events took place, incongruously, in a pretend city that was still a sprawl of buildings over a vast, largely undeveloped site. But the community had nonetheless begun to take on some characteristics of urbanity and wealth. Anna Maria Thornton commented with a bit of amazement that she had counted no less than twenty-seven carriages—the ultimate status symbol—whose owners had come to pay their respects to Captain Tingey, on the death of his wife in 1807. All the same, it was still a small southern town more than a city, and the winter political and social "season" had not yet become an endless round of events. Indeed, in these early years the town's social leaders, the congressmen, and certainly the majority of the other residents were quite often at home or in their boardinghouses of an evening. The British chargé d'affaires, Augustus John Foster, observantly compared life in Washington to that of an English provincial town; hospitable in a way that cities with older, established, and exclusive gentry were not.[5] In spite of the social and diplomatic swirl, cultural life was still essentially domestic, and evenings at home or with a few friends while reading, writing letters or drawing, playing cards, enjoying conversation, or making their own music compensated in many ways for the nascent state of the city's cultural institutions.

Washington was, from the beginning, a political town. Created by political act, supported by government expenditure (increasingly so, in sad fact, as the original commercial hopes for the city began to fade), the community lived on, and for, politics. Small wonder, then, that one of the most rapid areas of institutional growth that followed the

[4]Margaret B. Smith, 23 Jan. 1804, in *The First Forty Years of Washington Society,* ed. Gaillard Hunt (1906; reprint ed., New York, 1965), p. 47; Rosalie Calvert to Marie Stier, 24 Mar. 1804, in Calcott, *Mistress of Riversdale,* p. 77.

[5]Augustus John Foster, *Jeffersonian America* (Westport, Conn., 1980), p. 109.

transfer of government was in the areas of information and opinion. Indeed, Samuel Harrison Smith's *National Intelligencer and Washington Advertiser* was not the first daily newspaper to open; that honor went to William Rind and John Stewart's *Washington Federalist,* published in Georgetown. In those first years, other papers opened as well, including the *National Magazine and Cabinet of the United States,* which had Republican editors, and the *Washington Museum,* with Federalist ones. The *Intelligencer,* however, rapidly became the city's leading paper, largely because of Smith's close association with the administration, but also because of the couple's quick acceptance as part of the social leadership of the community.

In addition to newspapers, booksellers and libraries surfaced to meet the demands of an increasingly literate population. They were, only naturally, small in scale at first: Albert Gallatin dismissed one of the earliest ones, Rapine and Conrad's Washington Bookstore on Capitol Hill, as a "pamphlets and stationery shop." Nonetheless, business was apparently good enough so that William Duane, editor of the fiery Philadelphia newspaper *Aurora,* opened a competing bookstore and publishing house on Pennsylvania Avenue in 1801. Duane eventually sold out to Roger Weightman in 1807, under whose management the store became a popular center for residents with literary inclinations. Both Weightman and Daniel Rapine were well known and respected; both eventually served as mayors of the city. Other bookstores in the early years included Stickney's, near the Treasury Department; Joseph Milligan's in Georgetown (Jefferson's preferred dealer); and Robert's general store, where Anna Maria Thornton was a loyal customer.

Books, however, were expensive. Even Rosalie Stier, the European-born aristocrat who was married to George Calvert of Riversdale in Maryland and did not lack for money, wrote that "the expense of a complete library would be too great, so everyone purchases several new volumes each year, and they are loaned around and their merits discussed."[6] Anna Maria Thornton, whose husband's library was sniffed at as "modest" by a European visitor, was typical in this respect; her diary is full of notes about exchanges of books with her intimates Margaret Smith, Dolley Madison, Eliza Law, and even with the president. While the Library of Congress had probably the best collection of books in the city, loaning privileges were in theory available only to members (although the resourceful Margaret Smith found ways around the limitation). And Joel Barlow's library, probably the best private one in the city, was always available to his friends.

Given the need, it seems surprising that lending libraries were not more of a success. Nicholas King's effort to set up a subscription library in the city, before there

[6]Rosalie Calvert to Charles Stier, 10 Dec. 1815, in Calcott, *Mistress of Riversdale,* p. 196.

were enough readers, had been premature. Even in the more established community of Georgetown, the Columbian Library, under the management of David Wiley, continued to be only a modest success, having to appeal regularly to its members to renew their subscriptions and return their books. In the city, the merchants Richard Dinmore and Hugh Sommerville tried in 1801 to establish a circulating library off Pennsylvania Avenue, but it, too, folded after a short time. Another effort, in the Navy Yard area, which was chartered in 1805 as the Anacostia Library with James Stevenson as librarian was more successful, lasting at least until 1811.

But Washington did have its first novelist. Margaret Bayard Smith, who was caught up in the social and political life of the city, had not yet turned her talents to writing novels. So the distinction fell to a young Maryland lawyer, George Watterson, who moved to the city to work with Thomas Law, and whose entirely forgettable book *The Lawyer, Or Man as he Ought Not to Be* (at least he chose an enduring Washington type) came out in 1808. Watterson, who later wrote better books, eventually became Librarian of Congress and a fixture of the miniscule Washington literary scene. At about the same time, the city also had its first publicly identified book club. The Columbia Reading Society was founded in 1806 and claimed Nicholas King as one of its two dozen members. It may not, however, have lasted much longer than its 1807 anniversary dinner, for which one of its members composed a piece of doggerel that could typify the fashionable versifying of the period:

> When last we assembled, 'twas ruled that this day;
> Should in eating and drinking and jokes pass away;
> For as an whole twelvemonth we hard had been reading
> It was proper and good we for once should be feeding[7]

The move of the government to Washington brought another interesting addition to the town's cultural scene: an influx of artists who were drawn to the new seat of power. Almost none of them, however, came to settle, but rather to make the rounds of the salaried and landed residents, seeking commissions for portraits—the only truly profitable work for an American painter in those days. Ironically, the one painter of any note who did settle, Charles Peale Polk, did so because he had not been successful as a painter. Nephew and adopted son of Charles Willson Peale, the Philadelphia artist, naturalist, and museum owner, Polk landed a job with the Treasury Department in 1802 in order to feed his large family. (That regular income did not stop him, however, from going bankrupt in later years, as well as being suspended, not once but twice, from his Baptist congregation.) Polk continued to paint as the opportunity arose, but one

[7]*Columbia Reading Society,* a pamphlet by Duane & Co., 1807, Library of Congress Rare Books Collection.

portrait he did of a Washingtonian, the Columbian Academy principal David Wiley, may show why Polk's talents were not greatly appreciated. It seems that he did a better business by doing inexpensive profiles on glass, in a technique called *verre eglomisé*.

The first artists to come, in 1800, were not Americans but Englishmen. The miniaturist Robert Field found enough business to justify several extended stays over the next years. Interestingly, he did likenesses of two local residents who themselves had some pretensions as artists: George Washington Parke Custis and William Thornton. Field stayed on occasion at the Thornton house, and his host's notebooks show that he used his time with Field to good advantage; they contain notations on Field's methods for preparing his ivory surfaces and mixing pigments. Field painted miniatures of the family—Mrs. Brodeau looking appropriately matronly under her mob cap, the Doctor (as Anna Maria always called him) with a rather truculent stare, but Anna Maria striking, with a quizzical look in her beautiful eyes.

Thornton spent even more time, however, with another visiting Englishman, the landscape painter William Winstanley. Winstanley was a regular visitor to the Thornton house, where the two men often stayed up late drawing or painting together, reviewing manuscripts, and conversing. Winstanley began a portrait of Thornton, according to Anna Maria, but it is doubtful that it was ever finished, as the two reportedly had a falling out over business matters. It seems that Winstanley's visit was not a commercial success; no works are known to have survived from his visit to Washington.

A far more successful visit, and indeed the talk of the town at the time, was the extended stay of the eminent American portraitist Gilbert Stuart. Stuart came at the end of 1803, encouraged by Benjamin Henry Latrobe, who had even built a two-room studio for Stuart's use, north of Pennsylvania Avenue off 6th Street. Stuart was not only a talented painter, but also an entertaining raconteur who engaged his clients in lively conversation and encouraged visitors to come see him at work. His workshop soon became fashionable. People dropped in to see the artist at his easel, to hear the chat, to be seen, to consider a purchase, or just to pass the time amusingly. Anna Maria Thornton, her mother, and her husband came repeatedly, and Stuart dined at their house. The couple commissioned a pair of portraits—at two hundred dollars each, a considerable expense that represented a third of William's Patent Office salary. At least the Thorntons had their portraits finished on time, which was not the case for all Stuart's clients; he was thoroughly disorderly in his lifestyle, was drinking to excess, and, to cap it all, fell ill with malaria during the summer. But he nonetheless accomplished a good deal of work during his year-and-a-half stay. Among his portraits of Washington's "first circle" are paired likenesses of the Calverts, the Madisons, the Tayloes, the Thorntons, Richard and Anna Cutts (Anna was Dolley Madison's sister), the Spanish Minister Yrujo and his American-born wife, plus a stunning triple portrait of the

Baltimore beauty Betsy Bonaparte. The Thorntons' portraits were not, unfortunately, among Stuart's best work. William looks almost disdainfully at the viewer, while Anna Maria seems frumpy and misty-eyed, even though Stuart did try to show her love of music through the score she holds and a rather incongruous pipe organ in the background (there were none in Washington at the time).

Stuart was by no means the only painter to seek work in Washington. John Vanderlyn first came in 1803 to do some portraits and to show his large painting of Niagara Falls. Anna Maria and William Thornton, always involved with visiting artists, went next door to the Madisons several times to see Vanderlyn work on a pencil portrait of Dolley. (William took the opportunity to present the Madisons with one of his own paintings—a framed picture of their house on F Street.) Rembrandt Peale and his father, Charles, also came to Washington several times, first to visit with Stuart and then again in 1805 when the son painted Jefferson. Hoping perhaps to duplicate Stuart's success with his portraits of Washington, Peale put his finished picture on public display for those who wanted copies made.

A number of miniaturists also tried their hands in the new and uncertain market, among them William Dunlap, Nicholas Boudet, and the Swiss David Boudon. (Boudon and Boudet had the bad luck to visit almost simultaneously in 1807 and then again in 1810, when the latter felt obliged by the coincidences to take a newspaper advertisement stating rather petulantly that "he is not Mr. Boudon, and Mr. Boudon is not Mr. Boudet.")[8] These itinerant painters would generally take a room in a hotel or boardinghouse, place advertisements in the paper, and stay as long as business was promising. Perhaps the most successful of them was the French émigré and self-taught artist Charles Saint-Mémin, who in addition to some watercolors of visiting Indian chiefs did a brisk business in portraits of the local gentry and their wives. He had perfected a device called a physiognotrace that enabled him to turn out accurate silhouettes of his clients in just a few minutes, enabling him to produce colored portraits, complete with twelve engravings and the plate, for the bargain price of only twenty-five dollars for men, thirty-five dollars for women.

Anna Maria and William Thornton were, once again, clients of the visiting artist, but she was also an interested student: she visited Saint-Mémin's studio on several occasions to study his technique and then tried her own hand at silhouettes. (She had also tried to draw copies of Stuart's portraits of the Madisons but was dissatisfied with her efforts.) Anna Maria also helped her husband on many occasions by making copies of his architectural plans and drawings, but it was William who had aspirations as an artist. He had drawn and painted since he was a student and took great pleasure in the

[8]*National Intelligencer,* 13 Aug. 1810.

work. In her posthumous evaluation of his life, Anna Maria reminisced (while illumi-
nating for us the home-based cultural life of early Washington) that "he frequently
amused himself, by daylight and candle light, in drawing and painting while I read
to him and my mother."[9] Thornton's work, while by no means laudable, was at least
good enough to merit his being complimented as a "painter" by the artist and historian
William Dunlap. He was "a scholar and gentleman," Dunlap would write some years
later, "full of talent and eccentricity—a Quaker by profession, a painter, a poet, a horse-
racer—well acquainted with the mechanical arts—at the head of the Patent Office
a man 'of infinite humor'—humane and generous, yet fond of field sports—his com-
pany is a complete antidote to boredom."[10]

The Thorntons may indeed have been the most artistic of Washington's social lead-
ers at the time, but that was not a hard-won distinction. The residents were simply too
busy to pay much attention to art, other than to commission the sort of portraits that
raised their social standing. Even pictures of local scenes failed to find a market, as
Nicholas King, a skilled draftsman in addition to his talents as surveyor, found out when
he attempted to sell his engravings of the Capitol and the President's House. Nor did
popular art shows attract many customers, if the experience of Reuben Moulthrope,
who brought an exhibit of historical dioramas and wax figures to Georgetown in
1805, is any indication. For fifty cents, his customers could see wax figures of Ameri-
can heroes, dioramas of Napoleon's battles, and be entertained by an "elegant organ,"
yet attendance was apparently so thin that Moulthrope did not come back for almost
ten years.[11]

A few new artists had begun to work locally by 1807, when the young Arlington
landowner George Washington Parke Custis began to paint and New York portraitist
Caleb Boyle came to try his luck. But Custis (and his sister) were amateurs, and Boyle
had few customers (Anna Maria paid a visit to his studio at Gilbert Stuart's old place but
did not buy). It was not a good place for artists. American painters had not yet found
a buying public, and the Washington elites—the landholding families, the struggling
merchants, and the government officials—were simply not rich or interested enough
to patronize local talent.

While the activity, pageantry, and controversy of their government provided a sort
of theatrical background to everyday life in Washington, lovers of the theater like the
Thorntons, Van Nesses, Laws, and Madisons longed for the real thing as well. The in-
crease in the city's literate population was slowly providing an adequate audience and

[9] Anna Maria Thornton, "The Life of Dr. William Thornton," Anna Maria Thornton Papers, Library of
Congress Manuscript Division, reel 7, container 18, n.p.
[10] William Dunlap, *The Art of Design in the United States* (1834; reprint ed., New York, 1969), p. 336.
[11] *National Intelligencer,* 27 Feb. 1805.

gave promise that theater lovers would no longer have to depend on the occasional itinerant road company or drama performances at Georgetown College (one of which Anna Maria had called "intolerably stupid"). Law and Van Ness, in addition, had commercial motives for promoting the arts in their city: more urban amenities, after all, could attract more potential residents, and that would mean increased value for their extensive real estate holdings. Philadelphia's New Theater company, which already toured to Alexandria and Baltimore, was ready to expand to Washington. Opposition from the local clergy was virtually nonexistent. All that was needed, it seemed, was a proper theater.

The city's first theater was cobbled together in Blodgett's Hotel, finally almost finished even if the lottery that had financed it was still caught up in controversy. The huge building's assembly room was hastily converted in August 1800, with an unfinished floor and benches instead of seats, to accommodate a monthlong theater season. The opening was eagerly anticipated. Thomas Law had written a poem to commemorate the occasion and dropped by the Thorntons' house to obtain a qualified critique of his effort (William being absent, Anna Maria noted in her diary, she performed the task). Anna Maria for her part was so intrigued in the prospect of a theater nearby that she walked the mile or so to the hotel to see the preparations. The results, however, were not that exciting, either for patrons or the producers. Law's poem, an overly long sort of prelude to the opening night's play, was apparently as forgettable as the outdated tragedy called *Venice Preserved*. The Thorntons nonetheless went at least four times, including to one play that she thought "altogether very dull." All the same, the weeks of this first theater season were exciting for all concerned, and the Thorntons had so many houseguests for the occasion that at one point they had to surrender their bedroom.

Without a proper theater building, however, no regular season could be organized. For the next few years, the residents once again had to find their amusement in Georgetown student performances or occasional short stands by one visiting group or another. "The celebrated performer from Europe," Mr. Rannie, and his ventriloquist and magic act, appeared in April 1803, and a party of the three Thorntons, Dolley Madison, and her sister Anna Payne went to see him perform. They did not, however, go see *The Feast of Reason,* an olio put on the next month by two members of the Philadelphia company, Mr. Bernard and Mrs. Oldmixon. Then, the following summer, Anna Maria accompanied the Forrests to see a play called *The Soldier's Daughter.* But the choices, it seems, were few.

Moves to create a permanent theater began to take form in 1803. Not surprisingly, the leaders were the local landowners and promoters Daniel Carroll of Duddington, John Van Ness, Thomas Law, and the Brents. Van Ness, who offered a plot of land at

11th and C streets, was soon made chairman of the building committee and began a subscription drive: fifty dollars for a share, two hundred dollars for a lifetime seat. George Hadfield designed the building and the cornerstone was laid in June, but because of slow subscriptions it was not finished until the fall of 1804. And because no arrangement had been negotiated with the Philadelphia company (also known as the Chestnut Street Theater), the new Washington Theater had to open with a variety and magic show put on by a Mr. Maginnes, reputedly from London. The show was no great success. Anna Maria mentioned going but had nothing to say about the performance. After it closed, the theater had no business for almost a year. It was not a good start.

Although the Philadelphia company began to appear regularly in Washington in 1805, its seasons were short and the house dark much of the remaining time. A visitor dismissed it as "a little theater, where an itinerant company repeated, during a part of the year . . . to empty benches."[12] The managers did occasionally find other acts, one of which—the Virginia Company from neighboring Alexandria—actually brought the usually stay-at-home president out for an evening. Jefferson went to see his compatriots perform *A Child of Nature* in November 1806 and returned again the next year to see a rope-walker named Manfredi. He did not, however, attend one of the more dramatic events put on at the theater during his term of office. That was a war dance performance put on by a delegation of Osage Indians, who had been invited to Washington by Lewis and Clark. The theater promoters had promised them a share of the profits and a show that would include a concert and fireworks, and the Indians reportedly enjoyed the occasion so much that they gave a rousing, half-drunken performance.

By 1808, the theater season was well established and the choices a bit greater. The house had plays in both April and September and once again turned over the stage to a war dance by another group of western Indians, whose visits had almost become a regular feature of Washington life. The Thorntons, of course, attended both kinds of performances—and one evening in spring, they went to see the Indians play lacrosse.

But the theater, all the same, was not a great success. The house, and the plays, were adequate, but as the town grew they were just another option for spending an evening, even for buffs like the Thorntons. Anna Maria, for example, writes of an evening when they and the Forrests walked to the theater but decided not to go in—they dropped in on the Tayloes instead. The theater season, unfortunately, was tied to the schedule of the Philadelphia company, which generally meant that it opened in summer when many people were out of town. It did, however, inspire imitation: the first amateur drama society cropped up at about this time. Under the direction of a Mr. Ormsby, a

[12]Charles W. Janson, *The Stranger in America* (1807; reprint ed., New York, 1935), p. 210.

group of "amateur gentlemen of Washington and Georgetown" proposed to put on, "for their amusement," a David Garrick version of one of Shakespeare's plays.[13] Outside of one newspaper advertisement, there is no indication of what may have happened to this group—but the fact that a number of residents found it amusing, and socially acceptable, to practice their thespian skills (or lack of them) is an indication that the town's cultural horizons were expanding, even if slowly.

Periodic visits by the theater company provided still another addition to the Washington cultural scene—orchestras. The theater performances, featuring as they did a number of singing and variety acts, were generally animated by an ensemble of twenty pieces or so. This was a substantial addition to Washington's musical community and had the practical effect of increasing the possibilities for concerts, music lessons, or other musical events—at least during the periods the theater was in town. Washington, of course, had never lacked musicians, amateur, slave, or for hire, but the quality of most of them probably left something to be desired. Public events like the subscription balls or assemblies, the public diners, the dancing schools, the girls' academies, the churches that allowed instrumental accompaniment to hymns—all required musicians. Who provided this music is by and large undocumented, and quite probably a great number of the musicians played only as a part-time job, if not for free.

Slowly, a market for musical talents and supplies was developing, driven by the increase in educated families as well as the number of balls, diplomatic dinner dances, and other entertainments. Bookstores, stationery stores, and even those general merchandise stores that had been selling sheet music, scored paper, or even instruments began to find that they had new competitors who, themselves trained musicians, could deal in instruments and advice as well. One of the first of these was Frederick Wagler, a pianist, who opened shop in 1803, sold instruments at various locations over the years, and also became Washington's main concert pianist. Just a bit later, Philip Mauro, a German musician and language teacher, arrived and opened a studio and shop. He became a good acquaintance of the Thorntons and was a member of the Columbia Reading Society, but he is most notable for attempting to provide Washingtonians with an instrumental concert. Held in February 1805 at McLaughlin's Tavern assembly room in Georgetown with a group of local and visiting musicians, the concert unfortunately was not a financial success; Mauro never attempted one again.

If music-making was pervasive, it was still largely practiced at home. This was a time when well-raised young ladies were expected to have developed musical talents, and some men also played an instrument or sang; musical evenings at home or with company were a feature of educated society. At yet another part of the social scene, the

[13]*National Intelligencer,* 22 Apr. 1808.

laborers on the public works projects or at the Navy Yard undoubtedly had their fiddles or pipes with which they could spend an occasional musical evening. Even in the boardinghouses, fortunate congressmen could enjoy evenings of domestic music. That certainly was the case for Congressman Manasseh Cutler, who found his situation "much more delightful than I had expected," in large part because he was able to enjoy —several times a week—the piano playing of the landlord's daughter Anna King (a great friend, it seems, of Harriet Balch of Georgetown).

Music was very much part of domestic entertainment, and good musicians were appreciated for a number of reasons. Margaret Smith rather cattily described one advantage, arising from a boring evening: "Captain Tingey sings a good song, his wife and daughters accompany him. As not one of these folks [the dinner guests] were either scientific or sentimental, these songs very agreeably supplied the place of conversation."[14] But generally the music was appreciated for its own value, and fine musicians like Anna Maria Thornton, who both sang and played the piano, could contribute to the success of an evening. In addition to the numerous occasions in which she performed for her own guests, she also entertained the president's dinner guests, on one occasion singing to the violin accompaniment of another guest, Judge William Kilty. She also described another occasion, this time a ball at the British minister's, at which the hostess, "disappointed in the music, she and I played on the piano for them to dance."[15]

Washington did, however, have its own professional musicians. Foremost among these was the Marine Band. The band had come to Washington with the government and grew with the city and their role in it. At first a wind ensemble of thirty players, the band gave its first performance in August of 1800, at Camp Hill (also known as Peter's Hill) off 23rd Street—the proposed site of the national university. Their main task was to provide a musical accompaniment to official events, and quite naturally they played at the president's rare public receptions—New Year's and the Fourth of July. At almost every public occasion, the band would perform, and "in their scarlet uniforms, their various instruments, [they] made quite a dazzling appearance." Before long, they were giving regular outdoor concerts for the public, both at the Navy Yard barracks and at Camp Hill. They even, for a short while, performed at Sunday services at the Capitol, but that effort was soon abandoned in light of comments like the following by Margaret Smith: "The musick was as little in union with devotional feelings as the place. . . . The marches they played were good and inspiring, but in their attempts to accompany the psalm-singing of the congregation, they completely failed."[16]

The Marines were not the only band in the city, it seems. Rosalie Calvert described a dancing party at the Tayloe's: "he had two bands of good musicians, one for the

[14]Hunt, *First Forty Years of Washington Society,* p. 18.

[15]Anna Maria Thornton Diary, 11 June 1803 and 1 Mar. 1807, Anna Maria Thornton Papers, reel 1, nos. 233 and 445.

[16]Hunt, *First Forty Years of Washington Society*, p. 14.

dances, the other made up of military instruments, clarinets, kettledrums, etc."[17] The diplomatic missions had their own musicians—probably not bands—although, as we have seen, they were not always up to the mark. It was probably members of the Marine Band, however, who performed in 1805 with a professional flutist called St. Aubin, in a "grand concert" that included works by Mozart and Pleyel, the appearance of an amateur flutist, as well as marches and fireworks.[18] In addition, the newspapers of the early years make occasional mention of an "Italian Band of Music," which, for example, performed with Maginnes when he opened the Washington Theater in 1804.

What made the Marine Band truly ubiquitous was its ability to moonlight. Captain Burrows, the Marine commandant, put no restrictions on the band's off-duty performances, and as a result they played—usually for pay—at events ranging from theater performances, Georgetown College events, the ventriloquist, and even a fencing exhibit. We can probably assume that Marines also composed the military band at Mr. Tayloe's ball. But, in spite of the opportunity to earn dollars on the side, military life and pay was unappealing to professional musicians, and the Marines had difficulty in recruiting good musicians for the band.

Jefferson, himself an accomplished musician, wanted to improve the quality of the band's music. As most of the American fleet was in the Mediterranean to fight the Barbary pirates, he suggested that they might seize the occasion to recruit some Italian musicians. The navy took up the suggestion and soon hired some fifteen Italian musicians from Catania. Signed up for three-year contracts, they at first played aboard navy ships, but when the fleet returned to the United States at the end of the war, they and some of their families were brought to Washington and the Navy Yard. They were not integrated into the regular band, however, but were set up as their own Italian band, under Marine sponsorship. That arrangement did not sit well with the new Marine commandant, who understandably did not like the idea of an autonomous, Italian-speaking Marine unit. By summer of 1806, their contracts were annulled and the band members were given the choice of returning to Italy or signing up as regular Marines. Fortunately for Washingtonians, some of the Italians decided to stay. Among these were the clarinetist Gaetano Carusi, his sons Samuel, Lewis, and Nathaniel, and Venerando Pulizzi—each of whom would in time make a larger contribution to Washington's cultural life.

The Marine Band eventually had company in the field of military music as well. The city's incorporation brought about a need for self-defense, and as militia units in the city multiplied and their musters and banquets became fashionable, they organized their own bands. The Masons, too, liked bands for their public events. The growing variety of local events: theater, balls, receptions, militia muster, and public banquets,

[17]Rosalie Calvert to Marie L. Stier, 24 Mar. 1804, in Calcott, *Mistress of Riversdale*, p. 77.
[18]*National Intelligencer,* 27 Dec. 1805.

meant that the pool of locally available talent—amateurs and part-time musicians—had more opportunity to get engagements and to grow. The quality of the music, on the other hand, might be questioned, in view of the 1808 comment of a visiting Englishman that he had "never heard a band play more wretchedly."[19] And that was directed at the Marine Band! Still, a town with mediocre full-time musicians was a humble but still appreciable step up from a village with none.

[19]Helen Bede Lewis, "The Journal of Alexander Dick in America, 1806–09," master's thesis, University of Virginia, 1984, p. 139.

6

The Dolley Madison Effect

THE THORNTONS' NEXT-DOOR NEIGHBORS, THE MADISONS, WERE MOVING OUT. It was early spring of 1809, almost a dozen years since William and Anna Maria had moved to F Street, and more than seven years since the Madisons had moved into the house that William had prepared for them. Over those years, the neighborhood had changed in many ways. F Street was now graded and graced by many solid brick houses; it and Pennsylvania Avenue were the main axes of the settlement that had grown up in the neighborhood of the President's House. Other clusters of houses had developed around the Capitol, the Navy Yard, and the Potomac riverfront, and movement between the various parts of the city had become more or less routine rather than an adventure. All the same, it was still far from an urban setting—the Thorntons continued to grow grain in the middle of town, on a plot they owned just opposite the Tayloes' house. The days were gone, at least, when the Thorntons' horses would wander off regularly into the nearby woods; now the city—or at least the street grid—was advancing as the woods retreated. Before long, complaints would be raised that the area had been stripped indiscriminately of its trees. But the pace of building was still slow, and real estate prices remained weak.

All the same, the city was growing. By the 1810 census, its 8,200 inhabitants numbered almost double those of Georgetown.[1] Civic improvements were piecemeal, slow to

[1] Washington City's population of 8,208 inhabitants was composed of 5,902 whites, 867 free blacks, and 1,437 slaves, while Georgetown's 4,948 inhabitants were 3,235 whites, 551 free blacks, and 1,162 slaves. The

come, and hampered by a small budget and the continuing rivalry with Georgetown. But the city government, on its limited means, tried to maintain basic public facilities, sanitation, and order, while the leading citizens and landowners tried to foster civic pride, encourage commerce, and prop up real estate values. But they, and all the permanent inhabitants, were fully aware that their emerging civic community was almost totally dependent on government spending, and on maintaining the capital in town.

Which is why the F Street neighbors were not particularly sad to see the Madisons leave. They were, in fact, scarcely leaving, as their new home would be only a few blocks away, in the President's House. The neighbors sensed that their new president and his wife were going to be much more connected to the city than the somewhat distant and now retiring Jefferson. The Madisons had enriched life on F Street—James with his reserved public demeanor but private good humor, Dolley with her sense of theater and the elegant evening entertainments she had hosted. The Thorntons would perhaps miss their old neighbors the most, having been on intimate terms for years. Madison's ascent to the presidency would inevitably create social distance, as Anna Maria realized when she wrote in her diary a few nights before the inauguration ceremony: "Mr. & Mrs. Madison dined with us for the last time I suppose." That was indeed to be the case, and although the Thorntons were to be regular visitors to the President's House over the coming years, the ease of neighborly intercourse was gone. Already that summer, Anna Maria's letters to Dolley (who was spending some weeks at Montpelier) had taken on a tone of formality and reserve. "Dear Mrs. Madison" replaced the earlier "My Dear Friend" as a salutation, and "Yours most affectionately" was dropped entirely as Anna Maria tested the waters of a changed relationship. "I fear my letter may be an intrusion," she began a chatty enough letter, "and indeed not having had any encouragement, verbal or written, to address you I do not know whether I ought to take the liberty to do so, but I feel loath to relinquish all my ancient privileges and pleasures."[2]

If intimate evenings with the Madisons were no longer among the privileges and pleasures, a large part of the matter was because Dolley had definite and ambitious ideas on how to use her new position and the tool of presidential hospitality. Even while she had been doing frequent duty as Jefferson's unofficial hostess, Dolley had sensed that the president's restrained style of entertainment was missing political opportunities. When she and James began to hold receptions on F Street, they had filled

fastest-growing segment of the population was that of the freemen. Alexandria (still a part of the District) had an additional 7,227 inhabitants, and Washington County—the parts of the District of Columbia not included in the first city boundaries—had 2,729.

[2]Anna Maria Thornton Diary, 28 Feb. 1809, Anna Maria Thornton Papers, reel 1, no. 502; Anna Maria Thornton to Dolley Madison, 12 Aug. 1809, in *The Selected Letters of Dolley Payne Madison,* ed. Holly C. Shulman and David B. Mattern (Charlottesville, Va., 2003), p. 122.

a social gap at the time, and their success had helped solidify James's position as Jefferson's logical successor. Now that she was to be the official doyenne of the President's House, she wanted to use the power of hospitality to support her husband by creating a prestigious and glamorous setting that would enhance his image while compensating in part for his distinct lack of charisma. Moreover, she loved a good party. And Washington, a city still without a social or cultural center, needed a good gathering place.

The change was evident as early as inauguration day. That evening, Washington experienced its first inaugural ball. Held at Long's Hotel on Capitol Hill, the event was arranged in honor of the popular new presidential couple by a committee of Washington's notables, among whom were Captain Tingey, John Van Ness, Daniel Carroll of Duddington, John Tayloe, William Brent, and Thomas Law's son John (but not William Thornton). The event was not to be a *levée* or European-style formal reception such as had been the style of the first presidents in Philadelphia—that was too monarchical for the republican president—nor was it to be a *pêle-mêle,* the sort of protocol-free format that Jefferson had tried briefly to introduce. It would be a party, a simple yet dignified affair at which republican virtues would be displayed, married firmly to presidential and national prestige. The committee had no problem selling its four-dollar tickets, and more than four hundred persons crowded into the hotel assembly rooms. The crush was great. The Marine Band, of course, played while the guests danced the new-fangled waltz and enjoyed a solid dinner.

The tone of the event, however, was set by the guests of honor: the new president dressed in his usual somber clothes, Dolley Madison in a rich velvet gown, adorned simply with pearls and her signature turban. Gold braid, diamonds, and lavish display were left to the attending diplomats; the Madisons wished to provide a model of elegant, republican simplicity. It was a great success. Mrs. Madison's grace, charm, and natural conviviality assured that result—even if a number of the participants missed the point by terming her performance as "regal." For Washingtonians, moreover, there was another message from the ball: that the official social climate was to be a much more inclusive one, in which permanent residents, government officials, diplomats, visitors, and office seekers would be welcome to mix, expand their common interests, and help build a community.

The model established at the inaugural ball would shortly become routine at the President's House. Furnished rather indifferently during the Jefferson years by miscellaneous pieces from Monticello, the public rooms at the "mansion" were redecorated that spring with silks, damasks, mirrors, and new furniture, producing a stunningly elegant setting. As soon as the rooms were ready, the Madisons began to entertain regularly. Their Wednesday open house became known as "Dolley Madison's drawing room," an event open to all respectable residents of Washington as well as suitably

introduced outsiders. Immediately popular, the events were so well attended that they also become known as "Mrs. Madison's squeeze." A perceptive British visitor commented that "in a place like Washington, where there are Scarcely any Public places at all, such a meeting seems to be much relished."[3] Indeed, the events gave to Washingtonians a prestigious gathering place, a locale at which they could exchange information, opinion, and gossip, meet newcomers, and even (importantly, as the number of resident families increased) introduce their young daughters to society. Protocol was minimal, much to the distaste of some European diplomats, who found offense in the presence of tradesmen with mud-caked boots. There was no reception line, and attendees—male and female—moved about much as in a modern cocktail party, entertained by each other, the Marine Band, or occasionally a musical performance by one of the guests (including Anna Maria Thornton). But the center of attraction was always the vivacious and gracious hostess, whose open hospitality and welcoming attitude toward new persons and ideas soon put her "drawing rooms" at the center of the cultural as well as social life of the city.

The Madisons had been assisted in redecorating the public rooms by B. Henry Latrobe, whose wife, Mary Hazelhurst, was also an old friend from the Philadelphia Quaker community in which Dolley had grown up. The collaboration between Latrobe and Mrs. Madison was both broad and productive. It must, however, have been galling to Dolley's old neighbor Dr. Thornton (already resentful as he was over Latrobe's criticism about the Capitol design) to see his rival so involved with the president's business. Adding to the tension between them was the libel suit brought by Latrobe, a point of constant irritation to both men and of financial anxiety for Thornton. All the same, it was a small town; the two architects saw each other frequently and of necessity remained on coldly polite terms. Latrobe continued as an investor in Thornton's North Carolina gold mine scheme, and the two were even obliged to cooperate during the 1810 move of the Patent Office. (The government had bought Blodgett's failed hotel as additional office space, including for the Patent Office, and supervisor of works Latrobe claimed that he bent over backward to meet his touchy competitor's requirements during the reconstruction and move.)

The Thornton-Latrobe lawsuit finally came to a conclusion in June 1813. It had dragged on because Thornton's lawyer, Francis Scott Key, apparently thought his client had a bad case and had employed delaying tactics as long as possible. He was evidently right, as the judgment upheld Latrobe's charges of libel. But Latrobe, constantly in economic difficulties himself, was not vindictive against his old adversary. Understanding that Thornton's poor financial situation contributed to his erratic behavior, Latrobe

[3]Helen Bede Lewis, "The Journal of Alexander Dick in America, 1806–09," master's thesis, University of Virginia, 1984, p. 392.

instructed his lawyer, John Law, not to seek damages. When the court awarded him symbolic damages of only one cent, Anna Maria Thornton confided her relief to her diary: "One cent damages award given to Latrobe, instead of $10,000," she wrote.[4]

Outside of his perennially bad financial situation, Thornton was at the top of his form, active and engaged both socially and professionally. He and Anna Maria remained firmly in the first circle of society, ubiquitous at events of importance, friendly with the key diplomats, and on even footing with both Republicans and Federalists. They entertained grandly on occasion, but everybody understood that they were no longer rich (even though they had been able to buy the F Street house cheaply when Samuel Blodgett went bankrupt). William performed his civic duties: over the years he organized the first city market, served his turns as justice of the peace, was on the levy tax board, and even took a commission in the militia in spite of his Quaker background. But he did not participate actively in the city's politics—nor, it appears, was he a significant contributor, either in time or money, to the various benevolent or other organizations that were beginning to spring up.

His noninvolvement in local charities did not mean that Thornton had lost his idealism. He chose to direct it, instead, to more universal goals. (One exception was the very local case of Madame Turreau, the battered and maltreated wife of the French minister, whom Thornton assisted both officially and privately.)[5] William's republican sentiments were particularly stirred by the emerging struggle for independence of the South and Central American colonies of Spain. By 1810, he had become a point of contact in Washington for "patriots"—the Spanish minister, of course, called them traitors —from the various rebellions that were under way or germinating in the south. His main assistance to the revolutionaries, it seems, was in the form of hospitality and introductions; his political credentials were not strong enough to lobby effectively for them, and his position as an employee of the secretary of state would have created a conflict in any event. Never one to hide his feelings, however, he was well known in town as an enthusiast for the republican cause. He also continued to propound the idea of resettling freed slaves in Africa, even though he could not afford to release his own slaves, either in Washington or Tortola, from their bondage. His principles on this issue conflicted with economic reality in an uneasy stalemate, leading Anna Maria to comment rather acidly that he had refused sell his share of the plantation in Tortola

[4] Latrobe had written to his friend Joshua Gilpin on 28 May 1808 that Thornton "has miserably fallen in public estimation of late; but I think the worst that can be said of him is that he is a Madman *from vanity,* incorrect impecuniary conduct, and official intrigue from Poverty." In *The Papers of Benjamin Henry Latrobe,* ed. Edward C. Carter (New Haven, Conn., 1984), 2:268. Anna Maria Thornton Diary, 24 June 1813, Anna Maria Thornton Papers, reel 1, no. 643.

[5] The Turreaus' domestic fights were a local scandal. Thornton had to intervene, as justice of the peace, when General Turreau tried to have his wife forcibly sent back to France. Subsequently, Thornton led a drive to raise money to purchase her return passage.

because "he will not give up the almost impracticable scheme of freeing the negroes" as part of the transaction.[6]

Thornton's work at the Patent Office was engaging, intellectually and physically; Anna Maria's diary notes the frequent occasions on which he was detained at the office or worked at home. The move to new quarters in Blodgett's old hotel gave him a decent office as well as space to display the many working models required with patent applications. The office was increasingly busy, the flood of patent applications was bringing in money to the Treasury, and William nursed hopes for an increase in salary. Rather typically, however, one of his major projects as director mixed his private interests with the public business: he was determined to protect and capitalize on the steamboat inventions that he and John Fitch had developed some twenty years earlier. The potential competitors were numerous, but the most advanced was Robert Fulton, who unfortunately for Thornton also had powerful supporters such as Robert Livingston of New York, Joel Barlow, B. Henry Latrobe, and James Monroe. Thornton had tried a number of times since 1807 to convince Fulton that his and Fitch's inventions had precedence, but Fulton, with his powerful backing, was pushing forward to commercialize the steamboat and was not deterred by Thornton's technical presentations on patent precedence. Thus when Fulton applied for a steamboat patent in early 1807, Thornton promptly denied it—involving himself in yet another imbroglio out of a combination of pride and economic need.

Thornton's many activities continued to include designing houses for his friends and colleagues. One of his enduring monuments—a manor house for his friends Thomas and Martha Custis Peter—was on his drafting board as early as 1805.[7] The building project developed slowly, so that the house and its elegant, glass-walled reception room was not finished until 1816. Known as Tudor Place, it continues to be one of the architectural gems of Georgetown. Anna Maria's diary shows that William was also busy drawing up plans for other houses in 1811 and 1812, although she doesn't mention for whom he was doing the favors. While it is unclear if any of those projects were actually built, it is clear that William's friends felt at liberty to ask him for free advice, for which he, ever the gentleman (even if a rather impecunious one), never charged.

The Thorntons' close friends were from the first circle of genteel society, a relatively small group of families who saw each other regularly and shared an appreciation of education, culture, and social values—if not always political opinions. That group was slowly broadening as more senior officials and their families chose to reside in the capi-

[6]Anna Maria Thornton Diary, July 1820, W. Thornton Papers, Library of Congress Manuscript Division, vol. 7, container 20, n.p.

[7]Latrobe hinted in his correspondence that he may have been asked to design the house, but that Peter preferred to accept Thornton's free services rather than pay the normal fee of 2.5 percent. Carter, *Latrobe Papers,* 3:983.

tal city; the periodic influx of congressmen of course completed its ranks. At the same time, the growth of government had also brought in more junior government clerks, many of whom aspired to the first circle and were—the space being available—generally admitted to its fringes. But the city's respectable society—those who set the tone and were the potential audience for the emerging cultural amenities—also included two other groups. One consisted of the merchants and businessmen who provided the city's services and much of the municipal government; the other was a marginal but growing group of politicians, office seekers, and other operators who chose to settle near the seat of power. Finally, a much larger number of tradesmen, laborers, and slaves filled out the city's population, but their role in the social and cultural development of the city and its institutions was marginal.

Physically, the city these groups called home was slowly knitting together, although to outsiders it still appeared to be a formless straggle. Even newcomers were discouraged at first by the distances involved; the new comptroller of the Treasury (and subsequently attorney general) Richard Rush groused in 1812 about the "extraordinary inconveniences of the place . . . the difficulties of keeping up much intercourse with others, scattered and remote as they all are."[8] But Philadelphian Rush's grumbling aside, getting around the capital city had definitely become easier. Hackney cabs were readily available, though of course the residents complained about prices and service. And the roads had improved. Georgetown was easily reachable by horse, cab, or carriage, and even Alexandria became more accessible after 1809 when the "long bridge" directly over the Potomac eliminated the detour through Georgetown. The scattered hamlets of the Potomac plain were gradually coming together as a functioning, if diffused, town.

The pace of life for its inhabitants was slow, leaving time and appetite for social or cultural pursuits. Office hours for the men were reasonable, and they generally were home by three or four o'clock for dinner. The women, on the other hand, used the middle part of the day for shopping or to call on each other in an endless round of sociability. Free evenings were enjoyed at home or informally at teas with friends, where cards, musical evenings, and conversation were the staple pastimes. The October to May social season continued to be ushered in by the horse races, in which Dr. Thornton took enthusiastic part, even if his racehorses continued to be a financial drain. Once Congress convened, the social swirl—receptions, assemblies, patriotic events, diplomatic dinner dances, and formal balls—involved first circle as well as selected other residents in a steady stream of events, often involving different slices of the community.

[8]Richard Rush to Charles Ingersoll, 21 Mar. 1812, Richard Rush Papers, Library of Congress Manuscript Division, no. 263. As Rush's wife Catherine was the sister of Mrs. John Mason, the couple must have frequently visited the Mason summer home at Analostan Island, opposite Georgetown—an inconvenient distance it seems from their house near the president's.

Much of the town's business, it seems, was conducted informally at these various occasions, and the genius of Dolley Madison's new weekly drawing room was that it brought together all the active elements of this still developing community in one locale, where a sense of civic togetherness might emerge.

The fact that the President's House had become a sort of assembly point for the town's elite was, however, also a sign that local civic and cultural institutions remained primitive. The federal government and its business were still the pivot of local business, society, and intellectual activity. The town lived on politics. The flow of government expenditure had kept the local economy largely insulated from the cutoff of trade caused by the 1807 embargo and the war in Europe, and now, as the country stumbled into and through the first years of the War of 1812, the role of government loomed ever larger. National politics and national patriotism overshadowed local events. American victories were celebrated, while defeats were brushed aside as if keeping up the social swirl was vital to the war effort. A late 1812 event (which the Thorntons did not attend) may illustrate some of the flavor of the times:

> In my last I mentioned to you that some of us had subscribed for a ball in compliment to our naval heroes. It was held on Tuesday night, at Tomlinsons [Hotel]. The company and doings were such as you have often witnessed here. The rooms, lights, music, ladies, and every thing else, were pretty much as usual. Not more than about fifteen members of Congress were present. There were however, two or three occurrences which made the exhibition more remarkable than common. Lieutenant Hamilton arrived in the midst of the dance, bearing the intelligence of the capture of the British frigate *Macedonian* by Captain Decatur, and bringing with him the flag of that ship as a trophy of the victory. Mirth and jollity were suspended, and changed into the glow of patriotism and the rapture of applause. Cheers of welcome were reiterated, Yankee Doodle was played, the colors were exhibited, and finally laid on the floor at the feet of Mrs. Madison. The Secretary of the Navy took them up, and from him I bore them to the side of the room that Madame Bonaparte, Mrs. Hay, and others might examine them.[9]

In addition to the patriotic assembly, one other local cultural institution that had reached a certain level of maturity was the theater. The Thorntons, like their old neighbors the Madisons, continued to be enthusiastic playgoers. The summer theater season had become a regular fixture of the town's cultural life, as well as providing a sort of extension of the social season, offering animation and evening entertainment for Washington's residents after Congress had recessed and the major round of balls and receptions was over. The Philadelphia company presented a broad repertoire, even

[9]Samuel Mitchill to Catherine Mitchill, 10 Dec. 1812, *Harper's New Monthly Magazine*, 58 (April 1879).

if heavily weighted toward light comedies and musical numbers. The 1809 season, for example, ran from June 13 to August 7, during which time the company played twenty times, repeating a performance only once, when the final night was sold out and an encore performance was laid on. The show was usually in two parts: an opening play (often abridged) and a closing musical, comic opera, or song and dance number. It was light stuff: only three tragedies were shown that season, and the comedies (with titles such as *The Village Lawyer* or *The School for Reform—How to Rule a Husband*) were pretty much the contemporary version of today's television sitcoms. The only plays staged that year that have stood the test of time are Shakespeare's *Romeo and Juliet* and Sheridan's *A School for Scandal* (though the latter was withdrawn from the 1812 Washington playlist as too delicate for local taste). To make the performances even more frothy, short farces and musical numbers were often staged around the intermission. Patriotic numbers were often prepared for July 4, and on occasion the performances became a sort of local talent night, as when a local bagpiper was invited to play a Scottish reel. Not surprisingly, the theater drew a very mixed crowd—it was by no means a first-circle-only venue. The place was noisy and dirty, the crowd in the galleries were often salacious, and theater evenings were often marred by drunken disturbances. Although Washington residents might occasionally join the visitors in complaining about the atmosphere—Anna Maria described the July 4 performance in 1811 as "very hot, riotous and disagreeable"—they were glad enough to have the theater.

Unfortunately, the theater was more of a social success than a financial one. Not only was the season short, it was also during the hot weather, with the result that the house was rarely full. Occasionally, the Philadelphia or another company would put on a performance outside of the regular season; there were at least two such shows in autumn of 1809. And in 1810, *A Child of Feeling,* a play by Washington's own George Watterson, was performed at the theater. But most of the year the house was dark, and the Philadelphia company in general just broke even during its stay in Washington. And once the War of 1812 brought the threat of a British Navy raid into the picture, attendance fell still more. The few independent performers who did try their luck in the city were usually booked by the hotels, but the choice—as measured by events advertised in the papers—was not impressive. The Thorntons, always drawn to whatever was available in the performing arts, seem to have attended very few events outside of the theater season. Anna Maria's diary between 1809 and 1814 mentions attending only a "phantasmogoria" (which apparently was a set of allegorical and historical tableaux with musical accompaniment), and a "Pantamonion" (a sort of harlequinade), in addition to an equestrian show. The latter became a more or less permanent fixture: a "circus" that was set up right opposite the theater, with a show that was reportedly quite good.

Occasional visiting singers generally performed at one of the hotels, and Anna Maria's 1810 diary notes, without further details, that her husband went to a "concert." That was not, apparently, one of the concerts put on by a new addition to the Washington musical community, a Mr. DeRonceray. Previously a member of the Philadelphia theater company's violin section, DeRonceray had settled in the city in 1811 to take up a living as a music teacher—he gave lessons on the piano, clarinet, and violin. But his major contribution to the general public was to put together several concert performances at Long's and other hotels. He featured both "concert" and "city" bands (the latter presumably being one of the militia bands) and probably mixed popular pieces with symphonic music, though the program was not advertised. On the lighter side was a Mr. Pucci—a harpist reputedly "from the Italian opera house in Lisbon"—who during his several-year stay in the city gave performances at private homes and embassies, as well as with the theater orchestra. Just the same, it appears that there was a limited audience for concert performances of classical music. Chamber music continued to be played at home, of course, as attested by the fact that music stores advertised their stock of scores by Mozart, Haydn, and Beethoven. Events that incorporated music were increasingly frequent and included the theater, the circus, patriotic assemblies, the Marine Band's summer open-air performances, balls and assemblies, diplomatic and government receptions, and churches, where organs and other instruments now allowed the hosting of occasional concerts.

The hotels were also where those artists who came to Washington on business set up studios and tried to attract customers. Very few American artists, it seems, found it worth their while, and the majority of these itinerant painters and sculptors seem to have been Europeans of no particular reputation or skill. A few traveling exhibitions appeared, such as a panorama of the major cities and ports of America painted by a Mr. Esteps (shown, however, in a rented house), or Moulthrope's waxworks, which boldly returned to town in May 1814 even as the British navy was coming up the Chesapeake. An unfortunate Mr. Grain of the theater company had the bad luck to exhibit his paintings of U.S. naval victories at Lake Erie, just two weeks before the British occupied Washington; his viewers presumably were few. It was still a town not much interested in art, as can be seen by Caleb Boyle's 1811 effort to test the appetite for an art museum. Attempting to turn Gilbert Stuart's old studio into a permanent exhibit of portraits and natural science curiosities (similar to Peale's museum in Philadelphia), and grandly calling it the National Museum, Boyle unfortunately found very few customers. He closed up after just a few weeks.

The hotels were also used for a new (but now familiar) Washington institution, the charity ball. In May of 1810, for example, a ball was held at the Union Tavern (also known as Crawford's) in Georgetown for the benefit of the Ladies' Society for the

Relief of Indigent Women and Children. It was probably not the first event of this kind but very likely was successful, as it was directed by the well-known dancing and music instructor P. L. Duport and promoted by some of the town's leading booksellers.

While Watterson's play and two of his poems ("A Wanderer in Jamaica" and "Scenes of Youth") were the only works created by a Washington writer during the period, the town's residents were all the same great consumers of prose and oratory. The debates in Congress, the proceedings of the Supreme Court, and the homilies of the town's preachers were attended carefully and commented on regularly. Good oratory was as valued as good writing, and memorable discourses—such as Joel Barlow's July 4 orations—were published. (Not all found the oratory good, however; one Federalist congressman grumbled that speeches by his Republican adversaries "would have done no honor to a Sophomore at College.")[10]

When Washington Irving came to town for a short visit in early 1811, he had nothing to say about the literary climate in the city. Nonetheless, plunging into a hectic social routine, he found an intriguing intellectual climate. Noting that he had met "the most complete medley of characters I ever mingled amongst," he told a friend that "at all the parties you meet with so many intelligent people that your mind is continually and delightfully exercised," with "company suitable to every varying mood of mind— and men capable of conversing and giving you information on anything you wish to be informed."[11] But apparently he met no other authors.

Nonetheless, literary options in the new town slowly expanded. William Cooper opened a new bookstore on Pennsylvania Avenue in 1810, from which he sold music and instruments as well as the printed word. And even though the Columbian Library in Georgetown finally failed, the Anacostia Library continued in operation, and a new and better-backed lending library opened. The Washington Library Company was established in 1811, at first in a private home and the following year at Pennsylvania Avenue and 13th Street. With the backing of many leading citizens—Rev. James Laurie, Father William Matthews, Samuel H. Smith (who had sold the *National Intelligencer* to Joseph Gales and William Seaton), Joel Barlow, Mayor Robert Brent, the physician and future mayor James Blake, Thomas Munroe, Judge William Cranch, and John Law (Thomas Law's son), among others—the subscriptions sold well enough to create a sizable inventory. It would replace Joel Barlow's library as the best private library in the city, when the latter had to be broken up following Barlow's tragic death in 1812.[12] Unfortunately, however, there was no regular place where residents with literary

[10]Abijah to Hannah Bigelow, 5 Jan. 1812, in "Letters of Abijah Bigelow, Member of Congress, to His Wife, 1810–1815," *Proceedings of the American Antiquarian Society* 40, no. 2 (1930):305.

[11]Washington Irving, *Letters to Henry Brevoort,* ed. George Helman (New York, 1918), pp. 29, 32.

[12]Barlow was appointed by Madison as minister to France and died in Poland while following Napoleon on his eastern campaigns.

interests could gather. A "Literary Club," about which nothing is known beyond its name, had met in Long's Hotel before the Library Company was founded. But the Library Company apparently had no reading room, and no place emerged to fill the role of a literary coffeehouse.

Literary exchange, all the same, was part of the cultural life of the city. William Seaton, one of the new owners of the *Intelligencer,* described a presidential dinner in 1812 as involving conversation on "books, men and manners, literature in general, and many special branches of knowledge."[13] Books and commentaries on them circulated regularly, and a number of literary discussion groups surely existed beyond those documented in the newspapers. Among the educated, letter writing was an art as well as a constant social tool, while a number of residents tried their hand at more serious writing as well. Margaret Smith continued to write under pseudonyms for women's journals such as the *Ladies' Magazine,* William Cranch penned legal commentaries and translated law texts, while William Thornton apparently tried his hand at several novels, the unpublished manuscript remains of which lie (suitably ignored) in his papers.

Following a tradition of belles lettres, not a few residents tried their hands at poetry, or at least versifying. Thomas Law's long poems were prolific if not very good, and William and Anna Maria made the occasional effort at serious poetry, while more often jotting off notes in verse to their acquaintances and each other. Some of William's quick efforts demonstrate his whimsical character, if not necessarily his good judgment in choosing when to versify. For example, he wrote a totally inappropriate and flippant verse to the court trying the Latrobe libel case in 1804, and in 1810 dashed off the following note to the attorney general, urging him to help fund work on the Capitol:

> The genius of Columbia is at a stand,
> And calls on you to wave your magic wand
> Oh not be afraid
> On parchment to aid
> With a bold and a dashing hand.

More amusing, and perhaps marginally more appropriate, is a pass Thornton wrote for his slave Peter, who was transporting some animals to Virginia:

> Pray let the bearer, Peter, Pass;
> He rides a horse, and leads an Ass;
> This is the Vicar, famed, of Bray;

[13]Josephine Seaton, *William Winston Seaton of the National Intelligencer* (1871; reprint ed., New York, 1970), p. 85.

Who goes to Mr. Brent's to stay.
To Peter: If anyone you chance to meet;
Stay not to talk, but pass and greet;
And neither give nor take a treat.[14]

If literature was not exactly flourishing in Washington, at least applied agricultural sciences were—under the pressure of necessity. First the embargo, and then the threat of war with Britain—followed by the actuality—had shown Americans exactly how dependent they were on foreign manufactured goods. Consequently, interest grew in Washington and elsewhere for steps to promote domestic production and manufacture, particularly of fabrics. Raising merino sheep had already been a fashion among gentlemen farmers for a number of years (Dr. Thornton himself had several hundred head), and George Washington Custis's springtime sheepshearing party in Arlington had become a fixture of the year, combining agricultural promotion with a good party and a dash of patriotism (one of the tents used for the party had previously been used by President Washington to take Cornwallis's surrender).[15] In 1809, Custis and a number of other leading citizens decided to create a more formal and serious organization, the Columbian Agricultural Society for the Promotion of Rural and Domestic Economy. Backed by sponsors such as John Mason, Thomas Peter, Joseph Nourse, Robert Brent, William Cranch, and Charles Carroll, the organization held two well-attended fairs a year, at which prizes were awarded for the best animals as well as the best products in wool, linen, and cotton. The organization's secretary was David Wiley of the Columbian Academy, who soon launched another new enterprise as well: he began to publish a periodical called the *Agricultural Museum,* the first American paper devoted exclusively to agriculture.

Wiley was a tinkerer and practitioner of the sciences he taught at the academy. Charles Peale Polk's portrait shows Wiley posing proudly with an "electric machine," which appears to incorporate some of his own design innovations. He also was an amateur astronomer and encouraged his friends to share his enthusiasm for space: Joseph Nourse once wrote to his absent wife that he had spent an interesting evening observing Jupiter with Wiley, who had loaned him his telescope.[16] Observations that Wiley made in 1804 would later be part of the basis for an attempt to establish a national

[14]Thornton to Caesar Rodney, 28 June 1810, W. Lloyd Wright Collection, George Washington University Gellman Library; W. Thornton Papers, Library of Congress Manuscript Division, vol. 2, no. 554.
[15]The tent still exists as part of the museum exhibit at Yorktown National Park.
[16]Joseph to Mary Nourse, 4 Aug. 1804, Nourse Family Papers, University of Virginia Library, Special Collections. Wiley, the scientist, may have been more enthusiastic than the very devout and serious Nourse, who added, "but curiosity is over, and it [the telescope] may lie locked up some days before it is renewed."

meridian at the capital, but Wiley unfortunately would not be around to take part in that effort. Having added the job of Georgetown mayor to his other activities, Wiley passed away in 1812. The *Agricultural Museum* died with him.

Wiley's Columbian Academy, it seems, also went out of business at about the same time. Rev. Stephen Bloomer Balch, who was the academy's founder, shifted his interest to the newly incorporated Georgetown Lancastrian School, whose sponsors also included Henry Foxall and Francis Scott Key. Both it and the Washington Lancastrian school enjoyed a few years of relative success in expanding the educational opportunities for children of the city's less well-off. At the same time, Georgetown College was entering a new period of growth under Jesuit administration and an energetic new president, Giovanni Grassi. Appointed in 1810, Grassi brought a renewed sense of community involvement to the school. With a less rigid Catholic approach, lower tuition rates, and an active recruiting campaign, the school once again became attractive to students from outside the immediate vicinity. In addition, Grassi, himself a scientist and scholar, encouraged a broader curriculum for his students and faculty and their active involvement in the local intellectual community.

Washington was still, however, bereft of scientific establishments other than the Patent Office. And that office, as well as its director, Dr. Thornton, were so swamped with the growing number of patent applications that there was no time for innovation or education. By 1811, Thornton had finally won approval for a clerk to help him in his work but no raise in pay for himself. He was beginning to feel frustrated in his job.

Moreover, Thornton's dispute with Robert Fulton was beginning to cause him difficulty with his superiors. Fulton came to Washington again in 1811 to push his ideas for naval torpedoes, and once again he demonstrated his innovations to the government's leaders. He and Thornton had corresponded or met several times in an effort to settle their differences over the patenting of steamboat technology, and Thornton had intimated that he would drop his objections if Fulton let him in as a partner in his new operations. Fulton at one point even offered to buy out Fitch and Thornton's interests if they could build a boat that could go six miles an hour (a test the prototypes had more than passed many years earlier).[17] All efforts at conciliation or compromise, however, failed, and in reaction Fulton complained to his well-placed friends about Thornton's somewhat discretionary manner in running the patent system. He demanded Thornton's removal or, at a minimum, a regulation that would have prohibited the director from having any personal interest in patent issues. While this might seem today to be a reasonable step to limit conflict of interest, few such rules existed at the time and Thornton fought back. He had been selected for the position, he pointed out, exactly

[17]Thompson Westcott, *The Life of John Fitch* (Philadelphia, 1857), chap. 17. Accessed at University of Rochester, *Steam Engine Library,* http://www.history.rochester.edu/steam/westcott.

because of his technical and mechanical competence; why should he be the only citizen disbarred from filing for patents?

Thornton's real problem in this dispute, however, was not in the logic of his case. He won the actual skirmish; the proposed new regulation was not implemented and he would continue to take out patents until a year before his death. The more serious problem instead was political and personal. Fulton's friends and supporters included James Monroe, who had recently been appointed secretary of state and thus was Thornton's new boss. It was Monroe, in fact, who had actually drafted the new regulation. The relationship between the two men, which had never been warm, became all but frigid as a result of the steamboat patent dispute. Over the coming years, it would be costly to Thornton. And on a broader scale, Thornton's eccentricity, and his all too evident tendency to get into vituperative public spats with his adversaries—first Hallet and Hadfield, then Latrobe, and now Fulton—also had a growing cost. Already, his importance as a leading citizen had been watered down as the town grew. But now, beginning with Latrobe's victory in the libel case, the respect in which Thornton had been held by the early Washington community also began slowly to diminish. A local wag, it is said, poked fun at the doctor with a stinging couplet: "With his horses unfed, he loses his races / With his lawyers unfed, he loses his cases."[18]

[18]Quoted in Wilhelmus Bogart Bryan, "Dreamers as Capital City Builders," *Columbia Historical Society Records* 40–41 (1940):58.

7

Phoenix

IN THE LATE SUMMER OF 1814, THE WAR TRULY ARRIVED IN WASHINGTON. A British invasion force brushed aside the feckless American militia at Bladensburg, occupied the city for three days in late August, and burned the public buildings. The Capitol and the president's mansion were gutted; the magnificent new Hall of Congress and Latrobe's decorations at the mansion reduced to ashes and heat-crazed stone. The Treasury and War Department buildings were destroyed, though fortunately the records and much equipment had been evacuated or hidden. The arsenal at Greenleaf's Point had been blown up, while the Navy Yard, including ships at anchor and under construction, had been torched by Captain Tingey himself to keep it out of enemy hands. Of the public buildings, only Blodgett's Hotel had escaped the flames.

The humiliation was huge, the blow to national pride serious.

Fortunately for the town's property holders, however, the British occupiers had largely kept to their instructions—private property was not to be destroyed. The residential areas of the city as a result were largely undamaged—even most of the homes, hotels, and taverns around the Navy Yard inferno were saved by the citizens' energetic action. A few exceptions, of course, took place. George Washington's twin houses on Capitol Hill were cheerfully put to the torch by the British, who also systematically dismantled the offices, presses, and building of the *National Intelligencer,* as a sort of payback for the paper's vilification of the British leaders. The building, however, was

not put to the torch, because the neighbors convinced the British soldiers that their own houses would go up as well.

It was William Thornton who saved Blodgett's Hotel, and of course his Patent Office. Having evacuated most of the files to the refuge of his Bethesda farm on the night the British arrived, he rode back to town the following morning just in time to find a British army detachment on the verge of setting fire to the building. He pleaded successfully with Major Walker, the officer in charge, that the office housed the records of private, not public, inventions, which were moreover a part of the common heritage. The major called off his troops, and the building was spared.

In the general catastrophe, however, Thornton was accorded little credit for his action at Blodgett's Hotel and his subsequent efforts to restore order. More attention seems to have been paid to the tiff that soon developed between himself and Mayor James Blake, who seemed to believe that Thornton had charged him with cowardice for fleeing the city. Blake countered with insinuations that Thornton had been too friendly with the occupiers and overly lenient toward British prisoners. Whatever the facts behind the public exchanges may have been, the spat did little to revive Thornton's slipping reputation. He no longer enjoyed the status of a key official, while his Federalist social ties and his air of a British gentleman left him a bit out of step with the hyperpatriotic Washington mood. Moreover, it seems that he was seen increasingly as a quarrelsome gadfly rather than a man of influence.

For Washington's permanent residents like the Thorntons, the city's crisis had still another, and most ominous, dimension. The ashes had scarcely cooled before Philadelphia, and other cities that had always begrudged the transfer of the capital, began a campaign to recall the government from the wilderness on the Potomac. The fate of the city hung in the balance.

The government and the citizens rallied to meet the crisis. The Madisons' triumphant return lifted all hearts, and when the Tayloes offered their house as a temporary presidential mansion, the government went back to work. Evacuated records and clerks reappeared from the various places where they had taken refuge, and operations resumed wherever quarters could be found. Blodgett's Hotel was quickly taken over by the displaced government offices, as well as by Congress, which met there just a month after the fire. (Thornton's thanks for having saved the building was a summary request to move out.) Congress's first order of business was to decide on the fate of the capital, and debate on the subject was heated. But it was surprisingly short. Aided somewhat by a promise by local banks to lend money for the necessary reconstruction, Congress agreed in principle by late October that the capital would remain in Washington. The residents could breathe a sigh of relief.

But the debate about what kind of a capital city was by no means over. All the arguments of a generation earlier were brought up again: should the public buildings be rebuilt as they were or replaced by smaller and more modest ones, and if so, where should those be located? While the debate was heated, it was in the final analysis a tempest in a teapot. Reassured by news of the great American victory at New Orleans and the impending success of peace talks, Congress in the end voted impressively for a return to the status quo ante. In late February 1815, it agreed to finance the rebuilding of the Capitol and the president's mansion through bank loans. Thomas Law voiced the sense of relief that filled the city when he wrote to his niece in England, "motions to remove the seat of Government threaten[ed] me with ruin at length Congress voted $500,000 to rebuild and repair the public edifices, and next came the joyful tidings of peace . . . the sun shines to brighten the evening of my days."[1] Restoring the national monuments, and the wounded confidence of the city, could finally begin.

In charge of the effort, Madison appointed a committee of local dignitaries: John Van Ness, Tench Ringgold, and Virginian ex-congressman Richard Bland Lee. James Hoban and B. Henry Latrobe were engaged to oversee the work at the mansion and the Capitol, respectively. (Thornton tried to get into the process, as well, by urging that the House chamber should be rebuilt according to his original elliptical plan rather than Latrobe's semicircle, but his interventions were once again ignored.) Meanwhile, local investors, anxious that Congress remain in a friendly mood (and that the value of their real estate holdings not be further depressed) offered to provide a more suitable building while the Capitol was being rebuilt. Located on the site of today's Supreme Court, the building was financed by John Van Ness, Thomas Law, Richard Lee, and Daniel Carroll of Duddington and called the Brick Capitol. It would remain the seat of Congress from late 1815 through 1819, while Latrobe, and then his successor Charles Bulfinch, struggled to complete the Capitol and manage the usual design, money, and supply issues that bedeviled that project.

Following the congressional action, Washingtonians could look forward optimistically. The site of their city as the national capital would never again be seriously questioned, and rebuilding would begin in spring of 1815. Work on the public buildings, and of course the government payroll, would feed the economy, while the importance of the city would surely grow as the country and its government expanded into the western territories. The town's residents at last could feel confident. They were ready to invest, both morally and monetarily, in creating the institutions that their city still lacked. The next few years saw an impressive flurry of civic activity, which was only

[1] T. Law to Maria, Lady Temple, 15 May 1815, Thomas Law Papers, University of Virginia Library Special Collections. Law's optimism was such that he bought a 250-acre farm and invested in still more real estate, assuming that prices would rise. He was wrong, however, and by the time of his death in 1834 had essentially run through his fortune.

reinforced when in 1817 James Monroe ascended to the presidency in a calm political atmosphere that ushered in an era of good feelings. Paradoxically, then, the burning of Washington was the impetus not only to reconstruction but also to the birth of new institutions that would someday make the struggling town into a real city.

The motive force behind the flowering of the city came from the business community and not unsurprisingly from major landowners like Carroll, Law, and Van Ness. Disappointed in their hopes to make Washington an important commercial center (as George Washington had dreamed), they now saw that their land values would rise only if the city were to become a more cosmopolitan and comfortable place in which to live and work. Previously, they had donated land for the theater and for churches. After the fire, they financed the Brick Capitol. Now, John and Marcia Van Ness made a grand gesture that clearly announced their confidence in the future of Washington: they let it be known that they would build the finest private house in the city, just to the southwest of the burned-out presidential mansion. Construction would start rapidly, under the architectural genius of Latrobe. At about the same time, Thomas Law also voiced his confidence in the city's postwar future, though in a different manner. His fortune dwindling, he could not start a new house. His contribution was another long poem, a segment of which shows (in addition to his lack of real skill at this art), an endearing combination of boosterism and patriotism:

> "Droop not, Columbia," she exclaimed, "But trust
> In power Almighty, as your cause is just.
> The machinations of the bad shall fail
> The force of numbers be of no avail
> Our God shall shield thy chosen land from harm
> Our God protects thee with his outstretched arm."
> At this, methought, a peal of victory rung
> And a new edifice in splendor sprung
> Like Phoenix from its ashes, and a sound
> Of triumph and rejoicing rose around.[2]

The social cycle resumed; it, too, was a symbol of continuity and optimism. Indeed, it had continued until the very last minute. In view of the fact that the invading British troops had enjoyed the dinner for forty guests that Dolley Madison had set that fateful August morning, the resumption of official entertainment may have been a kind of symbolic revenge. First at the Tayloe house, then in a rented house on Pennsylvania Avenue, the Madisons' drawing rooms were renewed, amidst less splendid settings

[2]Josephine Seaton, *William Winston Seaton of the National Intelligencer* (1871; reprint ed., New York, 1970), p. 120.

but no reduction in enthusiasm. Cabinet members, the heads of diplomatic missions, and others soon followed suit in entertaining once again. It was as if the city's leaders wanted to forget the war and ignore the ruined buildings. The republic had survived, the victory at New Orleans had evened the score with Britain, the peace was honorable, and life could move on to better things.

In the spring of 1815, the theater season started on schedule. The company's equipment, which had been abandoned in Washington during the British raid, had not been molested, and the theater was undamaged. The season ran, as usual, from June to August, and the company's offerings included excerpts from Shakespeare plays and a patriotic show to mark the Forth of July. Unfortunately, business was only fair; the company was barely averaging the three hundred dollars per night (at a dollar per ticket) it needed to break even.[3] It seems that it was hard to fill the low-lying and muggy theater in summer, particularly now that so many of the leading families retired to their weekend and summer places in the hills surrounding the city.

A group of amateur performers made a spirited, if short-lived, effort to give the city a winter theater season. The Washington Benevolent Thespian Society was founded in 1815, with the purpose of raising money for local charities. It is not clear who the members were, but the idea was not new in the area; Alexandria already had supported a similar troupe for several years, and both William Seaton and Joseph Gales of the *Intelligencer* had done amateur theatrics in Raleigh. The group's enthusiasm, however, may have been higher than their skills. Even with the musical support of members of the Marine Band, their shows were not exactly a success. After their first two performances in early November 1815, the *Intelligencer* pleaded with its readership to support the troupe, pointing out that, after two performances, the gate receipts had scarcely covered the costs, and that the society therefore had little to distribute to charities. The high point of the amateur players' short season came later that month when they gave a special gala performance for the hero of New Orleans, Andrew Jackson, who was making a triumphal visit to the capital. But all in all their effort was a failure, and the last record of the group occurs a year later, when there was a call for an annual meeting—but apparently no performances as a result.

While the theater never did make much money in Washington (in fact, receipts dwindled year by year), Washington slowly began to attract a few musical and other performers for single concerts or even extended performances.[4] The harpist Pucci was one of the first to return to the city, giving a concert in a rented hall only four months after the British occupation of the city. Assisted at the piano by local resident Frederick Wagler, Pucci's grand concert was on the light side, mixing piano and violin pieces

[3]Reese James, *Old Drury of Philadelphia* (Philadelphia, 1932), p. 25.
[4]Receipts, which exceeded $250 per night in 1816, dropped to $213 in 1817 and were down to $134 by 1821. See James, *Old Drury.*

with songs, dance numbers, marches and national airs. Pucci then went on an extended tour, returning to Washington to give several concerts along with the Marine Band in 1818–19. By that time, other performers were also stopping in Washington to try out the local market. Most of them were solo performers, usually singers, although instrumentalists such as the Swiss "clarionetist" Mrs. Knittle occasionally performed. They were backed by some of the few local musicians, the theater orchestra when it was in town, or even amateur groups such as the Georgetown Harmonic Society, a group that appeared with visiting wind instrumentalists in 1819. These performances were usually given at one of the local hotels or assembly halls, Strothers—on the site of the present Willard Hotel—seemingly being the preferred site in Washington and Crawford's (the Union Tavern) in Georgetown. But concerts of this type were relatively infrequent, license fees and other expenses troublesome, and, given the rarity of return performances, apparently they were only middling successes at the box office.

If performing artists had difficulties attracting remunerative audiences in Washington, part of the problem was probably the social whirl. The spirit of optimism that animated the city after 1815 led to a profusion of increasingly opulent social events, which in themselves provided plenty of music and drama for the socially active (or "fashionable") residents. After 1817, when James Monroe was inaugurated as new president and moved back into the mansion, the round of receptions, dinners, assemblies, balls, civic banquets, and other events became both continuous and increasingly luxurious. Rosalie Stier Calvert wrote to her family that although there had been about a dozen concerts or recitals in the city during the season, she had not had time to go; as for the theater, she sniffed, "it is seldom frequented by the best people—we have never been there."[5]

The city's revival, its growing population, and its increasing taste for luxury also attracted a new influx of painters. Very few, however, came to live. One exception was Charles Bird King, who moved to the city in 1816 and eventually established his home and studio at 12th and F streets. (He had made occasional visits earlier, as can be seen by his 1810 portrait of William Thornton.) Primarily a portraitist, he painted many of Washington's political and social leaders, including the Gales and Seatons and a memorable portrait of the musical and poetic, but unhappy, Louisa Catherine, John Quincy Adam's wife. But King is especially remembered for the work he did on contract for the superintendent of Indian trade—depictions of the numerous Indian delegations that paid official visits to Washington as the nation expanded westward.

[5]Rosalie Calvert to Isabelle van Havre, 25 Mar. 1819, in *Mistress of Riversdale: The Plantation Letters of Rosalie Stier Calvert,* ed. Margaret Law Calcott (Baltimore, Md., 1991), p. 346. Rosalie, while decidedly a snob, did have other excuses for not attending the theater frequently. Although she was particularly active that year because she was presenting her daughter Caroline to Washington society, she had to cope with a two-hour coach ride from and back to the Calvert home near Bladensburg each time they went to an event in town.

Another artist who settled in Washington was Joseph Wood, from New York, who lived in the city from 1816 on, running a painting school but also doing portraits of James Monroe, John Quincy Adams, Henry Clay, John C. Calhoun, and others. John Vanderlyn also returned to the capital in 1816, staying long enough to do portraits of the Madison and Monroe families, as well as some other dignitaries such as Senator Benjamin Crowninshield and his wife. He showed his paintings at the Brick Capitol. So did John Trumbull, who was awarded a contract to paint four large historical canvasses for the Capitol rotunda, on which construction would soon begin. Two years later, Charles Willson Peale stayed in Washington for some months doing portraits of President Monroe, among others, and showed them to the public at Stelles's Hotel on Capitol Hill before taking them to his museum in Philadelphia. Non-American artists, too, came to stay for varying periods of time. The English miniaturist Robert Field once again paid an extended visit at this time, as did the Italian sculptors Carlo Franzoni and Giuseppe Valaperti, who added a small amount of private commissions (Franzoni also painted) to their major work on the Capitol.

The most important exhibit of paintings during this period—perhaps for years— came in 1816 when the Stier collection was put on show. That collection had been languishing in crates in Maryland ever since the previous century, when the family had fled revolutionary France; Rosalie Stier Calvert had feared for the collection's safety if the crates were opened—and also worried that "a number of curious troublesome people would be drawn here."[6] Now that Napoleon was banished for good and the European world again safe for aristocrats, the collection was to be returned to Antwerp; but it was put on show for a week before being repacked (Charles King Bird reportedly lent a hand in the latter operation). Those who were able to make the trip to Riversdale, the Calvert home near Bladensburg, were treated to a rare showing of works by Van Dyck, Rubens, Titian, Rembrandt, and Brueghel.

The city, at least for a short time, also had its own art gallery-museum: the Museum of the Metropolis. Or at least that was the name given to the old Van Ness house at 12th and D streets. The reality, it seems, was a bit more prosaic: the Van Nesses were allowing the empty house to be used for artistic purposes. Over a period of some two years (1817–19), it was used as an art school by a Mr. de Milliere, as an exhibit and salesroom for Italian sculptures, and for a sale of art that the auctioneer, the ubiquitous Mr. Mauro, claimed to include works by grand masters such as Tintoretto, Rembrandt, and Murillo.[7] But it was ephemeral, not yet the start of a lasting institution.

In spite of this spotty record of development in the arts, the pool of intellectual capital in the capital city was steadily deepening. The new expansive mood, and the addition

[6]Calcott, *Mistress of Riversdale,* p. 220.

[7]*National Intelligencer,* 5 Nov. 1817; *Washington Gazette,* 28 Mar. 1818 and 2 Mar. 1819. Mr. Mauro may not have given up his music but evidently found the auction business more profitable.

of new people of learning and culture, soon brought results in terms of institutional development. The war, and the country's inexorable growth, had taught the government that, its minimalist political philosophy aside, it truly needed better national institutions. Some of them, inevitably, were established in Washington. The army's ordnance department had been reorganized and strengthened in 1812, and its chief, George Bomford, soon recruited more talented officers to fill its ranks. Similarly, professor Josiah Meigs was asked to head up the new General Land Office in 1814, and the engineer Isaac Roberdeau expanded the new topographical office after its formation in 1818. Each of these new offices, technical as their work was, brought the welcome addition of men of learning and science, as well as their families, to live in the city.[8] Another military office to open in Washington was the board of naval commissioners, which brought not only a number of interesting professional families but also the glamour of the war heroes who headed it: captains John Rodgers, David Porter, and Steven Decatur.

One of the board's incidental contributions to Washington's cultural scene was in the person of its secretary, James Kirke Paulding, a prolific New Yorker writer who had been one of the original contributors to Washington Irving's "Salmagundi" essays and author of the political fable *John Bull in America.* While at the board from 1815 to 1823, he worked on a number of publications, including *Letters from the South by a Northern Man, Koningsmarke, Sketch of Old England by a New England Man,* and *The Backwoodsman,* a poem.[9]

Other newcomers also enriched the tiny literary community. The new attorney general under Monroe, for example, was William Wirt, already a published novelist and essayist, as well as a powerful orator. His *Memoirs of a British Spy* had been published in 1803, and two volumes of essays for the *Richmond Enquirer* had also been published. Another new resident, Peter Force, arrived in 1815 to publish government documents but also tried—unfortunately unsuccessfully—to launch a national political and literary quarterly review. Although he was unable to gain enough local subscribers to launch the magazine, his eventual and lasting contribution to the community would be as a historian and archivist, through which he succeeded in safeguarding many irreplaceable documents for posterity.[10]

[8]Bomford and his wife, Clara (a sister of Ruth Barlow), were already fixtures of Washington business and society, as well as good friends of the Thorntons. Meigs was a professor of natural philosophy and mathematics who had come to Washington as surveyor general in 1812. Roberdeau had been in Washington earlier as an assistant to Peter L'Enfant and had most recently conducted the official survey of the U.S.-Canadian border. He would also assist in Lambert's effort to establish a national meridian at Washington.

[9]Paulding also tried to launch a series of satirical essays, along the pattern of Salmagundi, but was unable to make a success of it in Washington. He returned to the capital in 1838–41 as secretary of the navy and continued to write prolifically, but at heart he was always a New York author.

[10]Force wanted to call his journal the *American Quarterly Review*. Five years later, in 1822, he backed still another stillborn attempt to launch a literary journal. Peter Force Papers, Library of Congress Manuscript Division, Series I, container 1.

William Thornton, who had longed for the intellectual stimulation of Europe even while in Philadelphia surely welcomed this influx of intelligent and cultured residents to his adopted city. But it also implied a change in his status. When Washington had been a very small backwater town, he had been one of its brightest lights. But the town had grown, and his role in it had diminished accordingly. He and Anna Maria were still of course prominent in social and cultural circles, while William's varied interests, his lawsuits, and his inveterate letter-writing to the local newspapers kept him in the public eye. But rarely anymore was he the brightest and most worldly man in the room, the one whom the others consulted. His government job gave him little influence, which, combined with his lack of activity in civic government, meant that he no longer had a discernable role in public affairs. His job at the Patent Office, he increasingly felt, was a dead end, and the repeated denials of his requests for promotion were to him a personal slight. Moreover, he suffered from the plight of other permanent Washington residents: he had no sponsor in the competition for jobs or preferment, no hometown congressman, senator, or pressure group to push his case. Already fifty-eight years old when James Monroe was inaugurated, he now ran the risk of being dismissed as a man respected more for his social skills and hoary collaboration with George Washington than for his current contributions. Active intellectually as ever in spite of occasional bouts of bad health, he was looking for new challenges.

Clearly, Washington had become a richer and more interesting place in which to live. Its permanent residents now formed a somewhat deeper intellectual pool, while their broader range of professional skills provided new opportunities for the community's cultural enrichment. Congress and the diplomatic corps had expanded as well and brought to the city a special tone, much political excitement, and a steady flow of information. It was gradually emerging as a worldly capital city, albeit one with a physical and cultural infrastructure that still resembled that of small southern town, at best. Even so, the town was still too worldly (and far too southern) for some, like the pious New England congressman who wrote, "Indeed it cannot be expected the morals of a people are very correct, when you see characters of all descriptions and people of all nations and all colors, with a variety of shades between white and black." Another New England resident complained about the lack of first-rate intellectuals, in what he called a "Golgotha of numbskulls." Those objections aside, most Washingtonians would have agreed with Margaret Smith, who wrote to a friend in 1814 that "Washington possess a peculiar interest, and to an active, reflective, and ambitious mind, has more attractions than any other place in America. This interest is daily increasing, and with the importance and expansion of our nation, this is the theater on which its most interesting [subjects] are discussed, by its ablest sons, in which its greatest characters are called on to act."[11]

[11]Abijah to Hannah Bigelow, 17 Oct. 1814, "Letters of Abijah Bigelow, Member of Congress, to His Wife, 1810–1815," *Proceedings of the American Antiquarian Society* 40 no. 2 (1930): 398; William to Mary Lee, 24 July

Mrs. Smith, of course, was thinking mainly about political discourse. The ablest sons of Washington indeed were exercising their minds largely in the political arena, and consequently the city as yet showed little promise as a broader intellectual center for the country. George Washington's dream of a national university in the capital was effectively dead. Shortly before he and Dolley went into retirement at Montpelier, President Madison had made one last appeal to Congress to support the idea, but that body once again had taken no action. Meanwhile, Jefferson was busy building up his own university in Virginia (and had asked both Thornton and Latrobe to submit plans for pavilions on the quadrangle).

With the government thus effectively not in the game, it was left to the private sector, or the churches, to provide Washingtonians with whatever opportunities they would have for higher education. Georgetown College under president Giovanni Grassi had seemed ready to assume the role of an institution with national aspirations. He had expanded the student body, bringing in many non-Catholics (including children of Washington's political and civic leaders); he had hired talented new teachers and broadened the curriculum. Wanting to integrate the college into the community, he opened a scientific museum (where he let people observe the skies through his telescope), conducted public experiments (including a balloon launch in 1815), and took his students on field trips to the Patent Office and Navy Yard. He got Congress to approve a charter for the college in 1815, authorizing it to issue university degrees. But then, in 1819, he was called to Rome on business and stayed. Grassi's absence and other factors caused the college's maturation to lose a few years, but its period of successful growth had started.[12]

Another higher educational option was beginning to emerge from an unexpected quarter. Obadiah Brown, the pastor of the Baptist church, had been joined in ministry in Washington back in 1810 by Spencer Cone, previously an actor with the Philadelphia theater company. Cone, who had taken a splinter group from Brown's congregation to found the Navy Yard Baptist Church, was, like Brown, an enthusiastic supporter of the energetic missionary and educational mission of their denomination. So when Luther Rice (one of the Baptists' most active and successful missionaries and fund-raisers) began to agitate for a national "literary and theological institution" to train churchmen, the three joined forces to push the idea. Largely as a result of Rice's tireless advocacy, the Baptist National Convention of 1820 approved the plan, and thanks to the three ministers' joint work, it was also decided to locate it in the nation's capital. Rice had, in fact, already prejudged the convention's decision; he had bought a parcel of land north of the Capitol. In a short time, he would see his new college take shape.

1824, Lee-Palfrey Family Papers, Library of Congress Manuscript Division (Lee, a constant critic of all things Washingtonian, was also close to Fulton and Monroe and thence no friend to Thornton); Gaillard Hunt, ed., *The First Forty Years of Washington Society* (1906; reprint ed., New York, 1965), p. 94.
[12]Robert Curran, *The Bicentennial History of Georgetown University* (Washington, D.C., 1993), 1:67–70.

The local churches, and in particular their ministers, also played an important role in the city's continuing, if struggling, efforts at providing education to poor children. In 1817, for example, clergymen held most of the key oversight positions. The city-run Lancastrian school had as its supervisors Father William Matthews and a lone non-cleric, Josiah Meigs. At the Washington Academy, the supervisors were Rev. James Laurie and Rev. William Hawley, the recently arrived minister of St. John's. (Laurie was also president of the school board and did some private tutoring—young William Gallatin and Robert Madison having been among his pupils.)

Reverend Hawley's St. John's Episcopal was one of the recent additions to the city's churches. Located just north of the president's mansion (now beginning to be known as the "White House"), its cornerstone was laid in 1815. The building's financing was assured by a vestry that included many leaders of the government and business community, such as John Van Ness, John Tayloe, Roger Weightman, Peter Hagner, and James Blake. Latrobe, the architect, also had the pleasure of playing the organ and directing the choir as they sang his own hymn at the building dedication in 1817. The minister, William Hawley, was a convivial, card-playing man and a good friend of the Presbyterian pastor James Laurie—although a notably less tolerant churchman, considered even to be "violent in expressing his condemnation of all different tenets from his own."[13]

Another new church was Christ Church Episcopal, dedicated in 1817 in Georgetown. On Capitol Hill, St. Peter's was dedicated in 1820; built on land donated by Daniel Carroll of Duddington, it soon replaced St. Mary's chapel as the Catholic church for the eastern end of town. The Foundry Methodist Church, which was first established in Georgetown but later moved to 14th Street in the city, was a gift from Henry Foxall, a Georgetown industrialist who had promised to make such a gift if his cannon foundry was spared by the British—as it had been.

Each of these new churches increased the cultural resources available to residents of the city. By 1820, the city had eleven separate congregations, Georgetown another seven, and each of the new churches had brought new clergy, new programs (the Sunday school movement, for example, had spread to Washington), or perhaps even new ideas to enrich the city. Sunday services in Congress had resumed as soon as space became available, but the citizens now had broader options, and Sunday at Congress Hall had become less of a social event.

The most notable development among the city's churches, however, was the beginning of separate black Protestant congregations. The city's free black population had been growing steadily, and quite rightly many of these citizens were unhappy with the

[13]Charles to Hannah Bulfinch, 1 Feb. 1818, in *The Life and Letters of Charles Bulfinch,* ed. Ellen S. Bulfinch (New York, 1973), p. 222.

way they (and of course the slaves) were treated by existing congregations. Relegated to the back of the church or the balcony, and excluded from parish management or preaching, the black members of many churches wanted a role somewhat more commensurate with their numbers. Inspired by a movement that had begun in New York and Philadelphia, 125 or so black parishioners separated from the venerable Dumbarton Methodist church in Georgetown in 1814. Moving just a few blocks away, and helped by a gift of land from Henry Foxall, they soon founded the first African American church in the District, the Mount Zion Methodist Church, at 27th and P streets. At the other Methodist church—Ebenezer, on Capitol Hill—a similar development was taking place. There, the black members of the congregation broke away from the parent congregation in stages. First building a separate social hall and Sunday school building, they separated completely only after 1822, when they established a separate congregation called the Israel Bethel African Methodist Episcopal Church.[14]

But Washington's churches, even if their number was continually growing, were never able to cope with the social welfare problems of a city that had a growing and rootless population of poor casual laborers. In times when the public works were slowed down, the condition of this underclass could become desperate. The ever-observant Latrobe reported coming across a woman in the woods north of the Capitol who was selling her recently deceased husband's gun to pay for food. Such poor people, he commented, "are to be found in extreme indigence, scattered in wretched huts over the Waste which the law calls the American Metropolis, or inhabiting the half-finished houses, now tumbling in ruins, which the madness of speculation has erected."[15]

The municipal government, for its part, simply had no budget for social welfare. Basic public hygiene, fire prevention, and the underfunded effort at basic education were the best it could do. A number of private charitable organizations, such as the Humane Society and the Benevolent Society, had sprung up over the years to meet needs on an ad hoc or continuing basis. One that sprung up in this postwar period of civic activism is particularly worthy of note. It was the Washington Orphan Asylum Society, founded by Marcia Van Ness in 1815 following the death of one of her own daughters. The wealthy Van Nesses of course knew everybody in town who counted, entertained often and lavishly in their new mansion, and could not be denied—and she had indeed hit on a real, and suitably pathetic, need. Dolley Madison, Margaret Smith, Elizabeth Laurie, Mrs. Obadiah Brown, Dr. Blake's and James Weightman's wives, and other leading ladies were quickly enlisted as trustees and officers (Dolley was

[14]See John W. Cromwell, "The First Negro Churches in the District of Columbia," *Journal of Negro History* 7, no. 1 (1922):64–106; Mary Beth Corrigan, "Making the Most of an Opportunity," *Washington History* 12, no. 1 (2000):90–101; and Nina H. Clarke, *The History of the Nineteenth-Century Black Churches in Maryland and Washington, D.C.* (New York, 1983).

[15] Edward C. Carter, ed., *The Journals of Benjamin Henry Latrobe* (New Haven, Conn., 1980), 3:70.

given the title of "First Directress'). The Thespian Benevolent Society gave a benefit performance and more serious fund-raising ensued. Soon, the organization found a house and began its mission, which was to find and shelter needy young orphan girls and train them for paying positions in good households. It was a fine symbol of the city's upbeat, institution-building mood.

The spirit of expansion and optimism that followed the war also led, beyond the formation of new educational, religious, and charitable bodies, to the creation of entirely new intellectual institutions. The old Agricultural Society, however, fell by the wayside first. Founded during the years of struggle with Great Britain as a way to lessen dependence on imported goods, it died a rapid death once the European wars were finally over and the seas once again were open to trade. But it had been a creation of political necessity rather than truly scientific inspiration and had in reality achieved very little. After the war, the mood was one of growth, and it was only natural that the city's boosters should seek to give their community some tools for participation in the country's rapid technological advance. The city's pool of learned and active citizens was finally large enough, it seemed, to support the kind of philosophical and scientific institution that Dr. Thornton had said, some twenty years earlier, he hoped to establish.

And yet, when such an establishment was set up, Thornton was not among the founders.[16] The impetus, oddly enough, came from a relative newcomer to the city, a naval surgeon called Edward Cutbush who had directed the naval hospital since 1813. He and a number of other men got together in 1816 to found an organization that they first called the Metropolitan Society, dedicated rather broadly to the dissemination of practical knowledge about agriculture, manufacturing, and natural resources. Among the original group were Samuel Smith, Thomas Law, and Rev. Andrew Hunter, who since 1812 had been chaplain at the Naval Yard and tutor for the young midshipmen stationed there. Thomas Law, with his broad contacts and energetic personality, was an active promoter of the institution, writing to his sister that "everyone subscribes to whom I applied."[17] The group soon decided to seek a national charter from Congress, and for that purpose broadened their membership to bring in more men of science as well as potential political sponsors. Prominent among the new sponsors were William Thornton, John Van Ness, Robert Brent, B. Henry Latrobe, Josiah Meigs, Dr. James Blake, Roger Weightman, the landowner Overton Carr, and Nathaniel Cutting, a businessman-inventor who was an ally of Thornton's in his legal fight with Fulton.

[16]Thornton had, it must be noted, made a plea to Madison in 1814 for the establishment of a botanical garden in Washington, arguing that the capital city should be setting the example in promotion of the sciences. Typically, however, he freighted his letter with a number of other issues that diminished its impact, and there is no evidence that he ever followed up. Thornton to Madison, 28 Jan. 1814, James Madison Papers, Library of Congress Manuscript Division, image 1064. Accessed at Library of Congress, *American Memory,* http://lcweb2.loc .gov/ammem/madison_papers.

[17]T. Law to Lady Rumbold, 19 July 1816, Law Papers.

With all this political support and no request for money directly connected with the measure, the Columbian Institute for the Promotion of the Arts and Sciences was duly chartered by Congress, without objection, in 1818. The organization was given some office space in Blodgett's old hotel, but beyond that Congress provided very little actual support. The Washington community, however, rallied to launch the new institute—more than 150 men joined, and the list of members is a virtual directory of the best scientific minds of the young city.[18] More than a hundred out-of-town, or corresponding, members also joined. Dues of five dollars per year, and the members' expected contributions in the form of scientific papers, were the planned basis for a program of periodic meetings and learned discussions on the papers presented. Unfortunately, the budget rarely covered the cost of publishing the papers presented, a problem that was only exacerbated when it turned out that, after the first year, many members tended to fall behind in paying their dues. Dr. Cutbush's energy, however, kept the organization moving forward, and it made some useful progress. The first step was to establish a small museum of geological samples, archeological finds, and miscellaneous antiquities. While not an important collection, this was at least the first government-sponsored museum in the capital. (Two other small museums did exist—the one at Georgetown College, and a small collection of natural history artifacts kept by Andrew Villard, a supervisor at the Greenleaf's Point Arsenal.) The second achievement of the institute, thanks again to its political connections, was obtaining a grant from Congress of a five-acre plot of land at the foot of Capitol Hill as the site for a botanical garden where useful plant species would be propagated and made available to scientists and the public. Congress's generosity did not extend, however, to providing any money for the purpose, and the institute was faced with the problem of financing this priority project on their own.

The institute clearly did not have money to fund still another priority that some of Washington's botanists cherished, namely the establishment of a dry herbarium. The botanists had already, in fact, formed a new organization, the Washington Botanical Society. Led by Dr. John Brereton and including Reverend Laurie, Dr. Henry Huntt, and George Watterson, among others, the society contributed to the campaign to start the botanical garden and then went on to set up its own herbarium. It also, at least initially, found the money to publish a number of works by its members.

[18]A large number of the new members were government officials who may have joined in their official capacity rather than out of personal commitment. Some of the more interesting or prominent among the new members were the chief of the Army Engineers Simon Bernard; Surgeon General Joseph Lovell; Commodore John Rogers; George Bomford of the Ordnance Department; Captain Tingey; judges William Cranch and Richard B. Lee; George Watterson of the Library of Congress; Isaac Roberdeau; a number of past and future mayors of the city, including Robert Brent, Daniel Rapine, Dr. James Blake, Joseph Gales, and Peter Force; a large contingent of medical doctors; and men of the cloth, including Obadiah Brown, James Laurie, Robert Little, Father William Matthews, and William Staughton.

Still another organization was established in this period, stimulated by the general feeling of opportunity and by the professional comradeship brought about by formation of the Columbian Institute. The city's doctors had gotten together only once before, in 1813, at which time they had done so only to honor the death of their distinguished colleague and teacher, Dr. Benjamin Rush of Philadelphia. But in 1817, sixteen of the city's practicing doctors met at a hotel and decided to form their own professional organization, even though most of them were already members of the Columbian Institute. The Medical Society that resulted was headed by Dr. Charles Worthington and included other notable physicians such as Thomas Sims, James Blake, Henry Huntt, Alexander McWilliams, and Nicholas Worthington. Thornton, even if inactive as a practitioner, also joined and was elected to the post of vice president. Like its counterpart organizations, it held quarterly meetings at which recent medical developments were discussed and papers presented.

Another institution established in Washington at the time was not at all focused on the local community. It was notable largely because of the number of Washington residents who took part and the scope of its political and humanitarian ambition. Yet this apparently was the organization that most enthused Dr. Thornton, quite simply because it promised to finally put into motion the ideas about slavery that he had long espoused. Thornton's project of 1787, in short, had finally become politically correct: the idea of settling America's freed slaves in Africa had caught on. White leaders such as the Reverend Robert Finley, of New Jersey, and black leaders like the Massachusetts merchant shipper Paul Cuffee had come to look upon the success (limited though it was) of British settlement efforts in Sierra Leone as a possible example for America. Finley supplied the organizational drive. Coming to Washington in late 1816, he and his brother-in-law Elias Caldwell got together a group of influential and interested men to form a new organization to promote the idea. Caldwell, who as secretary to the Supreme Court and a member of the Columbian Society was a sort of Washington insider, found the political weight he needed by enlisting Bushrod Washington, the ex-president's nephew, Henry Clay, Richard Rush, and Francis Scott Key to push the idea through Congress.

The organization—the American Colonization Society—was stitched together in a few weeks, and its officers elected early in the new year, with Caldwell becoming the executive secretary. The idea had gained support from a wide spectrum of politicians (their motivations, of course, varied equally widely), and before long the society not only had a congressional charter but also money to support its programs. Through its efforts, the first ship of American freemen, the *African Mayflower,* set sail for Africa in 1820, and the state of Liberia was eventually created. That story has been told excellently elsewhere.

For William Thornton, the society's formation almost certainly gave a sense of vindication; it was a small moral victory after a number of professional and financial setbacks. He naturally became a member; he had never abandoned his view that African colonization could be a solution to America's slavery problem. Dusting off the various papers he had written on the subject (the most recent having been an 1804 proposal to buy Puerto Rico as a site for colonization), he sent them to Henry Clay and other politically influential members of the government. It was too late, however, and he would not become a leader of the new organization; the successful initiative had come from others, and they would get the credit for an idea Thornton had so fervently espoused as a young man.

The American Colonization Society brought together many of the city's leaders. Although its officers were largely political figures (the only resident Washingtonian among them being John Mason), its work was largely done by a committee of managers, and almost all of those were local leaders. Among them were the secretary Elias Caldwell, Francis Scott Key, Judge Walter Jones, William Thornton, Henry Foxall, and the Reverends Stephen B. Balch, Obadiah Brown, James Laurie, and William Hawley. The focus of their meetings, however, was entirely on supporting the overseas colonization effort. While these Washingtonians worked to develop new opportunities for freed slaves in Africa, in the slave-dependent society and economy of Washington itself it was business as usual.

The society, like all the other new organizations that had sprung up during these fruitful years, was a sign of the town's gradual maturation. The nation's capital could finally boast of a few intellectual institutions outside of the political arena. Moreover, the government had become, even if only to a limited degree, a promoter of science and learning. The flood of postwar civic enthusiasm that had rebuilt the burned-out public buildings had also encouraged Washington's residents to turn to developing their town's cultural and intellectual potential. They had responded with enthusiasm, and the city seemed ready to flower.

8

"This Seat of Science, the Muses,
and of Pleasure"

ND THEN THE BUOYANT POSTWAR MOOD MET REALITY. THE CRESCENDO of activity had been fueled by an optimism that unfortunately ran beyond the young city's economic capabilities. True, the city's resident population, including that of Georgetown, had grown to almost 20,500 by 1820, but the rate of growth had not accelerated as it had elsewhere. More important, hopes that the city would become a significant entrepôt for trade with the western territories had collapsed. Georgetown harbor was badly silted, the Potomac wharves underutilized, and the Anacostia harbor used largely by the navy. Even General Washington's beloved Potomac Company, with its canal around the Great Falls that was supposed to have stimulated trade with the interior, was gradually approaching bankruptcy for lack of business. The federal government, unable to find a consensus for investment in internal improvements, had provided no help. It had sponsored only one trans-Appalachian route, called the National Road, which ignored the Potomac valley and would wind up serving Baltimore, not Washington. Private investors, too, remained skittish about Washington, which had come to be seen as a graveyard for speculators. Instead, the smart money was financing the Erie Canal, which would be completed in 1825 and make New York the prime gateway to the West.

In 1819, public works projects in the city peaked with the launching of the largest ship ever built at the Navy Yard (the seventy-four-gun *Columbus*) and the completion of the restorations at the White House and the Capitol. As nonsalaried workers in the

city began to be laid off, the boom slowed. The crash of 1819, however, put a definitive stop to the city's hopes for continued rapid growth. The money supply dried up across the nation, and every potential investor suddenly was strapped for cash, if not crippled by debt or one of the many bank failures. Investment in Washington, except in the perennial Capitol building project and the on-again, off-again city canal, dried up. Real estate prices fell still further, and capitalists like Thomas Law were once again faced with very tight prospects.

Fortunately for government employees and the merchants who served them, the federal payroll was still paid regularly, even though there were government-wide reductions in pay as late as 1822. As a result, many local families could continue to afford goods and services, and the post-crash depression was not as severe in the federal city as elsewhere in the country. An upbeat mood was also sustained in Washington, in spite of the crash and ensuing depression, by an optimistic view about America's new potential for growth. The country's population was swelling and rapidly expanding into the western territories, while the northern states were witnessing the beginning of a new industrialization. The government was no longer a weak and experimental one; it had weathered a war successfully, expanded its authority almost in spite of its republican tenets, and had begun to take a meaningful place on the world stage. Even its political premises were seemingly being vindicated internationally by a series of antimonarchical revolts in South and Central America. A mood of republican expansion was in the air, particularly in the nation's capital, where politics, more than economics, was the staple diet.

The result was that Washington, or at least the comfortably off and fashionable set, danced its way through the depression. Or, to be more accurate, continued to entertain and be entertained during the long social season that had become a distinctive fixture of the city, as well as its prime unofficial preoccupation. The Washington social season, highlighted as it was by the official entertaining of the president, his cabinet, and that of the diplomatic missions, had been growing in style and luxury ever since Dolley Madison had opened the President's House to the town's respectable citizens. Luxurious display, which had become more or less the norm before the crash, was by no means abandoned just because the citizens' financial circumstances had become tighter. In fact, some residents, to keep up appearances, lived well beyond their means. The situation even became the object of satire, as Librarian of Congress George Watterson noted in an 1822 novel, in which one of his characters commented:

> To ape one another indeed, they all do
> And none is regarded who can't make a show
> If you walk, they all cry "Tis a most shocking sight'

A thing the first circle has put down outright!
All, therefore, must ride in their carriage so fine,
If they have not a beef slice on which they can dine.
And some will show out, with a nice silver dish,
Who live for the most part on nothing but fish.
Perhaps once a month a fine dinner they give,
And the rest of the month, on the fragments will live
For they say, there is nothing more outré and queer
Than not to be one of the first circle here[1]

Attorney General William Wirt and his family, for example, may not have had to subsist on fish, but he had lost a good deal of money in the crash and was unable to pay his debts. Nonetheless, the Wirts were determined to introduce their daughter Laura into society with a proper show and added a room to their house in 1820 for the purpose —a cost, presumably, necessary to keep face in the increasingly competitive social scene. At the same time, Thomas Law, in better days a truly generous host at his grand house in town, apparently found it economically prudent to withdraw to his country home for extended periods. Putting as good a face as he could on his rustication, he wrote to relatives in England that "all my thoughts are about gardening and farming—when a little fatigued with country concerns I go to town see a play and enjoy the amusements."[2]

The social scene in the city had evolved considerably. Dolley Madison's efforts, a decade earlier, at establishing a style of simple republican elegance had gradually given ground to conspicuous elegance and then to outright luxury. The Monroe White House, in addition, set a consciously more European tone. Official events, while frequent, were much more formal and run with a tighter protocol than the previous open-door approach. Aristocratic and European-born Rosalie Calvert, of course, approved of the trend toward social differentiation by wealth and rank. Writing to her sister, she enthused that "one always finds all the ambassadors with their wives, secretaries etc, consuls, all the foreigners who are in Washington, a large number of members of Congress, and sometimes the residents of Washington and Georgetown with their families. One goes at eight and leaves at ten. During the Madisons' reign everybody went, even the shoemakers and their wives. But things are better managed now and one meets the best of society there."[3]

Other residents, on the other hand, were not at all enthusiastic over the trend, which they saw as a dangerous dilution of plain American and republican morality. As the

[1]George Watterson, *The L Family in Washington* (Washington, D.C., 1822), manuscript copy in Peter Force Papers, Library of Congress Manuscript Division, series IIC, container 9, p. 34.

[2]Thomas Law to his sister Lady Rumbold, 29 July 1819, Thomas Law Papers, University of Virginia Library Special Collections.

[3]Rosalie Stier Calvert to Isabelle van Havre, 26 Apr. 1818, in *Mistress of Riversdale: The Plantation Letters of Rosalie Stier Calvert,* ed. Margaret Law Calcott (Baltimore, Md., 1991), p. 334.

New Englander Charles Bulfinch, newly arrived in Washington as the new architect of the Capitol, wrote home to his pious wife, "the place is new but the society, especially in winter, is such as has grown up in older capitals, and has been accustomed to all the refinements and elegancies, and I fear the extravagances and dissipations of established cities." Another New Englander, ex-congressman and now Supreme Court Justice Joseph Story, commented in the same spirit that "there is a great deal of gayety, splendor, and, I think, extravagance in the manner and habits of the city the public taste becomes more and more gratified with public amusements and parade."[4]

While the new and restrictive official protocol was inspired in part by the taste of Elizabeth Kortright Monroe, it was also a response to the changing nature of Washington society. The Madison squeezes had been able to include all respectable citizens because the town was still small, its population new and unfamiliar with each other, and the need for a unifying forum all too evident. But in the intervening decade the eligible population—government clerks, military officers, foreign diplomats, members of Congress, prominent residents, and distinguished visitors—had expanded greatly and no longer could all be accommodated. The new protocol drew lines based on official rank. This was useful, perhaps, in limiting the number of junior clerks, military officers, and diplomats at official functions. But it tended at the same time to cut out those permanent residents who had neither high official rank nor wealth and to accelerate a process in which the various elements that made up the city's population went their own ways. Old residents like the Smiths, certainly, resented the Monroes' policy of neither making nor receiving calls. As Margaret Smith wrote to a friend in 1817, "both Mr. and Mrs. Monroe are perfect strangers not only to me but all the citizens."[5] In a city where the social network had been lubricated from the start by exchanges of calls, especially by the women, it was a setback to a still tenuous sense of community.

In this new social milieu, the Thorntons were on less firm ground than previously. While still firmly in the first circle due to their social and intellectual brilliance, they no longer had either rank nor friendship with the presidential couple to reinforce their standing. William, once a powerful commissioner and familiar of presidents, was now only one of many second-rank officials, and one with a purely technical job at that. His job continued to occupy his time but was increasingly a source of frustration rather than satisfaction. He was effectively excluded from planning concerning the Capitol, while lack of involvement in municipal governance also kept him removed from civic affairs. He was an active, if not a leading member, of the new intellectual associations; they did not appear to occupy his attention as fully as they might

[4]Charles Bulfinch to Hanna Bulfinch, 1 Feb. 1818, in *The Life and Letters of Charles Bulfinch,* ed. Ellen S. Bulfinch (New York, 1973), p. 222; Joseph Story to Ezekiel Bacon, 12 Mar. 1818, in *The Life and Letters of Joseph Story,* ed. William Story (Union, N.J., 2000), 1:311.

[5]Gaillard Hunt, ed., *The First Forty Years of Washington Society* (1906; reprint ed., New York, 1965), p. 41.

have earlier. More and more over the next decade, indeed, Thornton appears to have been absorbed by his personal interests—patent cases, support for Latin American independence, art and science, his horses, his troubles at law, and always, always, his financial embarrassments. He and Anna Maria, in spite of their accomplishments and talents, were retreating from the foreground of Washington's social and cultural scene.

That cultural scene had, of course, grown with the rest of the city. While well-considered residents like the Thorntons may no longer have been automatically included in official events at the White House, diplomatic missions, homes of cabinet secretaries, or Congress, they now had an expanded range of other social and cultural options. Even during the busy congressional and social season, unofficial events such as the regular dancing assemblies, cotillions, patriotic dinners, and civic events were important parts of the "constant succession of parties" about which Charles Bulfinch advised his wife.

In addition, residents had the choice of participating in an ever-richer menu of special associations. The Masons, for example, had grown in number to the point that they had seven lodges in the District and Georgetown by 1820. They were then incorporated into a metropolitan Grand Lodge, led at first by Alexander McCormick (the brother of the minister at Christ Church), and then by another distinguished citizen, William Seaton of the *Intelligencer*. Still larger numbers of the town's men were involved in the local militia units, which in spite of their miserable showing in 1814 remained popular because of the appeal of fancy uniforms, musters, parades, and banquets. Civic affairs and politics were also a major preoccupation of many of the citizens, particularly among the merchants who made up the backbone of the Corporation Council. (In 1824 the citizens were finally given the right to elect their mayor in addition to aldermen, and they chose Roger Weightman the bookseller—interestingly enough the third of that occupation to hold the job, following Daniel Rapine and Peter Force.) Special ad hoc committees of leading citizens were also set up from time to time to manage public events such as Fourth of July celebrations or the festivities surrounding VIP visits like that of General Lafayette in 1824. Benevolent organizations increased, and many citizens served as well on the boards or as volunteers in their churches, or on the various school boards—including that of the public schools. Then there were the professional and intellectual organizations discussed earlier, most prominently the Columbian and colonization societies. And finally were a number of smaller associations, some of them permanent like the theater and library companies, others perhaps ephemeral or entirely informal, such as the "Bread and Cheese" book discussion group hosted by Joseph Gales of the *Intelligencer*. Among them were the Sons of Erin, the Harmonic Society, the Columbian Highlanders, the Quoit Club, the Military Philosophical Society, the Columbian Society for Literary Purposes, the Wash-

ington Royal Arch Club, the Washington Abolition Society, the Society for Meliorating the Conditions of the Indians, the Bible Society, and a temperance society set up by Judge Cranch and Rev. Obadiah Brown, under the somewhat ominous-sounding name of the Society for the Suppression of Intemperance.

In short, the American genius for forming voluntary associations was well expressed in Washington. While little is known about most of these organizations, they were surely set up to meet some perceived need of the citizens who took part and must have played a not unimportant part in the cultural and social life of the young city. In addition, many of the leading citizens were members of multiple organizations and thus met their fellow residents in a variety of personal and public capacities. (However, the overlapping of memberships probably was also a burden, and one of the reasons why attendance at the Columbian Institute meetings, for example, began to drop off after an enthusiastic first few years.) The majority of the organizations were peopled largely, given the times, by men. But women were also involved, not only in backing up their spouses' activities, but also on their own in the benevolent organizations—particularly the several orphanages that were set up following the lead of Mrs. Van Ness in 1815. Free blacks, as well, were involved in the process. The Resolute Beneficial Society was established by freemen in 1818, in part to combat the separatist premise of the Colonization Society—namely, that free blacks and whites could not coexist in harmony. The Resolute Society's first priority was to establish a free school for black children, in an effort to promote their integration into general society. They wanted their children to make a home in Washington and be part of a growing America, not to be sent off to Africa.

Much as Washington's cultural and intellectual horizons were broadening through the piecemeal contributions of such associations, the fact was that it was still a small city, with only a small group of well-rooted and wealthy gentry, and no nationally recognized institutions outside of the government. New York was six times bigger in terms of population and Philadelphia unchallenged in its intellectual and artistic leadership. Contemporary visitors to the capital tended to be fascinated by the action in Congress and impressed by the social and diplomatic whirl, but dismissive of the city's few private cultural institutions or the role played by the permanent residents. "This skeleton city affords few of the amusements of a metropolis," an English visitor reported a year before the crash, even while allowing that "it seems however to possess the advantage of a very choice society. The resident families are of course few, but the increasing influx and reflux of strangers from all parts of the country affords an ample supply of new faces to the evening drawing rooms." Another English visitor was less kind while making more or less the same point a decade later: "There are few families that make Washington their permanent residence and the city therefore has rather the

aspect of a watering place," he complained. Like most visitors however, both commented on the city's social culture as one of friendly hospitality—there was "a peculiar courtesy and easy politeness," the first remarked, while the second only grudgingly conceded that "people consider it necessary to be agreeable."[6]

The curious visitor came to Washington primarily to see the novelty of a custom-built capital city and its government in action, not to enjoy its urban pleasures. Few, indeed, were impressed by the city itself, although a good number praised the beauty of the site and the concept of the city plan. But when it came to sightseeing, they had few things from which to choose. The city as yet had only one monument beyond the public buildings, almost no public spaces other than the markets, no promenades other than Pennsylvania Avenue below Capitol Hill (which was often too muddy to walk), and many open fields but no parks—Lafayette Square was hurriedly cleaned up and fenced in for its namesake's visit in 1825 but was still far from a place of beauty. After taking in the architectural and oratorical distinctions of Congress, visitors found few places of interest. The State Department had paintings of Indians, official documents, and foreign gifts on display; the model room at the Patent Office intrigued the mechanical or intellectually inclined; the Navy Yard had impressive machines and the Tripoli Monument, and a few of the modest local churches were of architectural interest. But there were no museums of note, few public facilities, and fewer places of entertainment. For a worldly (indeed snobbish) New Englander like William Lee, familiar with the great cities of Europe, Washington was still "very dull" and sorely lacking in cultural amenities: "this delightful place, this seat of science, the Muses, and of pleasure," he sneeringly wrote of it in 1822.[7]

Most visitors did mention the Washington theater, generally disparagingly. "Most astonishingly dirty," groused one, while even a resident complained that the place reeked of "tobacco smoke, whiskey breath and other stenches, mixed up with the effluvia of the stables and miasmas of the canal." Some residents in fact disapproved of the whole idea; the theater in their minds being too much associated with sailors on leave, ladies of the night, and sharp operators—not a place for genteel company, indeed "a matter of regret in so young a state of society," as Charles Bulfinch put it.[8] In spite of such carping, the theater had more supporters than detractors, and when the first theater building burned down in 1820, it was rapidly replaced. Sixty subscribers (including John Quincy Adams, at the time secretary of state) put up the necessary

[6]Frances Wright, *Views of Society and Manners in America* (1821; reprint ed., Cambridge Mass., 1963), p. 266; Thomas Hamilton, *Men and Manners in America* (Philadelphia, 1833), 2:20.

[7]William to Mary Lee, 28 and 29 June 1822, Lee-Palfrey Family Papers, Library of Congress Manuscript Division, container 2.

[8]Frances M. Trollope, *Domestic Manners of the Americans* (1832; reprint ed., New York, 1949), p. 233; William Lee to Mary Lee, 8 July 1822, Lee-Palfrey Papers; Charles to Hannah Bulfinch, 1 Feb. 1818, in Bulfinch, *Life and Letters of Charles Bulfinch*, p. 222.

capital. The new building was an improvement over the old one, seating seven hundred persons and having a better lobby, reserved seats, and stoves.

All the same, the business still struggled. In an effort to overcome the disadvantages of a summer theater season, the company moved its season in Washington up to September in 1824 and subsequently. But attendance still lagged—to the degree that in 1825 the Philadelphia company for the first time actually lost money during its Washington run.[9] On rare occasions, the company would come back in winter for special events, as was the case in early 1825 when a gala theater evening was held in honor of Lafayette's impending return to France. Thomas Abthorpe Cooper, America's leading tragedian, performed Shakespeare and Greek theater scenes for an audience that, in addition to the guest of honor, included President Monroe, John Quincy Adams, Andrew Jackson, plus the cabinet and many members of Congress.

During the winter, and in spite of the distractions of the social season, occasional concerts, vaudeville shows, and other forms of both popular and high culture were put on at the local hotels, assembly halls, and even on occasion the reopened theater. Sometimes the performers were well-known actors or singers from the Philadelphia company, in town for a special performance. A few examples from 1820 show the variety of the acts: a ventriloquist, Mr. Charles, at Strothers in January; a vocal concert by Messrs. Kelly and Gegan, accompanied by a local orchestra, led by Samuel Carusi, playing Haydn, Beethoven, and Mozart, at Tennison's Hotel in March; also in March, a set of historical and patriotic tableaux called a "Phantasmagoria," accompanied by song and music, at the Washington Theater; in August, a vocal concert by Mr. Keene, also at the piano, at Strothers; and in December, two novelty concerts—one by two small people called the Lilliputian Singers, at Strothers, the other concert an act of four children, aged four to ten, who played harp, violin, cello, and piano at the Long Room. An intriguing performance in 1826 appears to have been a sort of magic show, billed rather mysteriously by the performer, Vincent Dumilieu, as opening with "a great variety of Incomprehensible Experiments in Natural Philosophy, And Apparent Necromancy."

Mr. Dumilieu's show was put on at the Washington Assembly Rooms, which rapidly had become the premier ballroom, exhibit, and assembly room in the city. It was no less than the old theater building, which had burned to the walls but had subsequently been bought, enlarged, and refurbished. The new proprietors were Gaetano Carusi and his sons, originally immigrants from the Italian contingent of the Marine Band, now entrepreneurs in the best American tradition. Gaetano was, in fact, the motivating force behind the Harmonic Society, which he started in 1820 and which began giving performances in 1821. (One has to wonder whether William Thornton was a member,

[9]Reese James, *Old Drury of Philadelphia* (Philadelphia, 1932), p. 46.

because, according to one report, the society got to use a room at the Patent Office for rehearsals.) Samuel Carusi taught music, led the occasional orchestra, and later published music, while another brother, Lewis, ran the assembly rooms, popularly known as Carusi's Saloon. The Carusis, Frederick Wagler, and an F. Massi were the only residents of Washington in 1827 to report that they earned their living teaching and playing music, by which time the Carusis had also become the leading cotillion organizers, exhibitors, and impresarios of their adopted city.

But the main wintertime theatrical entertainment was the circus, which combined music, performance, and spectacle in its own building. And even this popular show, like almost anything else in this most political of American cities, was occasionally caught up in the political game. During the fiercely competitive maneuvering for the presidency in early 1824, the circus became an accidental locale for the competing groups to make displays of strength. As described by Margaret Smith, the process started when John Q.'s wife, Louisa Adams, invited a group of her friends to the show. They made such a display that Mrs. Calhoun, the wife of John C.—also a candidate—arranged a similar party several nights later for her friends. This in turn prompted the supporters of William Crawford (including Mrs. Smith) to invite all their friends, with the result, she gloated, "that there was an overflowing house, very brilliant, and what is better still, but with few exceptions all Crawfordites. Quite imposing, I assure you. Mr. C and party sat in the front box."[10] (Unfortunately for the very political Mrs. Smith, her man lost and John Quincy Adams won when the election was finally decided in the House of Representatives.) Incidentally, the acts enjoyed by the political buffs that week included tight and slack rope walking, stilt dancing, juggling, vaulting, clowns, and even a balloon ascent.

A sense of the locale can best be gathered from one of George Watterson's characters in the 1822 novel *The L Family in Washington,* who writes to a friend that he "went a few evenings ago to the Circus, the only kind of exhibition they have in this place in the winter. . . . The house was crowded, almost suffocatingly, with spectators, many of whom were members of congress and others in authority." The upper gallery, he continued, was most crowded, with the presence there of "very brightly colored" women —the "necessary evils of a town—the worshippers of Venus, whose temple seemed to be more devoutly and better attended that in any other city, especially in the winter The crowd you now witness attending this exhibition surprises you, but it is occasioned by the want of other amusements in the City. They have but one theater and that is only open during part of the summer."[11]

Watterson's novel is a thoroughly cynical look at his city. "There is certainly a great lack of rational amusements in this place," one of his characters declared. "Literary or

[10]Hunt, *First Forty Years of Washington Society*, p. 171.
[11]Watterson, *L Family,* p. 102.

scientific society is a commodity not to be found within the precincts of the metropolis . . . the bookstores and galleries of congress are the only resort from absolute ennui to the literary lounger. Men there are, undoubtedly of high literary and scientific attainments, but they form not a body, and are so scattered and dispersed throughout the city that you but rarely meet with them," while the government employees, who because of their after-hours social responsibilities and need to find other ways to make money, "have little time to devote to intellectual pursuits."[12]

Unfortunately, the character in the novel had it more or less right. Over a quarter century after Nicholas King had tried to start a lending library in the infant city and failed for lack of customers, the appetite for books and ideas had grown along with the population. The Library Company was doing well—well enough to put a competing lending library started by Peter Force out of business. Booksellers were doing a good business, and Weightman's in particular was a place where one could learn the latest in literary news. The hotelkeeper Tennison had even opened a coffeehouse on 10th Street—apparently trying to attract an intellectual crowd away from the taverns—although it is unclear how well he succeeded. The Library of Congress room, finished in 1824 at the west portico of the Capitol's new central building, finally provided a comfortable and beautiful place to house Jefferson's library, bought to replace the collection the British had burned in 1814. With comfortable chairs, sofas, and good light, it was a grand place to read or discuss ideas and books. But it was not central, not open to all, and could not really serve as a place where people of a literary bent could gather. Almost surely there were numerous small book groups such as Joseph Gales's or sessions like the 1822 afternoon at the Samuel Smith's place in the country, "where there was a large party of literary people such as Dr. Thornton." But, even after all those considerations are taken into account, it was largely a city of consumers, not producers, of literature and ideas.

The Columbian Society had been founded in the hopes of filling that creative gap, at least in the scientific area. But it soon lost momentum, was already fading by the mid-1820s, and Dr. Cutbush's departure in 1826 stripped it of its motive force. It became harder and harder to get the busy members to attend, and even more difficult to get them to present papers. Of the eighty-five papers presented over the twenty years of the organization's activity, more than half, in fact, were by one member—William Lambert. Lambert, a government clerk, was a mathematician and astronomer who had been arguing since 1809 that Washington should be made the location of a new, national meridian that would replace "dependence" on the Greenwich line. Most of his papers for the society were on his work toward that (never fulfilled) fixation, and one can imagine that the other members may have tired of the issue. The ever-prolific

[12]Ibid.

Thomas Law wrote four papers for the society on his particular hobbyhorse, which was monetary reform; Samuel Smith wrote one, but William Thornton none.

Watterson followed up five years later with another novel, *Wanderers in Washington,* yet another dissection of the office seekers, opportunists, and social climbers who filled the town during the season. (It would be interesting to ask the author, such a critic of Washington practices, how it was that his daughter, Sarah Watterson, had been chosen to read the welcoming address to General Lafayette when he visited the Capitol.) But one senses that Watterson was probably closer to the mark in describing the climate of the young city than another Washingtonian novelist of the time, Margaret Bayard Smith.

Mrs. Smith, herself a practiced political manipulator, was at the same time a disappointed intellectual. She had complained years earlier, at the height of her and her husband's political influence, that she found Washington's culture to be lacking. "I love society, but not such as I have hitherto enjoyed in Washington. To me that society is barren of enjoyment, where the heart and mind find neither exercise nor expansion," she had confided to her daybook.[13] Following the sale of the *Intelligencer* in 1810, the Smiths retired to their place in the nearby country, but economic necessity brought him back into government service—and society—in 1814. It was not until the 1820s that Mrs. Smith began to limit her socializing in order to write novels under her own name, publishing *A Winter in Washington, or Memoirs of Mrs. Seymour's Family* (modeled on the very correct Wirt family) in 1824, and *What Is Gentility? A Moral Tale* in 1828. In both books, Mrs. Smith's focus was much more on the families and the moral dilemmas they faced than on the city in which they lived. Writing may indeed have been more an outlet for Mrs. Smith's active intellect (as it was also for Louisa Adams, who wrote unpublished poetry and satirical plays) than a purely literary effort.

Washington, in short, had a few writers but no literary or intellectual community that could stimulate debate or new ideas. The authors were too few, and their positions and interests too disparate. Moreover, they all had their daytime jobs—even Ms. Smith, who had to deal with the myriad housekeeping and social responsibilities of a genteel lady of the times. Finally, one has to wonder what such different authors would have found to talk about. There was little in common, after all, between the satire of Watterson, Mrs. Smith's moralism, the political essays of Wirt and Paulding, and the bombastic historical approach of George Washington Parke Custis.

There were, of course, also working journalists, pamphleteers, and publishers in the city. New newspapers opened and closed frequently, although the *Intelligencer* continued to prosper under Gales and Seaton, who also printed the congressional debates.

[13]Margaret B. Smith daybook, 23 Mar. 1806, in Cassandra Good, "A Transcript of My Heart," *Washington History* 17, no. 1 (2005):76.

William Elliott, a man of many parts, edited the *Washington City Gazette* for a time while running a stationery shop. (An amateur surveyor and astronomer, he had an observatory in his home, helped Lambert make his calculations for the national meridian, published the city's first guide books, was a member of the Columbian Society, and eventually became Thornton's clerk at the Patent Office.) Other newspapers and journals opened in the 1820s but did not last long: the *Senator,* the *Washington Republican,* and the *United States Telegraph* among them. Only Peter Force's *National Journal,* which opened in 1824, succeeded for some time—in part, perhaps, because of a close relationship with John Adams II, working for his father at the White House. Force was also the publisher for the theater and for George Watterson, who peppered him with complaints about the lack of advertising for his books or the paper's concentration on politics. "Nothing that appears in this city is noticed by the papers in it. I am sorry to see so much apathy and indifference to literary matters," the author-librarian grumbled.[14]

Washington's artistic community was equally ignored by the press, which by and large reported only on the arrivals and departures of visiting artists. The city did have a miniscule community of professional artists. The 1827 "Washington Directory," a fascinating listing of all heads of household in the incorporated city, showed three residents who actually earned their living through painting: John Wood, Charles Bird King, and Lewis Clephane. Three other residents listed themselves as skilled stone carvers or sculptors. That is a tiny number when compared to the scores of blacksmiths, carpenters, joiners, stonecutters, shipfitters, and tavern keepers, or the two hundred plus government clerks, fifteen attorneys, or eighteen teachers on the list, but it indicates that there was at least some market for art. Of course, Clephane, King, and the three sculptors also had government work at the Capitol or elsewhere, which certainly helped put food on their tables. King also taught art and had the pleasure years later of seeing some of his students succeed—including portraitist John Cranch, a son of the very serious judge. (Interestingly, another of the judge's sons also became a painter, still another a pottery designer.)

While Wood, and particularly King, did remarkable work during this period, a few of the more iconic Washington paintings of the time were painted by non-Washingtonians. Samuel F. B. Morse, the inventor, came to the capital to prepare for his memorable painting of the House of Representatives, which was finished in 1823. John Trumbull's four huge historical paintings were finally delivered from New York and hung in the Capitol Rotunda in 1824. Other well-known painters who came to the capital, either to show their works, seek commissions for copies, or to make new ones were Charles Willson Peale in 1819, John Vanderlyn in 1820, and Rembrandt Peale

[14]Watterson to Force, 5 Apr. 1828, Peter Force Papers, Library of Congress Manuscript Division, series I, container 3, no. 77958.

in 1823 and 1824, when Thomas Sully and William Dunlop also visited, and Morse again in 1825 when he did portraits of Lafayette. Exhibits of traveling works such as the panorama of the battle of Waterloo, shown at Carusi's Saloon in 1826, and a panorama of Niagara Falls in 1828 provided occasional other opportunities for the residents to see new art.

The Lafayette visit provided much activity for artists, as well as the beginning of an interesting story. A young Washington student, James Alexander Simpson, was allowed at the time to make a copy of the renowned Lafayette portrait by the French painter Ary Scheffer. His work was good enough to draw attention, and he became a teacher of art at Georgetown College some five years later. He also married Julia Franzoni, daughter of the artist who had come from Italy years earlier to work on the Capitol—a marriage that might illustrate that, in a small way, Washington was beginning to develop a community of artists.

Lafayette stopped over in Washington several times during his triumphal 1824–25 tour of the country that he had helped become independent, and each of his visits was an occasion for ceremony and civic pride. One of the largest public ceremonies he attended in 1824 was the graduation ceremony of Georgetown College, which traditionally included a full program of orations, drama performances, and music. In honor of the visiting hero, the ceremony that year had an audience of more than five hundred persons, including President Monroe and many other dignitaries. It was, in short, an excellent opportunity for the citizens to show off to their distinguished visitor the cultural progress they were making.

Georgetown College was the city's premier educational institution. The national university idea had finally died, even though Monroe had made one last (if halfhearted) appeal in his first inaugural address. But the college was having problems, too. Following the departure of president Giovanni Grassi, its more recent Jesuit leaders reverted to a strict regime that once again caused enrollment to slide. Financial and procedural arguments with the Jesuit leadership in Rome did not help either, nor did the drain of an effort to sponsor a seminary alongside St. Patrick's Church in Washington. Fortunately for the long-term health of the college, its financial angels, the Neales, continually helped it to buy up more Georgetown real estate at distress prices. Toward the end of the decade, under the presidency of the dynamic Thomas Mulledy, it renewed its growth and began its rise to national prominence.

But Georgetown was no longer the only college in the city. Luther Rice and Obadiah Brown's dream of a college in Washington had finally taken form. They organized the Columbian Society for Literary Purposes to apply for a college charter from Congress, and thanks to their friends there, they were awarded one in 1821. But approval came at some cost to the original concept, which had been to train young men for a Baptist

profession. Congress insisted that admission and instruction, as well as the college's board of trustees, be strictly nonsectarian, and the Baptist Convention reluctantly agreed. Soon, the acreage that Rice had bought in the hills north of the White House became the site of a four-building campus with room for a hundred students, plus faculty. College Hill, as the rural site came to be called (they even had a college cow), opened in 1822 with only thirty students. Just two years later, it was up to its capacity and already honoring its first three graduates with a bit of dash. The ceremony was held in Dr. Laurie's church (the college did not yet have an auditorium) but was gala —the Marine Band played—and it was attended by the president, General Lafayette, and other dignitaries. The college's president, Dr. William Staughton, was active and ambitious for his institution, encouraged the formation of debating clubs such as the Ciceronian and Enosinian societies, and expanded the field of instruction with a medical department in 1825 and a school of law in 1826. The two specialized schools helped in the rapid integration of the college into the city's life, as a number of Washington doctors were soon teaching there and Judge Cranch was active in the school of law. By the end of the decade, and in spite of management and financial problems that led to the virtual end of its Baptist sponsorship, the college—which eventually would become George Washington University—had become a vital part of Washington's cultural spectrum.

The Washington Seminary, too, was a success story—at least for a while. When it opened in 1821, it was obliged by popular demand to accept lay students, because so many of the city's residents, anxious for a permanent school of quality, had pressed for open admission. They were prepared to pay, but—in spite of Father Matthew's and others' pleading—Jesuit rules would not allow other than token payments. As the school had no endowment or other source of funds, it was losing money. While the resulting financial argument dragged on, the school continued to attract students, to enjoy the support of President Adams, and for a number of years to hold its well-attended annual celebrations at Carusi's Saloon. But by 1827, with the financial conundrum remaining unresolved and the school failing financially, the Jesuits withdrew and the school passed through a period of hard times. It limped along, reduced in enrollment and prestige, for some years, until 1848, when the Jesuits finally returned and the institution moved along the trajectory that would transform it into today's Gonzaga High School College.

The seminary's success illustrates the fact that Washington still lacked good and reputable schools. The city corporation financed three free schools, two of them on the Lancastrian model, but the quality was low and most parents with any means preferred home tutoring or one of the various private schools that opened and closed without pattern. The 1827 survey of households indicated that there were eighteen

teachers in the city, but this figure is certainly low, as many of the schools were run by housewives as a second source of income, or by men of the cloth whose parishes could not afford a large salary and ran schools to make ends meet. The result was a wide variety of educational opportunities that were uneven in quality and uncertain in tenure.

Free blacks in the city also continued to organize a few schools for members of their own community. (That community, incidentally, was subjected to increasing restrictions after 1820, including a curfew and a peace bond that had to be guaranteed by a white citizen.) There were several schools for free black children in addition to the school run by the Resolute Beneficial Society, but the most enduring seems to have been a school on H Street near 14th that was run by Henry Smothers. Smothers ran the school until 1825, at which time he turned it over to John Prout, and the school continued to run until a general school system was set up after the Civil War. The fact that Prout charged his students only twelve and a half cents per week says a good deal about the low earning power of this group of citizens.

Several blocks away, the "genteelest" vestry of St. John's Episcopal Church (as one visitor described the senior government officials who were prominent there) were under no such financial pressure. They had been able, in spite of the depression, to expand their church, adding a columned portico and a bell tower, with the second church bell in town (the first having been at St. Patrick's). On the other hand, the theological rigidity of Reverend Hawley had driven away some of the parishioners, specifically those of a Unitarian tendency.

The Unitarians, a group which came to include William Seaton, Joseph Gales, Judge William Cranch, Justice Joseph Story, Robert Weightman, Charles Bulfinch, William Elliot from the Patent Office, John C. Calhoun, and Daniel Webster, plus their families, had been meeting in rented rooms and a school in Georgetown under the guidance of a recent arrival from England, Robert Little. In 1821, they organized themselves more formally, bought land at 6th and D streets, and raised money for a church, for which Bulfinch donated the design. Even though the building fund had more than forty subscribers (including Thomas Law), the new congregation still incurred a substantial debt—but it had the satisfaction of a stylish building and a lively place of worship. Part of the interest came from the character of Reverend Little, who soon earned such a reputation as one of the most eloquent and liberal-minded speakers in the city that even the good Catholic Lafayette asked to attend one of his sermons in 1824. Little, who was also active in the Columbian Institute and its botanical garden, and editor of a short-lived journal called the *Washington Quarterly Magazine,* unfortunately died prematurely in 1827. But it was not before he had the pleasure of inaugurating the church's fine new organ in 1826 at a concert featuring the music of Handel.

The number of Washington churches grew in the 1820s to fourteen, according to Elliott's guidebook, or a church for roughly every thousand inhabitants. The George-town parishes should be added to that figure, as well as the black congregations that had begun to have separate identities. The churches moreover played a key role in the intellectual life of the city. The relatively wide selection of denominations represented, plus the regular presence of visiting preachers and chaplains at Congress, assured that a wide spectrum of views were available; they probably reinforced the city's reputation for tolerance and hospitality as well. In addition, most of the parishes, although small and strapped for money, remained in the forefront of charity and benevolent work in the community. That in turn was due, at least partially, to the fact that a number of the ministers—Father Matthews, Reverend Laurie, and Pastor Brown in particular— had the longevity in office, civic-mindedness, and dedication to education that made them strong practical, as well as moral, leaders of the community.

Most important, the churches formed an important pillar of the cultural life of the average Washington family. The Great Awakening flavored much thought and be-havior at the time, and Sunday was a day for contemplation and enrichment. Even non-church members like the Thorntons went more often than not to one or another service, where the mind was stimulated by the sermons and the emotions by the music.

The other main pillar of cultural life in the early city, it is worth restating, was the family itself. Washington may still have lacked cultural institutions, but it was by no means a town without culture. In a society where exchanges of visits were routine, where good conversation was a sort of genteel art form, and literature, music, religion, and art were discussed as well as enjoyed around the hearth or over dinner, culture was disseminated largely by personal contact and reading. Public cultural events—concerts, exhibits, and plays—were perhaps simply, as Thomas Law put it, the "amusements of the town" and not really essential to the town's lively enough, if often privately prac-ticed, cultural environment.

9

"A Very Singular Character"

IN EARLY MARCH OF 1825, AN ASSEMBLY OF THE LEADING GENTLEMEN OF THE city gathered on horseback in the street outside of William and Anna Maria Thornton's house. The men had come to escort the new president-elect, the Thorntons' neighbor John Quincy Adams, to the Capitol for his inauguration ceremony. The scene must have been rich with reminiscences for the Thorntons. Once before, just more than twenty-five years earlier, another procession had stopped at the same place in order to have Dr. Thornton, then the ranking commissioner of the new Federal City, escort the elder John Adams to the Capitol. And it had been only sixteen years since the Thorntons' good friends and neighbors, James and Dolley Madison, left the very next-door house that the Adamses now occupied to take up their residence at the presidential mansion.

The event was rich, perhaps, with reminiscences, but it held few solid expectations for the future. While John Quincy and Louisa Adams had been friendly neighbors, they would offer no more White House patronage to Thornton than had the Madisons before them. John was far too judgmental, Louisa had too many problems of her own, and moreover they had too many political debts to pay after their long campaign for the presidency. The sad reality was that Thornton, while still eminent in the city's social and intellectual life, no longer had a significant public role. As the bureaucracy had gradually increased and well-connected newcomers landed more prestigious and lucrative jobs, he had come increasingly to see his job as an underpaid professional as a dead end, "unworthy (in point of compensation) of his Education, Talents and Knowledge,"

as his wife would complain.[1] But with no local roots outside of Washington, he lacked a political sponsor who could help him overcome his uncomfortable professional and financial situation.

All the same, Anna Maria would say, "he was sanguine, full of hope, and of a cheerful temper." His intellect was as lively as ever, his imagination "exuberant," and the breadth of his interests amazing.[2] Patent Office business naturally took a great deal of his time, and the mechanical genius of his compatriots continued to enthuse him. His dedication to the Patent Office idea was such that even the normally hard to impress John Q., visiting in 1819, had become excited over the promise of the work for the technological future of America. Thornton continued, as well, to patent his own ideas (though unfortunately none of them ever turned out to be commercial successes). One of his most quixotic efforts was to create a mechanical musical instrument, an idea he had pursued intermittently since 1813, even having a prototype model (unsuccessful, it turned out) built by his piano tuner, a Mr. Hilbush. But his main preoccupation in the patent area continued to be his long fight against the efforts of Robert Fulton to develop monopolies using steamboat technologies that Thornton insisted had been invented earlier by Fitch and himself.

Another area of preoccupation for Thornton was the Capitol, where he consistently carped, publicly as well as privately, about design changes which did not flow from the original design he had inspired and that had been approved by his hero, President Washington. Although he no longer had an official role in the project, he was occasionally consulted as a courtesy, even if his often sarcastic and bitter commentaries were usually ignored. When Charles Bulfinch paid a call on his arrival in Washington in 1818, for example, he was treated to such a hail of complaints from Thornton that he could only write home that his host was "a very singular character, . . . very dedicated to finding fault with Latrobe for the changes."[3] Nor would Bulfinch, in turn, be spared from Thornton's sarcasm, for only two years later the Doctor wrote a long, hyperbolic letter attacking the new architect's plans for the central rotunda. In his seeming compulsion to attack every plan not directly inspired by his original design, Thornton unfortunately showed the ungenial side of his temperament, one which even his obituarist described as "highly sensitive . . . not exempt from those alloys which are blended with genius."[4] That is to say, he was defensive of his own creations to a fault and tended to personalize any dispute and hold grudges against his critics.

[1] Anna Maria Thornton, "The Life of Dr. William Thornton," Anna Maria Thornton Papers, Library of Congress Manuscript Division, reel 7, container 18, n.p.

[2] Ibid.

[3] Charles to Hannah Bulfinch, 12 Jan. 1818, in *The Life and Letters of Charles Bulfinch,* ed. Ellen S. Bulfinch (New York, 1973), p. 215.

[4] *National Intelligencer,* 1 Apr. 1828, W. Thornton obituary signed "C."

The remainder of Thornton's pursuits, happily, were more positive. He still enjoyed painting and believed his work had improved: "I can show you some of my latest pieces, which are my best," he proudly wrote to Charles Willson Peale when he heard that gentleman planned to visit in 1818.[5] And although he had not practiced medicine for years, he retained his interest in medical issues, as witnessed by his inclusion in the Medical Society. Thus we find him in correspondence with the Philadelphia Society of Friends in 1816, offering them medical and practical advice on the planning of a humane facility for the insane—more advice perhaps than they had asked for but illustrative of his desire to put his humane concepts to practical use. His correspondence shows he was studying the effects of spinal paralysis in 1822, with a view toward writing a paper on the central nervous system—one he apparently never finished. In the same year, he wrote a long paper on yellow fever for correspondents in New York and another long paper on the patterns and functions of sleep. He also began to draft notes for a long but never completed paper on comparative religion.

Education was another area that retained his interest. So when Jefferson wrote him to ask for a design for one of the pavilions at the University of Virginia, Thornton's response ranged, typically, far beyond the immediate issue. From architecture and construction issues, his advice to Jefferson flowed to other subjects as they "strike my mind," as he put it—from some of the pedagogic points raised in the paper he had given to President Washington years earlier, to the design and landscaping of the proposed campus, to physical education for the students, and so on. Jefferson already had enough ideas of his own about education, but he did see to it that Thornton's design for a pavilion was turned into brick and mortar. In the end, however, it was Latrobe's pavilion that had more influence on the final shape of the university quadrangle than Thornton's.

Given Thornton's idealistic and somewhat abstract bent of mind, it is a bit surprising to learn that he also put his restless intelligence to work on mathematical questions. That was, at least, the subject of an exchange he had in 1819 with senator and diplomat Rufus King on the qualities of the number nine. He was, it seems, fascinated by new ideas, quick to take up new fields of study, but not necessarily practical in applying his learning and equally quick to drop a subject and move on to something else. His wife would later write, "His thirst for knowledge was great, and perhaps too diffuse and general, but his views were noble and enlarged, more so than those, a few excepted, with whom he generally associated. When explaining to some members of Congress his noble and splendid conceptions of mind on various subjects, they coolly answered him 'Ah, Doctor, you have lived a hundred years too soon!'" (One wonders if she saw the irony of their remarks.) "Alas!" she concluded, "He lived not to complete any of his plans, but left all unfinished, tho his industry, and activity were unsurpassed."[6]

[5]Thornton to Peale, 22 Sept. 1818, W. Thornton Papers, Library of Congress Manuscript Division, vol. 3, no. 817.

[6]Anna Maria Thornton, "Life of Dr. William Thornton."

The issue that most consistently stirred Thornton's imagination and emotion was the issue of liberty. With his dream of emancipation and resettlement of America's slaves finally being addressed by the Colonization Society, he returned to his old schemes for an ideal African colony. Encouraged by the society's efforts to found a colony in Liberia, he drafted a long message to the society in which he set forward his ideas on city planning, sanitary conditions, education, military training, and other subjects.[7]

In a still more idealistic vein, he became a fervent supporter of the Greek fight for freedom from Turkish rule, placing articles in newspapers, addressing public rallies, and even proposing to the president that all government employees be asked to donate one day's pay to Greek independence causes. ("The Doctor urged all the arguments of the crusading spirit applicable to the idea, but I was inflexible," the cynical Adams noted in his diary.) Some of Thornton's comments to a town meeting in October of 1822 show the flavor of his thinking. Pleading for money to aid the Greeks, he pointed out that "the independence of this country [the United States] appears to be the precursor to more good to mankind than the common mind can readily calculate," went on to express his pleasure that the South Americans were obtaining their independence, foreseeing an alliance between North American and South American republics, and closed with a plea to address the issue of slavery. "In permitting the blacks to remain in bondage in this country, think you, my fellow citizens," he asked, "that their situation is to be endless? They are rapidly increasing, and provision must gradually be made for change."[8]

Thornton's public enthusiasm for the cause of Latin American independence led him, however, into difficulties with the administration. His zeal for what he called the "Sacred Cause," indeed, drove him well beyond such idealistic and harmless schemes as drafting a proposed constitution for a North American–South American federation.[9] He placed articles in the *Intelligencer* and other papers that were so anti-Spanish that they threatened to roil relations with that country. He rashly acted as middleman for visiting Latin American rebels and adventurers in addition to properly accredited officials, thereby annoying his boss, Secretary of State Adams, and adding to President Monroe's scorn. Monroe not only did not share Thornton's enthusiasm about the republican tendencies of the rebels but also had to keep reasonably good relations with Spain, and in time became quite angry at what he saw at Thornton's meddling. He

[7]Thornton to the managers, Colonization Society, 4 Jan. 1825, W. Thornton Papers, Library of Congress Manuscript Division, reel 3, no. 1027.

[8]Charles Francis Adams, ed., *The Memoirs of John Quincy Adams* (Freeport, N.Y., 1969), 6:324; *Washington Gazette,* 26 Oct. 1822.

[9]Thornton claimed to have first drafted the paper in 1810, but shelved it at the time as premature. The paper, which called for a federal union of thirteen American "regions," with a capital at Panama, was completed in 1815. The United States, shorn of some of its Louisiana territory, would simply have been one of the regions. The proposition—visionary, idealistic, and quite impracticable—displayed Thornton's proclivity to be "philosophical," as Margaret Smith once described him (See *The First Forty Years of Washington Society,* ed. Gaillard Hunt [1906; reprint ed., New York, 1965], p. 51)

eventually told John Quincy Adams, when Thornton tried to explain away his latest faux pas, that he "would not see him, nor have any conversation with him upon anything, unless it were patents, and very little then."[10]

Thornton's relationship with the president was already troubled enough as a result of the Fulton steamboat dispute, and Monroe most likely had little trust in the politics of a man whose personal friends included so many old Federalists like the Peters, Custises, and Tayloes. It is no surprise, therefore, that Thornton's repeated requests for preferment fell on stony ground throughout the Monroe era. For years, he conducted a many-pronged but quite unsuccessful campaign for a raise in salary, the elevation of the Patent Office to an independent department, or for an entirely new appointment. "This office has never enjoyed its proper rank," he wrote to his boss, Henry Clay, a few years later, "it is an office which has done much to encourage and perfect the useful and liberal arts of this country and from which a considerable revenue has been derived. It has produced during the last seven years, at the small rate of $30 a patent, $42,000."[11]

Thornton's incessant quest for promotion was driven by his great financial need, but also by pride. In a city where he had once been one of the leading citizens, but where official protocol now gauged one's importance by salary, he had lost much status to crass newcomers whose political connections had gotten them higher-paid jobs. Anna Maria's letters and diaries, which must to some extent reflect her husband's feelings, certainly demonstrate a deep sense of resentment over the issue and the indignity of his being "a seeker of office from illiberal and selfish politicians."[12]

Thornton did, over time, get congressional approvals to increase the staff of his office, but they never translated into an increase in his personal salary. By 1819, he was looking for ways to escape the Patent Office entirely, asking the secretary of state to appoint him U.S. commissioner or consul general in one of the emerging Latin American states. Knowing that he was considered to be a bit off-center on the issue, he tried to convince Adams that "my great attachment to the great Cause in which the South Americans are now engaged, does not emanate from a Source peculiar to that people, but springs from the great cause which embraces the happiness of Mankind, the Cause of General Liberty." When the request was ignored, he sharpened his demand a bit in the following year, asking specifically to be sent to South America as a special envoy to the new government in Columbia. Thornton pleaded his long service and good contacts

[10]Adams, *Memoirs of John Quincy Adams,* 4:55.
[11]Thornton to Secretary of State Clay, 28 Nov. 1826, Patent Office Letter Book, p. 22 as transcribed by P. J. Federico. Accessed at Pierce Law Center, *I.P. Mall,* http://www.ipmall.fplc.edu/hosted_resources/PatentHistory/poltrbk.htm.
[12]Anna Maria wrote to Louisa Adams on several occasions as early as March 1816 to seek John Quincy Adams's help in obtaining a raise, but got only ambiguous answers. W. Thornton Papers, Library of Congress Manuscript Division, unnumbered copies of Anna Maria Thornton's letters; Anna Maria Thornton, "Life of Dr. William Thornton."

with the South Americans and offered to obtain testimonials from supporters of the administration. Adams let Thornton know that he was considered to be too conspicuously partial to the rebels, confiding acerbically to his diary that "he [Thornton] has very foolishly made himself a fanatical partizan for the revolutionary South Americans, and had committed the grossest indiscretions in pursuit of this ignis fatuus." Monroe was even more opposed to Thornton and his suit and appointed another man on the ostensible grounds that Thornton's appointment would have been too controversial. The doctor, chagrined but ever hopeful, tried to save face by writing the president that he was glad to have learned that the turndown had not been due to "any personal disregard for me, which I must own I very much feared."[13]

The next year, he renewed his appeals to Congress, this time going public by having the *Washington Gazette* publish his letter to the Speaker of the House, in which he recounted his long service, his saving of the Patent Office during the 1814 war, and the increased workload of the office in his effort to justify a raise in pay. At the same time —and showing remarkable optimism for a man who was now more than sixty and not in the best of health—he suggested that he be sent to South America as a natural historian, leading a scientific expedition to the new southern republics. Neither proposal was successful. But Thornton still was not discouraged. In 1824, he again asked Secretary of State Adams for a diplomatic assignment, this time to Guatemala, which he promised to combine with scientific exploration. When his request appeared to be going nowhere, he tried to take his case to the public, drafting a newspaper piece in which he (using a favorite pseudonym of "Franklin") bemoaned the government's record of sending unqualified, unscientific persons to fill its South American posts. In 1825, he again petitioned Congress, this time for arrears of pay and a raise, but once again the appeal was unsuccessful. When Adams became president and Henry Clay was named secretary of state, Thornton tried still again—this time asking, separately, for a raise in the status and pay of the Patent Office director, and for a diplomatic appointment in Latin America. Once again, however, his requests were put aside.[14]

His old neighbor President Adams, perhaps conscious that Thornton could use some positive reinforcement after so many refusals, did throw him a small bone in 1825. But it was one that had no cost in patronage terms—an appointment on a panel to choose a design for a sculpture at the Capitol. The other "persons of taste and skill" chosen to sit on the panel were Charles Bird King, the painter, and Thornton's good friend Colonel Bomford of the Army Engineers. It was a bit of an honor, but by no means a help, in Thornton's money problems, for it was service without pay.

[13]Thornton to Adams, 22 Mar. 1819, W. Thornton Papers, Library of Congress Manuscript Division, reel 3, no. 843; J. Q. Adams Diary, 23 Aug. 1819, Adams Family Papers, Library of Congress Manuscript Division, part I, reel 34, p. 159; Thornton to Monroe, 20 July1820, W. Thornton Papers, reel 3, no. 920.

[14]*Washington Gazette,* 3 Mar. 1821.

The Thorntons' money problems had gone from troublesome to very serious. His salary, frozen for more than twenty years, had lost purchasing power and scarcely paid the bills. Yet, outside of a few rents from properties in England and Washington, he had no alternative source of income. Remittances from Tortola had all but dried up, and he could not even sell his share of the plantation because of differences within the family. All his business ventures had done badly—the failed insurance company with Blodgett, the various unsellable Washington building lots and houses, the North Carolina land that had no gold, the flocks of expensive Merino sheep, his various efforts to gain benefit from his and Fitch's steamboat patents. And worst of all, his bad business judgment and worse choices of partners had left him deep in debt—including almost ten thousand dollars in surety, which he claimed was forfeited when his old friend Samuel Blodgett, arrested for indebtedness, had jumped bail.

Thornton was by no means the only one of his contemporaries to be caught in failed speculations and debt. But he was determined nonetheless to live like a gentleman. Although he and Anna Maria entertained relatively modestly, they continued to keep a household and carriage that would not embarrass them before their rich friends like the Tayloes. Most significantly, the doctor's "unfortunate and unconquerable passion for horses," as his wife called it, was a huge drain. His horses indeed were a rare subject of discord between William and Anna Maria—she later said that she "was always trying to persuade my poor husband to sell" them. But he would not give them up. Meanwhile, he sought continually for schemes that would allow his finances to recover, exploring in particular steamboat ventures from the Mississippi to rivers in South America. None succeeded, and one failed amongst recriminations when his co-investor, Fernandino Fairfax, put up worthless securities. In short, Thornton's finances were a tenuous mess. Although he succeeded in keeping afloat through further "imprudences" (as Anna Maria called his investment decisions), such as rollovers of his debt to less demanding but more expensive creditors, he was occasionally caught so short that he could not even pay his taxes. In 1820, the municipality put a lien for arrearages on his house; in 1824 on some of his lots, furniture, and slaves; and in 1825 on his carriage and horses. Even though he was able eventually to pay the taxes, the experiences were surely an embarrassment.[15]

His financial problems, as well as a natural combative disposition, also kept Thornton embroiled in legal disputes; in 1819 alone he was involved in no less than five cases before the district courts. His dispute with Latrobe had finally been resolved in the courts, at no cost to his pocketbook even if at some cost to his reputation. The dispute with Fulton was eventually resolved before it could get to the courts, by Fulton's death

[15]Anna Maria Thornton, "Life of Dr. William Thornton"; Anna Maria Thornton Diary, 27 Oct. 1828, and 3 July 1820, Anna Maria Thornton Papers, reel 1, no. 704, and reel 7, container 20, n.p.

in 1815, but it was no victory. Fulton's patents were proven to have been fraudulent, a circumstance that even occasioned a sort of apology from Fulton's friend Latrobe, who admitted to having been his "dupe." But, even though the result was a sort of vindication for Thornton, it was a hollow thing. Fulton may not have had valid patents, but he did have a valid monopoly. His steamship companies as a result were successful, whereas Thornton never made a cent from all his efforts to commercialize his various patents. To such a proud man, it rankled. Thornton, who had long complained that "Mr. Fulton is for engrossing not only all the profits, but likewise all the honors of the invention of Steam Boats," continued his lonely campaign against the monopoly and in defense of his and Fitch's rights, even after Fulton's death.[16] Nor did his other legal cases go much better. He lost his suit against Fairfax and was bedeviled for years by a suit brought against him by Samuel Blodgett's widow, who claimed that he had prejudiced her rights to the dead man's (nonexistent) estate.

Anna Maria Thornton may have summed up the disappointments of these late years when she wrote in her diary, "Oh, how my heart aches when I think of the variety of trouble in which my poor husband was involved."[17]

William Thornton's troubles, and his exuberance as well, came to an end with his death on March 28, 1828. He passed away at home, after a short and relatively painless illness and a full life of sixty-seven years. His burial ceremony, just two days later, was distinguished by attendance of the president, members of the cabinet, Congress, the municipal government, his and Anna's personal friends, and colleagues from the Columbian, Colonization, and Medical societies. The following day, members of the Columbian Institute met in special session to honor their departed member and pledged themselves to wear black armbands for a full month in his memory. Shortly thereafter, his grave at the cemetery now known as Congressional Cemetery was marked by erection of a monument (chosen by the cemetery directors for the graves of distinguished officials), the design for which had been inspired—a final irony—by William Thornton's old rival and enemy Benjamin Henry Latrobe.

Thornton's death in some ways marked a watershed in the evolution of Washington and its social, cultural, and intellectual life. The city, which—a third of a century earlier when Dr. Thornton had come—was little more than a fragile concept, had finally come into its own. Admittedly, it was still a town rather than a city, with the beginning (but not much more) of a cosmopolitan intellectual and cultural life. Washington, L'Enfant, and Thornton had all imagined a city with vibrant trading, industrial and intellectual underpinnings that would in time enable it to play the central role of a European capital. That had not happened, due to the failure of Washington's commercial hopes plus

[16]Latrobe to Thornton, 13 Feb. 1815, in *The Papers of Benjamin Henry Latrobe,* ed. Edward C. Carter (New Haven, Conn., 1984), 3:619; W. Thornton to Benjamin Say, 7 Jan. 1811, W. Thornton Papers, reel 2, no. 548.

[17]Anna Maria Thornton Diary, 28 July 1828, Anna Maria Thornton Papers, reel 1, no. 698.

decades of congressional parsimony and small-government approach. Rather than be-coming more European in flavor, the town had in some ways gradually become more Western—the expansion of the nation and the government had brought more than a smack of the frontier to Washington. The influx of frontiersmen also coincided with a generational change, as the old founders like Thornton passed from the scene. This, indeed, was a trend that would be accelerated greatly when the Jackson administra-tion came into office a year later, speeding up the process by replacing many of the old office-holders under a new (but not really so new) "spoils" system.

It is entirely logical to assume, in short, that had Dr. Thornton lived, he would not have liked the Washington of 1829. Ever the worldly and cultured gentleman of Eng-land and Philadelphia, he made social choices that indicate he did not mix all that easily with the plain folk of the region—the "good old fashioned hog and hominy peo-ple," as another resident described them.[18] How he would have coped with Jacksonian Washington—in which he almost surely would have been asked to resign—we can only guess. It would not have been easy.

Meanwhile, it was Anna Maria Thornton who had to deal with the financial puzzle left by her husband's death. He left, by her estimate, more than $25,000 in outstanding debts, against an estate that he valued at $69,000. The debts, however, were much more real in the short run than the valuations that William had placed on his assets—such as his shares in Foxall's old foundry, which was no longer in operation. Practical and abstemious when necessary, Anna Maria gradually whittled away at those debts. Sell-ing the horses was easy; Henry Clay took some of the best—but none got the prices William had expected. Then went the artworks and even some of Thornton's own drawings: "It gave me a pang at the heart to part with the drawings—but I have some finished specimens of his talent in drawing and I hope I am justified in doing so, as the Estate is deeply in debt and it may take my life time or more to pay them." She was able to hold onto the farm for another year, but eventually had to sell it, too, as well as most of the eleven slaves. "It is very contrary to my wishes and feelings to sell any of them," she confided to her diary, "but . . . what can I do? I cannot afford to give them free."[19] She did, however, manage to keep the house, even though she and her mother were obliged to move downstairs that winter so as to save on firewood and even ex-perimented briefly with taking in a boarder. Some years later, the interest in the Tortola estate was finally sold, though it brought in little more than a year's worth of the doctor's old salary. Before too long, Anna Maria emerged from the burden of her husband's

[18]William Lee to Susan Lee, 12 Oct. 1824, Lee-Palfrey Family Papers, Library of Congress Manuscript Division.

[19]Anna Maria Thornton Diary, 13 Nov. 1828, Anna Maria Thornton Papers, reel 1, no. 707; ibid., reel 1, no. 705.

financial debt and even enjoyed a certain amount of comfort when property values increased enough to finally justify the doctor's real estate investments. She lived in the F Street house for yet another thirty-seven years, a respected and active member of a society and city that continued to grow and evolve around her.

William Thornton's primary legacy lives on in stone, brick, and mortar. The Capitol first, which—in spite of his endless complaints about the work of his contemporaries and successors—adhered to his original architectural concept over many alterations and additions. The basic design of a wing for each house of Congress and a central ceremonial space under a dome continues to make a strong statement about the nature of the building and its republican purposes, just as Washington and Jefferson foresaw. The building was essentially completed before Thornton's death, with most of his original interior designs changed and much even of the exterior, yet it was true to his concept and a tribute to his vision. His other Washington designs, the Tayloe or Octagon House, and the Peter house called Tudor Place, remain among the architectural treasures of the city. Thornton has occasionally been credited with other architectural designs around Washington, but those three buildings are enough to earn him a niche of honor in the city's history. Even his Philadelphia library, or at least its distinctive facade, has been replicated because of its architectural value.

Thornton's contribution to the cultural and intellectual growth of the city, however, is harder to fix. When he arrived in Washington and for years thereafter, he was one of the community's very few broadly educated, aesthetically inclined, and multi-talented individuals; a beacon of culture and science in a townscape of farmers, small merchants, craftsmen, and speculators. He apparently intended, or at least that is what he told his correspondents, to enrich his new home with institutions of learning and science, and to play a serious role in the growth of the new national capital. And yet, a third of a century later, with the town gradually developing some cultural depth and permanent institutions, Thornton's specific contribution to that evolution appears to have been minimal. Indeed, the Jockey Club was the only institution in the city that clearly bore his fingerprints as a founder. The Columbian Society, the Library and Theater companies, the dancing assemblies, the schools and universities, even the Colonization Society, all had been founded and organized by others. He and Anna Maria were of course active and honored participants in these enterprises, but he was not the moving force behind any of them.

Her husband had "left all unfinished," Anna Maria later commented. She was right; he had always been more interested in analysis and prescription than in buckling down to make a suggested solution work. His work seems to have been full of flights of reasoning with little follow-through; he had "no steadiness to pursue anything to a useful result," as John Quincy Adams astutely noted. Even Thornton's masterpiece, the design

for the Capitol, had been unworkable as far as the interior spaces were concerned, and he had not found it necessary to finish the necessary detailed plans for the builders until prodded. He was ever a fountain of ideas and enthusiasms: on slavery, on education, on art and architecture, on mechanical devices, even on chemistry, but few of those ideas ever came to fruition as a result of his efforts. It would seem that it was not from lack of physical energy, for he was an energetic commissioner, worked long hours at the Patent Office, and spent days in the field with his laborers at the farm. John Quincy Adams considered him to be lacking in "judgement, discretion, and common sense,"[20] and Thornton's unfortunate forays into politics and finance would lend some credence to that cruel judgment. But he seemed, above all, to be simply disinterested in the slow and tedious process of getting things accomplished, as when he abandoned thoughts of a medical career in Philadelphia because he found the actual work to be "laborious." Added to that, of course, was the bias of a gentleman against engaging in a profession or trade—an important part, indeed, of the antipathy between himself and the proudly professional Latrobe. Admiring as he evidently did the style of Virginia's landed gentry, Thornton may in fact have thought that a gentleman such as he should be measured more by how he lived, how he defended his honor, and what he believed than by any practical achievements.

Be that as it may, it was to more practical men that early Washingtonians owed most thanks for those cultural amenities that they enjoyed. To men like Thomas Law, Daniel Carroll of Duddington, and John Van Ness, who started theaters and libraries, backed the public schools, and promoted civic improvements in order to build a community where their real estate investments would bear fruit. To men like Obadiah Brown, William DuBourg, Giovanni Grassi, and William Staughton, who worked to make their visions of higher education a reality for Washingtonians. To ministers like William Matthews, James Laurie, and Andrew McCormick, who promoted schools and charitable works. And to the businessmen like Robert Brent, Peter Force, Samuel

[20]Both quotes from John Quincy Adams Diary, 23 Aug. 1819. Adams's biting critique of Thornton was written in evident exasperation at the importunate doctor but is worth quoting at length because it shows how Thornton's eccentricities affected his reputation, even among supposed friends. As Adams confided to his diary:

Thornton . . . is a man of some learning and much ingenuity; of quick conception and lively wit; entirely destitute of Judgment, discretion and common sense. He has been nearly twenty years Superintendent of the Patent Office; a place principally made by Mr. Madison to put him in it, and there has scarcely issued from it during the whole time a Patent, for any invention, but the Doctor had a counter claim, as the inventor of the same thing himself. He has a fine taste in Architecture, and a real turn for mechanical invention but no steadiness to pursue anything to a useful result. . . . The Doctor is a horse racer too, and often boasts that the South Americans have repeatedly offered to appoint him a Col. of Cavalry in their services. He considers himself the principal author of the South American Revolution, and that all the principal measures of the Patriots have been adopted at his suggestion. In the course of my life I have met with very few men of minds at once so active, intelligent, and weak. Yet he is withal a man of good intentions, and generally harmless deportment. As superintendent of the Patent Office, he is useful and fully competent to the place, though by his interfering pretensions he gives great offense to many of the patentees. As for the agency to South America, the President considers him utterly unfit for any such office, and will never appoint him to it.

Smith, or Roger Weightman, who strove both in their private capacities and as city officials to make Washington a more livable, culturally richer place.

And yet it would be wrong to dismiss lightly Thornton's contribution to the intellectual and cultural growth of the town. While the practical men may have gotten more done, the goals they were striving for were inspired in part by the example shown by Thornton and his wife. In a small community such as Washington's, the Thorntons set a sort of standard, and the tone emanating from their intellectual, artistic, idealistic, and scientific qualities was important. During the capital's formative years, Thornton was the community's resident authority on matters artistic and scientific, his Patent Office the premier scientific establishment in town, while his wife was admired for her skills as a linguist and musician. Their social skills, lively intelligences, and connections to the family of George Washington made them one of the town's prime "power couples," a position that they more or less retained even after William's eccentricities in the Latrobe case began to lose him some respect. Three decades of prominence cemented their place among the city's most important cultural leaders, and their lives had enriched the town both by example and activity. At the time, indeed, the doctor was remembered more for his cultural and intellectual contributions to the city than for his architectural achievements.

William Thornton's grave carries no epitaph. Perhaps most fitting, by the way it expresses his love of knowledge, aesthetics, and inquiry, would have been a piece of poetry he had written some years earlier:

> Friends, books, a garden, and perhaps a pen;
> Delightful industry enjoyed at home
> And nature in her cultivated trim
> Dressed to his taste, inviting him abroad
> Can he want occupation who has these?"[21]

He lived by those sentiments, and his fellow citizens were enriched by it. While we today can admire his architectural achievements, his own best reward was, perhaps, a life fully lived.

[21]Anna Maria Thornton Papers, reel 1, no. 142.

Appendix

Biographical Sketches of Early Washington Cultural Leaders

JOEL BARLOW. Essayist, poet, diplomat, and businessman, Barlow and his wife, Ruth, came to Washington in 1804, after almost two decades in Europe, at the suggestion of President Thomas Jefferson. Buying an estate near Rock Creek and calling it Kalorama, they provided Washington's cultural and literary elite with a hospitable gathering place and the city's best library. The Barlows left Washington in 1811 to return to France on diplomatic assignment; he died in 1812 while following Napoleon's army. Mrs. Barlow returned to Kalorama, where she stayed until her death.

SAMUEL BLODGETT. A Philadelphia businessman, Blodgett played a role in Washington's development through his various promotional schemes. Unsuccessful in a short early stint as supervisor of public works, the ebullient Blodgett then turned to promoting the ambitious hotel that long bore his name, and in which Washington's first theater was established. A tireless promoter of the Federal City, he also advocated establishment of a national university and a national monument to General Washington. Few of his schemes, however, were successful, and he died bankrupt in 1807.

GEORGE BOMFORD. The West Point–trained engineer came to Washington in 1815 as part of the army's new Ordnance Department and became a close friend of the Thorntons. He soon met and then married Ruth Barlow's half-sister Clarissa (Clara),

and the couple became prominent in Washington's social and cultural circles. Promoted to colonel and head of the department, Bomford became a permanent resident of Washington and lived for many years in the Barlows' old house at Kalorama.

ROBERT BRENT. A member of the prominent Virginia Catholic family that owned the Aquia Creek quarry from which the building stone for the Capitol was quarried, Brent married the daughter of Notley Young, one of the most important original Washington landowners. Appointed by Jefferson to be the town's first mayor, Brent held that position for ten years until resigning to pursue his business interests full time. As mayor, he helped establish city services and was particularly active in getting the municipality to accept responsibility for schools. He died in 1819.

OBADIAH BROWN. From New England, he came to Washington in 1807 to serve as first pastor of the First Baptist Church. Convivial and energetic leader of that nonaffluent but growing congregation, and several times House and Senate chaplain, he was also a leader in the national Baptist Convention. He obtained the convention's backing for establishing an academy in Washington, which was chartered by Congress in 1821 as a nondenominational school and eventually became George Washington University.

CHARLES BULFINCH. Appointed architect of the Capitol in 1818, replacing Latrobe, he completed the original building with the central rotunda and first dome. He also designed the first Unitarian church, finished in 1822 and unfortunately now demolished.

ELIAS BOUDINOT CALDWELL. Chief Clerk of the Supreme Court from 1800 to his death in 1825, Caldwell was active in the Presbyterian church, charitable activities, and the school board. He was cofounder of the American Colonization Society in 1816.

JOHN CARROLL. A member of the prominent Carroll family of Maryland, he was closely related to Daniel Carroll of Duddington, one of the major original Washington proprietors and a business leader of the new city. A Catholic clergyman, Father Carroll became the first American bishop of that faith. Although his seat was in Baltimore, his leadership of the Catholics in Washington was strong, and he was the key founder of Georgetown College.

GAETANO CARUSI. Along with his wife and sons, Samuel, Lewis, and Nathaniel, Carusi came to Washington in 1806 as one of the Italians hired to play in the Marine Band. He decided to stay in the United States, left the Marine Band for private busi-

ness, and by 1822 became proprietor of the city's best private meeting hall, the Washington Assembly Hall, also known as Carusi's Saloon.

WILLIAM CRANCH. From Massachusetts, Cranch came to Washington in 1794 as agent for the real estate promoter James Greenleaf. Appointed as judge by John Adams in 1801, Cranch was subsequently reappointed by Jefferson and became the author of the city's first law code. Musical and literary, he published translations from Latin and the city's early court records. A vice president of the Columbian Society, he was also one of the founders of Colombian College Law School. Two of his sons became artists.

GEORGE WASHINGTON PARKE CUSTIS. The grandson of Martha Washington, he inherited the Arlington estate and began in 1802 to build Arlington House on the hill overlooking Washington. Active in agricultural promotion (though not himself a successful farmer), he was also a painter of large allegorical canvases, writer of historical dramas (his play *Pocahontas* was performed in Philadelphia's Chestnut Street Theatre), and the writer of a biography of George Washington.

PETER FORCE. Established in Washington as a printer and publisher in 1815, Force founded the *National Journal* in 1823. He served as mayor 1822–24 and began to amass an important collection of historical documents.

JOSEPH GALES. Co-owner of the *National Intelligencer,* post 1810. See William Seaton.

GIOVANNI GRASSI. President of Georgetown College for almost a decade (1810–19), Grassi presided over its growth as a national institution and its increasing integration into the life of the capital city.

JAMES HOBAN. Winner of the 1792 competition to design the President's House, Hoban (even though disparaged as a mere builder or "carpenter" by Thornton and Latrobe) contributed to the cultural as well as the physical development of the city. At various times responsible for work on the Capitol in addition to the presidential mansion, Hoban became unofficial sponsor for the Irish workmen who had been attracted to the city's construction jobs. Founder of the city's first Masonic Lodge, he was also active in Saint Patrick's Church, the public schools, the city council, and the Sons of Erin.

CHARLES BIRD KING. The city's first resident artist of note, King established himself in 1816 and painted portraits of the city's elite. His most important work, however,

was done on contract for the government and consisted of paintings of the various Indian delegations that came to the capital on tribal business.

NICHOLAS KING. Surveyor for the commissioners, King also worked for private clients and sought to earn money with his other skills. Although attempts to sell his engravings and to open a lending library proved unsuccessful, his design for "Evermay," Samuel Davidson's house on the hills above Georgetown proved an enduring success. When the commission was disbanded, King went to work for the topographic division, where he prepared maps for the Lewis and Clark expedition. He was also active in education, serving several times on the city school board.

BENJAMIN HENRY LATROBE. English born, Latrobe studied architecture there before coming to the United States. Successful in Philadelphia, he married Mary Hazelhurst in 1800 and traveled back and forth to Washington for some years after being appointed by Jefferson as supervisor of works in 1803. Responsible for much of the interior design of the Capitol (particularly the Old House chamber), Latrobe also collaborated with Dolley Madison on the public rooms in the White House, was architect at the Navy Yard, supervised the post-1814 reconstruction of the Capitol, and designed many other public and private buildings in the city. He was an investor in Robert Fulton's steamboat ventures, but his finances were perpetually shaky. He died in New Orleans in 1820.

JAMES LAURIE. A recent graduate of Edinburgh University, Laurie came to Washington in 1802 at the invitation of a group of Associated Reform Presbyterians who wanted to open their own congregation. He preached first in the Treasury Building (where he also found employment) while raising money for a church on F Street that was completed in 1807. Laurie rapidly became active in the city's philanthropic life, serving regularly on the school board and other civic and charitable bodies during the forty-six years he served his congregation.

THOMAS LAW. From a distinguished English family, Law came to Washington in 1793 after having amassed a fortune in India. Convinced that Washington was destined to be a great city, he invested heavily in business real estate, particularly near Capitol Hill, where he had his own residence, but also in civic improvements such as the theater, the canal, and the post-1814 Brick Capitol. His marriage to Elizabeth (Eliza) Parke Custis, Martha Washington's granddaughter, did not last. Law, who was known for his generous but at times quite eccentric behavior, was active in many civic causes and had a wide-ranging intellect. As a founding member of the Columbian So-

ciety, he presented several papers on the subject of monetary reform. His son from an earlier marriage in India, John Law, was a Washington lawyer who unfortunately died before his father.

ROBERT LITTLE. Minister at the first Unitarian church for six years beginning in 1819, he was renowned for his eloquence and liberal views. He was active in the Columbian Institute and the Botanical Society and editor of the short-lived *Washington Quarterly Magazine.*

JOHN MASON. Son of George Mason, the drafter of Virginia's Bill of Rights, Mason was a banker and businessman who had a city home off Pennsylvania Avenue near Rock Creek and a summer home on Analostan (now Roosevelt) Island opposite Georgetown. He was involved in numerous civic projects, including the militia, though his major contribution to the cultural life of the city was through the entertainment he offered to residents at his beautiful Analostan retreat.

JOSEPH NOURSE. Registrar of the Treasury, he came to Washington in 1800 with the government and served until replaced by the Jackson administration. A pious man, he was instrumental in the formation of James Laurie's Presbyterian congregation. The family home, on Q Street in Georgetown, is now known as Dumbarton House.

JAMES K. PAULDING. A New York author, Paulding resided in Washington from 1815 to 1823 as secretary to the board of naval commissioners. He wrote a number of books while in Washington, none of them, however, with Washington themes.

THOMAS PETER. The son of Georgetown merchant and mayor Robert Peter, Thomas married Martha Washington's granddaughter Martha Parke Custis. Staunch Federalists, they became close friends of the Thorntons. William Thornton provided the design for the Peters' new house on the hills of upper Georgetown, now known as Tudor Place.

ISAAC ROBERDEAU. Roberdeau initially came to Washington to assist Peter L'Enfant in executing the city plan. Thornton, as commissioner, helped him obtain compensation for damages resulting from his separation at the time L'Enfant was fired. Roberdeau returned to Washington in 1818 as head of the Army Topographical Bureau and came to be active in the intellectual life of the capital until his death in 1829. He was a member of the Columbian Society, where he presented a paper on the Coastal Survey.

William SEATON. Purchased the *National Intelligencer* in 1810, along with fellow Virginian Joseph Gales. The two ran the paper successfully for many years, were active in the city's civic life, and helped found the Unitarian congregation. Seaton served on the city council and was an active Mason.

Margaret Bayard SMITH and Samuel Harrison SMITH. The newly married couple came to Washington in 1800 at Jefferson's suggestion that Smith found a Republican paper, the *National Intelligencer*. The paper became the city's most influential news source, and Smith and his wife were leading members of society. He sold the paper in 1810 to retire to his country home but returned to government service in 1814 for financial reasons. Mrs. Smith initially wrote articles, anonymously, for magazines but after 1815 began to write novels under her own name.

William STAUGHTON. Dr. Staughton was called from a successful Philadelphia ministry to become the first president of Columbia College in 1822. An eloquent preacher, he was also successful in building up the new institution, adding schools of medicine and law before his departure in 1827.

John TAYLOE. A wealthy Virginia planter whose wife came from an equally well-placed Maryland family, the Tayloes established a city residence in Washington from which he could pursue his political and business interests. He asked William Thornton, who became a personal friend, to design his house (now known as Octagon House) near the president's mansion. There they entertained lavishly and loaned the house to the government in 1815 to serve as the presidential residence after the 1814 fire.

Thomas TINGEY. An English-born naval officer who became celebrated after standing up to the British during the Quasi War with France, Tingey was named first commandant of the Washington Navy Yard in 1800. The gregarious and musical Tingey was a fixture of the Washington social scene until his death in 1829.

John Peter VAN NESS. A New York congressman, Van Ness met and married the Washington real estate heiress Marcia Burnes and settled in Washington in 1803 after resigning his congressional seat. He devoted himself to banking and civic affairs, sponsoring the city theater company, commanding the militia, serving on the city council as well as contributing to many civic causes, and helping to finance the Brick Capitol after the 1814 fire. He and his wife built a grand new home at the edge of the canal in 1815, which Latrobe designed for them and where they entertained often. Mrs. Van Ness founded the first orphanage for young girls.

Frederick WAGLER. Music teacher and seller of musical instruments, Wagler arrived in Washington in 1803 and was for years the town's only concert-level pianist.

George WATTERSON. A Maryland lawyer, Watterson came to Washington in 1811 to work for Thomas Law. In 1815, he was appointed Librarian of Congress to oversee the acquisition of Thomas Jefferson's library, replacing the original collection burned by the British. He served in that position until removed by the Jackson administration and wrote several Washington-based novels during the period. He was also a founding member of the Botanical Society.

Roger Chew WEIGHTMAN. Owner of one of the city's more important bookstores, Weightman combined his literary interests with municipal government, being elected councilman and mayor.

David WILEY. A Presbyterian minister, Wiley's main activity was as director and teacher of science at the Columbian Academy in Georgetown. He ran the Columbian Library for years, was an amateur astronomer and owned a number of scientific instruments, and for a short time published a journal called the *Agricultural Museum*. He was also active in Georgetown civic affairs—becoming mayor shortly before his death in 1812.

William WIRT. Wirt, a Virginia lawyer and author, was attorney general of the United States 1817–1829. He and his family (his wife was also an author) were fixtures of the city's intellectual community during their stay in Washington.

Joseph WOOD. Wood was a New York portraitist who established himself in Washington from 1816 on, during which period he painted a number of presidents and other dignitaries, often in miniature.

Bibliographic Note

The history of early Washington has been explored in a goodly number of books and articles, many of which touch on the Thorntons as well as the events and processes that shaped the cultural life of the new city. In general, those works tend to sort themselves into studies of the physical development of the city and ones about its social and political life. While they provide a rich history of the growth of the city and its political and social life, they are thin in discussing its cultural life and will not be listed here in any detail. In the first category, Bob Arnebeck, *Through a Fiery Trial: Building Washington, 1790–1800* (Lanham, Md., 1991), as well as his unpublished but electronically available *The Seat of Empire: A History of Washington, 1790–1861* (Bob Arnebeck, *The Seat of Empire,* http://www.geocities.com/BobArnebeck/introduction.html) are highly readable and informative sources for the general reader. For the story of the building of the Capitol, the key general source was William C. Allen, *History of the United States Capitol* (Washington, D.C., 2001). Other valuable sources on the design and construction of the city and the Capitol are Saul K. Padover, *Thomas Jefferson and the National Capital, 1783–1818* (Washington, D.C., 1946), *The Papers of Benjamin Henry Latrobe,* and of course the papers of William Thornton (both cited more fully below). Useful in discussing an often-ignored section of the city was Taylor Peck, *Round Shot to Rockets: A History of the Washington Navy Yard* (Annapolis, Md., 1949), while Wilhelmus B. Bryan's old classic, *A History of the National Capital* (New York, 1914), retains value as a trove of miscellaneous information about the young city.

The city's political and social life has been the focus of many works (including the accounts of most early visitors), in almost all of which the cultural setting is unfortunately treated tangentially, if at all. Anne H. Wharton, *Social Life in the Early Republic* (New York, 1902), among works of this nature, provided useful background and anecdotal information. Particularly valuable in shedding sidelights on cultural developments was Constance Green, *Washington: From Village to Capital* (Princeton, N.J., 1962.) Catherine Algor's more recent works on the political role of women in shaping early Washington are a stimulating addition, particularly *Parlor Politics* (Charlottesville,

Va., 2000). Similarly, Fredericka J. Teute's several studies of female roles in Washington, especially "In the Gloom of Evening: Margaret Bayard Smith's View in Black and White of Early Washington Society," *American Antiquarian Society Proceedings* 106, no. 6 (1996), explore the intellectual aspirations of women in the early city. James Sterling Young, on the other hand, looks at male groupings and their effect on society in *The Washington Community, 1800–1828* (New York, 1958). From another angle, Anya Jabbour, *Marriage in the Early Republic: Elizabeth and William Wirt and the Companionate Ideal* (Baltimore, Md., 1998) looks at a prominent Washington marriage and its social and cultural ramifications.

Anna Maria Thornton's diary provides a wealth of useful information on events in the cultural life of the city, and one could only wish that she had commented more on what she saw and did. Margaret Bayard Smith's papers (cited below), on the other hand, are much more introspective, while her correspondence, as quoted in Gaillard Hunt, ed., *The First Forty Years of Washington Society* (1906; reprint ed., New York, 1965), is a mine of information about political, cultural, and social happenings. Similarly, Rosalie Calvert's letters in Margaret Law Calcott, ed., *Mistress of Riversdale: The Plantation Letters of Rosalie Stier Calvert* (Baltimore, Md., 1991) provided much useful firsthand information on the fashionable life in Washington and it surroundings. Richard B. Davis, *Intellectual Life in Jefferson's Virginia* (Chapel Hill, N.C., 1964) spoke to the regional intellectual environment, while Jean B. Russo, "The Wonderful Lady and the Fourth of July: Popular Culture in the Early National Period," *Maryland History* 90 (1995), gave a brief but valuable look at popular culture.

For the life and work of William Thornton, his papers at the Library of Congress are of course a prime resource, as are those of his wife. But for a full and magisterially annotated collection of his correspondence, C. M. Harris, ed., *Papers of William Thornton* (Charlottesville, Va., 1995), is invaluable. Unfortunately only volume one, covering the period up to 1802, has been printed to date, and those interested in a fuller study of Thornton's life will have to wait for the second volume; one can hope for an eventual definitive biography. Other useful works on Thornton include two books published by the American Institute of Architects, the current owners of Thornton's Octagon House: Elinor Stearnes and David Yerkes, *William Thornton: A Renaissance Man in the Federal City* (Washington, D.C., 1976), and Orlando Ridout, *Building the Octagon* (Washington, D.C., 1989). Less scholarly and reliable but still useful was Beatrice Starr Jenkins, *William Thornton: Small Star of the American Enlightenment* (San Luis Obispo, Calif., 1983). Thornton's work at the Patent Office is analyzed usefully in a number of places, including P. J. Frederico, *Outline of the History of the United States Patent Office* (Federalsburg, Md., 1936), and Kenneth W. Dobyns, *The Patent Office Pony: A History of the Early Patent Office* (Fredericksburg, Va., 1994).

A most useful resource in exploring the general cultural climate and its development was *Washington History,* the journal of the Historical Society of Washington, D.C., previously published as the *Records of the Columbia Historical Society.* Published for more than a century, these journals have made available a wealth of information, including biographical sketches, church and other institutional histories, and analyses of social and cultural developments. Well more than fifty articles were consulted; each one added something useful to the mosaic, and collectively they were indispensable, even though they are too numerous to mention here individually. Also indispensable were the local newspapers, especially the *National Intelligencer,* which was reviewed issue by issue for most of the period. Other papers such as the *Washington Gazette* were winnowed by subject and keyword through electronic search engines, which turned up many useful items.

The growth of the young city's two premier educational institutions, Georgetown and Columbian academies, was best covered, respectively, in Robert Curran, *Bicentennial History of Georgetown University* (Washington, D.C., 1993), and Elmer L. Kayser, *Bricks without Straw: The Evolution of George Washington University* (New York, 1970); the latter and other interesting material is also available online at George Washington University, *Gelman Library Special Collections,* http://www.gwu.edu/gelman/archives/almanac/index.html. Another educational institution of the time whose successor now provides useful online documentation is the Washington Seminary (now Gonzaga), at Gonzaga College High School, *History,* http://www.gonzaga.org/html/history.html. For the history of black schools, most useful was William A. Joiner, *A Brief Review of the Origins and Development of the Colored Schools in the District of Columbia* (Charleston, S.C., 1901), and Winfield S. Montgomery, *Education for the Colored Race in the District of Columbia, 1807–1905* (Washington, D.C., 1905). The history of the Columbian Institute is covered most thoroughly in the Force Papers (series VIII D) at the Library of Congress, and more conveniently in Richard Rathbun, *The Columbian Institute for the Promotion of Art and Science* (Washington, D.C., 1917). Other useful sources for the institute and the development of the scientific community in Washington are at the Web site of its eventual successor organization, the Smithsonian Institution, at Smithsonian Institution Archives, *Columbian Institute Records,* http://siarchives.si.edu/ findingaids/FARU7051.htm#FARU7051h, as well as National Oceanic and Atmospheric Administration, *National Oceanographic Data Center Library,* http://www.lib.noaa.gov/edocs/ TITLE.htm.TITLE, for the early history of the Coastal Survey. Finally, the best summary of the debates surrounding the educational institution that Washington did not get, the national university, was Albert Castel's article, "The Founding Fathers and the Vision of a National University," *History of Education Quarterly* 4, no. 4 (1964).

While the fine arts did not exactly flourish in early Washington, their slow emergence has been documented in a number of useful books. Those include Andrew J. Cosentino and Henry H. Glassie, *The Capital Image: Painters in Washington, 1800–1915* (Washington, D.C., 1983), Ellen G. Miles, *Saint-Mémin and the Neoclassical Profile Portrait in America* (Washington, D.C., 1940), as well as Reese James, *Old Drury of Philadelphia* (Philadelphia, 1932). Thomas A. Bogar graciously made available a prepublication manuscript of his colorful *American Presidents Attend the Theatre* (Jefferson, N.C., 2006). The catalog for the National Gallery of Art's 2006 exhibit of works by Gilbert Stuart also contained much useful information. Finally, two theses were useful in exposing the growth of the music profession in the city: John C. Haskins, "Music in the District of Columbia" (master's thesis, Catholic University, 1952), and Kenneth W. Carpenter, "A History of the Marine Band" (Ph.D. diss., University of Iowa, 1970).

Books or articles on the literary scene are even fewer than the number of early Washington authors. Julia E. Kennedy, *George Watterson: Novelist, Metropolitan Author and Critic* (Washington, D.C., 1933) is a useful biography but has little local context, while Fredericka Teute's articles (referenced above) on Margaret Bayard Smith shed light on the problems faced at the time by a female writer. The history of the city's most important newspaper, on the other hand, is well covered in both William C. Ames, *A History of the National Intelligencer* (Chapel Hill, N.C., 1972) and Josephine Seaton, *William Winston Seaton of the National Intelligencer* (1871; reprint ed., New York, 1970).

Washington's churches are much better documented. A number of parish histories have been written up in the journals of the Historical Society and its predecessor; still others have been made available in a variety of parish and diocese publications, such as those of the Catholic Historical Society of Washington. Useful books in this category were Morris J. MacGregor, *A Parish for the Federal City* (Washington, D.C., 1994), about Saint Patrick's; Constance M. Green, *The Church on Lafayette Square* (Washington, D.C., 1970), about St. John's Episcopal; and Lawrence C. Staples, *Washington Unitarianism* (Washington, D.C., 1970). John C. Hillhouse, "Obadiah Brown, Pioneer Baptist Denominational Elder and U.S. Post Office Official" (master's thesis, Indiana University, 1970), while a bit overly hero-worshipping, was useful for its human details. Russel E. Train, *The Train Family* (Washington, D.C., 2000) also includes some interesting material on Brown. Similarly, a forthcoming history of the New York Avenue Presbyterian Church by Elaine Foster and others has useful information on Rev. James Laurie of the predecessor Second Presbyterian and was made available in prepublication manuscript. For information on the growth of African American parishes, John W. Cromwell, "The First Negro Churches in the District of Columbia," *Journal of Negro History* 7 (1922), and Nina H. Clark, *The History of the Nineteenth*

Century Black Churches in Maryland and Washington, D.C. (New York, 1983), were both valuable. Finally, for a record of the congressional chaplains and their offices, a handy resource was U.S. Senate, *House and Senate Chaplains,* http://www.senate.gov/reference/resources/pdf/RS20427.pdf.

Much useful firsthand and anecdotal information was extracted from the published letters and journals of visitors or part-time residents such as congressmen and their wives. Where comments from these observers have been used, the sources are cited fully in the footnotes. The principal resources of this nature were the letters of three congressmen and their wives: Samuel and Catherine Mitchill, Abijah Bigelow, and Manasseh Cutler, as well as the letters of a senior government clerk, William Lee. Also useful was John Kennedy, *Memoirs of the Life of William Wirt* (Philadelphia, 1853), as well as the letters of Mary Crowninshield, wife of a congressman, in Francis B. Crowninshield, ed., *The Letters of Mary Boardman Crowninshield, 1815–16* (Cambridge, Mass., 1905). The British diplomat Augustus John Foster, resident for a number of years on two separate occasions, provided a number of trenchant observations, as did the travelers Alexander Dick (in 1806–9) and Frances Wright (in 1820). Other travelers whose journals and descriptions helped fill in a picture of cultural life in the early city were Richard Parkinson, *A Tour in America, 1790–1800* (London, 1805); Charles W. Janson, *The Stranger in America* (1807; reprint ed., New York, 1935); John Melish, *Travels in the United States of America, 1806–1811* (Belfast, 1818); Washington Irving, *Letters to Henry Brevoort,* ed. George Helman (New York, 1918); and Frances Trollope, *Domestic Manners of the Americans* (1832; reprint ed., New York, 1949).

Published correspondence of other key figures in the story of early Washington was essential to the effort. Among the most valuable was that of the prolific, opinionated, and observant B. Henry Latrobe, excellently edited in Edward C. Carter, ed., *The Papers of Benjamin Henry Latrobe* (New Haven, 1984–88). Margaret Bayard Smith's letters have already been mentioned. Charles Bulfinch, Latrobe's successor as architect of the Capital, provided some good descriptions of the city and its life upon his arrival, as edited by Ellen S. Bulfinch in *The Life and Letters of Charles Bulfinch* (New York, 1973). The Madisons' papers were also valuable. See *The Selected Letters of Dolley Payne Madison,* edited by Holly C. Shulman and David B. Mattern (Charlottesville, Va., 2003), as well as Shulman's electronic resource at University of Virginia Press, *The Dolley Madison Digital Edition,* http://rotunda.upress.virginia.edu:8080/dmde/, which gives the flavor of the social scene as well as the Madisons' changing relationship with the Thorntons. James's correspondence in *The Papers of James Madison,* edited by Robert J. Brugger et al. for the Secretary of State Series, 8 vols. (Charlottesville, Va., 1986–2007), and Robert A. Rutland et al. for the Presidential Series, 5 vols. (Charlottesville, Va., 1984–2005), although predictably less "newsy" than Dolley's was also useful. John

Quincy Adams's diary was also very informative, as edited by Charles F. Adams, *The Memoirs of John Quincy Adams,* 12 vols. (1874–77; reprint ed., New York, 1969). Finally, the Library of Congress's electronic George Washington Papers and the Thomas Jefferson Papers, easily searchable at Library of Congress, *American Memory,* http://memory.loc.gov/ammem/gwhtml/ gwhome.html, and Library of Congress, *American Memory,* http://memory.loc.gov/ ammem/collections/jefferson_papers, respectively, were a ready source for consultation and cross-checking.

In addition to the published sources noted above, archival collections were vital for gaining an understanding of the cultural life of the early city. The papers of William Thornton and Anna Maria Brodeau Thornton, mentioned above, were of course essential. Both collections, at the Library of Congress Manuscript Division, are unfortunately only partial; his correspondence, however, has been excellently filled out—at least for the period up to 1802—by C. M. Harris (cited above), but the missing years of Anna Maria's diary are probably lost forever. (Her diary for the key year of 1800, on the other hand, was made more generally accessible in the 1907 *Records of the Columbia Historical Society*). Other useful collections at the Library of Congress were the papers of Margaret Bayard Smith (much more introspective and troubled than her published correspondence), the Peter Force papers (which contain one of George Watterson's novels as well as records of the Columbian Institute), and the papers of Richard Rush, William Wirt, Thomas Hubbard, Louis McLane, Thomas Law, Catherine Ackley Mitchill, Charles Willson Peale, the Cranch family, the Lee-Palfrey family, the Custis/Lee papers, and the Cutts/Madison papers. Another interesting collection of Thomas Law's papers was consulted at the University of Virginia Library Special Collections Division, which also has a few pertinent papers of Joseph Nourse. (Nourse family papers at the Dumbarton House in Washington were also consulted.)

If the present book has any lasting value, it may be largely in its effort to bring together much of this material, previously published or available only in scattered form, into a single narrative description of the modest early cultural environment of our city, a place which has gradually evolved into the true world capital that L'Enfant, Washington, and Thornton—but not Jefferson—envisaged.

Index